大学英语拓展课程系列教材

新编艺术英语

NEW ART ENGLISH 2

总主编 杨小彬 主编 张 宁 王 婷
编者 黄 薇 韩晓龙 陈虹波 皮重阳
 谢蕊婷 吕洪波 熊召永

清华大学出版社
北京

版权所有，侵权必究。举报：010-62782989，beiqinquan@tup.tsinghua.edu.cn。

图书在版编目（CIP）数据

新编艺术英语. 2 / 张宁，王婷主编. —北京：清华大学出版社，2018（2023.8重印）
（大学英语拓展课程系列教材 / 杨小彬总主编）
ISBN 978-7-302-49690-8

Ⅰ.①新… Ⅱ.①张…②王… Ⅲ.①艺术—英语—高等学校—教材 Ⅳ.①J

中国版本图书馆CIP数据核字（2018）第035215号

责任编辑：曹诗悦
封面设计：平　原
责任校对：王凤芝
责任印制：杨　艳

出版发行：清华大学出版社
　　　　网　　址：http://www.tup.com.cn, http://www.wqbook.com
　　　　地　　址：北京清华大学学研大厦A座　　邮　编：100084
　　　　社 总 机：010-83470000　　邮　购：010-62786544
　　　　投稿与读者服务：010-62776969, c-service@tup.tsinghua.edu.cn
　　　　质量反馈：010-62772015, zhiliang@tup.tsinghua.edu.cn

印 装 者：北京鑫海金澳胶印有限公司
经　　销：全国新华书店
开　　本：185mm×260mm　　印　张：10.75　　字　数：245千字
版　　次：2018年3月第1版　　印　次：2023年8月第5次印刷
定　　价：49.00元

产品编号：078778-01

Preface

《国家中长期教育改革和发展规划纲要（2010—2020年）》明确指出，高校要"适应国家经济社会对外开放的要求，培养大批具有国际视野、通晓国际规则、能够参与国际事务和国际竞争的国际化人才"。在高等教育全球化的时代背景下，随着全球文化艺术交流日益频繁，培养艺术类大学生的英语思维能力和应用能力受到教育界的广泛关注。如何开设符合艺术类大学生语言起点、认知特点，能调动学生自主学习积极性的艺术英语课程，是从事大学英语教学的教师们面临的重大课题。

一直以来，部分院校对于艺术类学生的英语教学定位不够明确，在大学英语课堂教学中，未能充分考虑艺术类学生的英语基础、认知能力、学习习惯与兴趣诉求，导致课堂气氛沉闷，效果欠佳。由于英语基础薄弱，相当一部分艺术类学生不能很好地适应普通模式的大学英语教学。他们对与自己专业相关的语言知识和语言素材有着浓厚的兴趣，对参与与艺术相关的国际交往和实践（如参与国际间艺术品的展览、拍卖，在画廊中向国际买家介绍艺术作品，参与艺术设计的招投标等）有着极大的热情，但这种兴趣和热情在以通用英语为主要内容的大学英语课堂上却得不到回应和满足。

克服种种错位是大学英语改革的重要目标之一，但改革的成功绝不是简单地通过在语言教学中进行艺术元素的渗透就能达到的，而是需要我们对艺术类大学英语教学进行重新设计，包括教学大纲的制订、教材的编写、教学方法和策略的革新等多个方面。其中新教材的编写是整个教学改革设计中的关键环节。

本套《新编艺术英语》教材的目标定位是通过对与艺术知识相关的英语语料、教学内容的设计，帮助学生积累艺术专业领域英语知识，提高他们的语言自主学习能力，在英语学习过程中拓宽眼界，获取相关领域表达技能。本教程从学生的真实语言起点出发，遵循《大学英语教学指南》，语言素材的选取和教学内容的设计介于"通用英语"和"专门用途英语"之间，力求帮助艺术类大学生逐步达到"指南"规定的基础目标，为学生未来专业领域英语语言的自主学习和运用打下坚实的基础。

⌘ 教材特色

1. 精心选材，内容新颖

语言素材的选取与艺术文化背景紧密结合，选用艺术史料和社会生活中的艺术题材，突出艺术文化通识，有效地将艺术背景知识和语言交际需求融为一体，使语言素材充满浓郁的人文色彩。单元阅读内容涵盖艺术史、平面艺术、造型艺术、工业设计、园林与建筑设计、动漫设计等方面的内容，契合艺术类大学生的专业兴趣，满足学生专业学习的需求。

2. 科学编排，体系完整

语言素材难易程度上，以大学英语基础目标为起点，循序渐进，重视积累。语言训练体系上注重叙述、描写、议论等语言技能的强化和批判性思维、跨文化交际等实际应用能力的培养。采用体验式学习策略，围绕单元主题开展相关语言技能的学习训练，利用场景再现、团队协作的形式，为学生在未来可能出现的艺术场景中的语言表达提供模拟训练的机会。

⌘ 教材框架

每单元的基本结构为：

1. 听说（Part One: Listening and Speaking）：围绕单元主题，提供情景对话，设计听力*和口语训练，同时引导学生对单元文化背景进行初步了解，起到导入作用。

2. 深度阅读（Part Two: Active Reading）：由两篇阅读文章组成，其中 Text A 为重点阅读课文，选材上知识性、趣味性并重；Text B 为辅助阅读材料，选材上更侧重相关概念与知识的介绍。两篇选文后均有课文阅读理解、词汇与句型、翻译等练习。

3. 应用文写作（Part Three: Practical Writing）：实用文体写作训练，目的在于提高学生书面语产出的能力，以适应未来学习和工作的需要。

教材最后以附录形式列出了本书的词汇表。

本册教材编写分工如下：张宁负责统筹教材编排总体思路、所有单元阅读文章选文的整理以及最后的统稿工作，王婷负责单元框架设计工作，一至八单元内容设计分别由黄薇、王婷、韩晓龙、陈虹波、皮重阳、谢蕊婷、吕洪波、熊召永具体负责。

编者力求为艺术类大学生提供一套适应专业特点与学生的语言基础、兼顾艺术专业人文知识的英语教材。必须承认的是，对于语言类教师而言，兼顾语言的流畅、地道、自然与用英语传授专业知识具有相当的难度。编写团队唯有尽心尽责，才能为艺术英语的教学改革倾尽绵薄之力。

编者
2017 年 12 月于武汉

* 音频文件请登录 ftp://ftp.tup.tsinghua.edu.cn/ 下载。

Contents

Unit 1 — Modern Painters I 1

- Text A Vincent van Gogh..........................4
- Text B Paul Cézanne..................................9

Unit 2 — Modern Painters II 19

- Text A Pablo Picasso..................................23
- Text B Henri Matisse..................................29

Unit 3 — The Bauhaus 37

- Text A The Bauhaus....................................41
- Text B *Bauhaus Manifesto*......................47

Unit 4 — The Man Who Reinvented World Urban Skyline 55

- Text A Le Corbusier....................................58
- Text B Ronchamp..64

Unit 5 — Industrial Designer Raymond Loewy 71

- Text A Raymond Loewy, the Man Who Gave Coca-Cola a Modern Look ..74
- Text B Paul Rand..80

Unit 6 — Interior Design and Garden Design 89

- Text A Interior Designer and Interior Design..93
- Text B Garden Design................................98

Unit 7 — Animation Master Hayao Miyazaki 107

- Text A A Guide to the Films of Animation Master Hayao Miyazaki..110
- Text B Hayao Miyazaki..............................117

Unit 8 — Andy Warhol and Pop Art 125

- Text A Andy Warhol and Pop Art...............128
- Text B The Top Five Luxury Auction Houses..135

Part One　Listening and Speaking

Task 1　Listen to a conversation between a student and his art history professor and answer the questions.

Questions:

1. What's the topic of the student's writing?
2. Which painting of Van Gogh's was the student planning to focus on?
3. What's the problem of the student's writing?
4. How did the student work out the problem?
5. What's the shared feature between the two paintings called *Starry Night*?

Task 2　Susan is visiting an art exhibition with Mike. Listen to their conversation and fill in the blanks with what you hear.

Susan: Mike, come and look at this painting of shrimp! It is so simple yet so **1.**_____!

Mike: Yeah. It is **2.**_____! Is it the work of Qi Baishi?

Susan: Yes, it is. How do you know that?

Mike: Well, Qi is famous all over the world, isn't he? Besides, I am quite **3.**_____ in Chinese painting.

Susan: Cool! What kind of Chinese painting do you **4.**_____, free sketch or elaborate-style painting?

Mike: I prefer free sketch, especially the **5.**_____ paintings. I can always feel **6.**_____ and harmony from those landscape paintings.

Susan: That's true. Chinese art **7.**_____ the harmony between man and nature, which is an important part of China's **8.**_____ culture.

Mike: I love this art exhibition!

Susan: So do I. Let's go to other areas to see what they have got, shall we?

Mike: OK.

Task 3　Work in pairs. Suppose you are going to sign up for an art class, so you ask your friend for some suggestion. Make a conversation with reference to the expressions below.

Useful Expressions

Asking about reasons

Why/Why not?

Unit 1
Modern Painters I

May I know the reason?

I'd like to know the reason why…

Give me one good reason why…

Could you give me some reasons on…?

Can you conclude the causes of…?

What evidence can you offer to prove that…?

Why do you think so?

What are your reasons for…?

How has it come about that…?

What makes you choose…?

How come…?

Giving reasons

My point of view in…/that… largely results from the fact that…

The main/major reason why… is because/is that…

One of the reasons I say that is because…

One possible explanation (for that) is…

To understand why…, you first need to… (understand/know/be aware that)

This is due to the fact that…

It's closely linked to/associated with…

Due to/Owing to…

Giving reasons for

It's great because…

One advantage is that…

Another good reason is…

You're right, but I also think…

The other thing (reason) is that…

Giving reasons against

The problem is that…

One big disadvantage with that is…

One argument against that idea is…

I don't think…

Part Two Active Reading

Van Gogh was a largely self-taught artist who changed the face of Post-Impressionism forever. Van Gogh was a troubled yet highly skilled painter, whose works were an outlet for his emotion, particularly when battling depression. Working at an often-furious pace, Van Gogh produced more than 2,000 works of art in his 10-year career. However, he sold only one painting during his lifetime and did not become successful until after his death. Some of his most famous works include *Starry Night*, *Sunflowers*, and *The Bedroom at Arles*. His expressive and emotive use of color and distinct brushwork became hugely popular and influenced Expressionism, Fauvism and early abstraction massively as well as various other aspects of 20th-century art. Today, Van Gogh is generally regarded as the greatest Dutch painter since Rembrandt.

 Text A

Vincent van Gogh

Whenever people mention Vincent van Gogh (1853–1890), the first thing that likely comes to mind is his masterpiece *Sunflowers*, which fascinates the public all the time. His paintings are so amazing and overwhelming that they have astounded millions of people around the world.

Van Gogh was born in Holland in 1853. The son of a pastor, brought up in a religious and cultured atmosphere, Van Gogh was highly emotional, lacked self-confidence and always struggled with his identity and direction.

At the age of 16, Van Gogh got his first job as a clerk in a gallery in France. Soon he lost interest in becoming a professional art dealer. He then studied theology and worked as a missionary in a dreary coal-mining area in Belgium. He once believed that his calling was to preach the gospel; however, it took years for him to discover his true calling as an artist. "An artist needn't be a clergyman or a churchwarden, but he certainly must have a warm heart for his fellow men." Van Gogh blended himself with the miners and peasants with whom he deeply empathized. It was nature, and the people living closely to it, that first stirred his artistic inclinations. Van Gogh was particularly taken up with the peasants he saw working in the countryside; his early compositions featured portraits of peasants and rural landscapes, and rendered in dark and moody tones, as exemplified in the piece entitled *The Potato Eaters*.

In 1886 Van Gogh relocated to Paris, where he encountered and was greatly influenced by works of Impressionism, an artistic trend in the late 19th century and gained exposure to artists such as Gauguin, Pissarro, and Monet. As a result, he adopted more vibrant colors in his art and

began experimenting with his skill. The style he developed in Paris and carried through to the end of his life became known as Post-Impressionism, a term encompassing works made by artists unified by their interest in expressing their emotional and psychological responses to the world through bold colors and expressive and symbolic images.

Two years later, in 1888, Van Gogh moved to Arles in the French countryside, again living close to the peasants who had inspired him early on. He concentrated on painting landscapes, portraits, and still lifes full of personal symbolism.

One of Van Gogh's dreams was to start a colony for artists in Arles. He hoped that his new friends would join him. Later Paul Gauguin did join him in Arles. Van Gogh entered the most productive and creative period of his life. It was in this period that he created the famous *Sunflowers* series. On the canvas, sunflowers erupt out of a simple earthenware pot against a blazing yellow background. Some of the flowers are fresh and perky, ringed with halos of flickering and flame-like petals; others are going to seed and have begun to droop. The sunflowers paintings proved that Van Gogh stood his ground as an artist.

However, it was also a time of great mental turmoil for the artist. Van Gogh's nervous temperament made him a difficult companion and nightlong discussions combined with painting all day undermined his health. Near the end of 1888, an incident led Gauguin to ultimately leave Arles—Van Gogh, in a fit of madness, pursued Gauguin with a razor and threatened him intensely. Van Gogh was then sent to an asylum for treatment.

From then on, Van Gogh began to alternate between fits of madness and lucidity. In the asylum, he created the *Starry Night*, based on his direct observations as well as his imagination, memories, and emotions. It is his most popular work and one of the most influential pieces in history. The swirling lines of the sky are a possible representation of his mental state. This shaken style is visible in all of his works during his time in the asylum.

On July 27, 1890, Van Gogh attempted suicide by shooting himself in the chest. He survived, but died two days later from the wound. It wouldn't take long for the art world to recognize the genius they lost. Van Gogh's inimitable fusion of form and content is powerful, dramatic, lyrically rhythmic, imaginative, and emotional, for the artist was completely absorbed in the effort to explain either his struggle against madness or his comprehension of the spiritual essence of man and nature. Van Gogh is now viewed as one of the most influential artists who have helped lay the foundation of modern art.

New Words

fascinate	['fæsɪneɪt]	vt. 使着迷，使神魂颠倒 vi. 入迷
overwhelming	[,oʊvər'welmɪŋ]	adj. 压倒性的；势不可当的
astound	[ə'staʊnd]	vt. 使惊骇，使震惊
pastor	['pæstər]	n. 牧师
emotional	[ɪ'moʊʃənl]	adj. 情绪的；易激动的；感动人的
dealer	['di:lər]	n. 经销商；商人
theology	[θi'ɑ:lədʒi]	n. 神学；宗教体系
missionary	['mɪʃəneri]	n. 传教士
dreary	['drɪri]	adj. 沉闷的，枯燥的
gospel	['gɑ:spl]	n. 真理；信条
empathize	['empəθaɪz]	vt. 移情；神会
inclination	[,ɪnklɪ'neɪʃn]	n. 倾向，爱好；斜坡
render	['rendər]	vt. 使处于（某种状态）；实施；着色
exemplify	[ɪg'zemplɪfaɪ]	vt. 例证；例示
vibrant	['vaɪbrənt]	adj. 充满生气的；振动的
encompass	[ɪn'kʌmpəs]	vt. 包含；包围
symbolism	['sɪmbəlɪzəm]	n. 象征，象征主义；符号论；记号
productive	[prə'dʌktɪv]	adj. 多产的；能生产的；富有成效的
erupt	[ɪ'rʌpt]	vi. 爆发；喷出；长芽
earthenware	['ɜ:rθnwer]	n. 陶器
blazing	['bleɪzɪŋ]	adj. 闪耀的；强烈的；燃烧的
perky	['pɜ:rki]	adj. 神气的；得意扬扬的；自信的；活泼的
halo	['heɪloʊ]	n. 光环；荣光
flickering	['flɪkərɪŋ]	adj. 闪烁的，忽隐忽现的；摇曳的
droop	[dru:p]	vi. 下垂；萎靡；凋萎
turmoil	['tɜ:rmɔɪl]	n. 混乱，骚动
temperament	['temprəmənt]	n. 气质，性情，性格；急躁
undermine	[,ʌndər'maɪn]	vt. 破坏，渐渐破坏
asylum	[ə'saɪləm]	n. 收容所，救济院；庇护
alternate	['ɔ:ltərneɪt]	vi. 交替；轮流
lucidity	[lu:'sɪdəti]	n. 清醒度；明朗；清澈
influential	[,ɪnflu'enʃl]	adj. 有影响的；有势力的
swirling	['swɜ:rlɪŋ]	adj. 打旋的
inimitable	[ɪ'nɪmɪtəbl]	adj. 独特的，无比的；无法仿效的
rhythmic	['rɪðmɪk]	adj. [生物] 有节奏的；间歇的；合拍的

Unit 1
Modern Painters I

Useful Expressions

blend with	与……混合
experiment with	做实验
carry through	贯彻；完成；坚持下去
lay the foundation of	打下……的基础，奠定了……的基础

Proper Names and Cultural Notes

Impressionism	印象主义，西方现代艺术流派之一，19 世纪 60—80 年代风行于法国，强调作品中对外光和色彩的直接表现。
Gauguin	保罗·高更，法国后印象派画家、雕塑家，与梵高、塞尚并称为"后印象派三大巨匠"，对现当代绘画的发展有着非常深远的影响。
Pissarro	毕沙罗，法国印象派大师，是印象派的先驱，有印象派"米勒"之称。
Monet	莫奈，法国画家，被誉为"印象派领导者"，是印象派代表人物和创始人之一。

Reading Comprehension

Task 1 Read the text and answer the following questions.

1. What can we know about Van Gogh's family background?
2. What's the feature of Van Gogh's early paintings?
3. What is Post-Impressionism in terms of Van Gogh's style?
4. Which painting proved Van Gogh's ground as a great artist?
5. Why was Van Gogh sent to an asylum for treatment near the end of 1888?

Task 2 Read the text and choose the best answer to the questions.

1. Where did Van Gogh begin to paint?
 A. In Holland. B. In France.
 C. In Belgium. D. In England.
2. What did Van Gogh not enjoy about painting?
 A. Landscapes. B. Portraits.
 C. Architectures. D. Flowers.
3. Which words best describe Van Gogh's later years?
 A. Sad and boring. B. Normal and peaceful.
 C. Happy but fruitless. D. Painful but productive.

4. Why did Van Gogh kill himself?
 A. Because he was a failure as an artist.
 B. Because he had an unhappy family.
 C. Because he lost his beloved brother.
 D. Because he was suffering from mental illness.

Language in Use

 Task 1 Match the underlined words in Column I with their corresponding meanings in Column II.

I	II
1. His paintings are so amazing and <u>overwhelming</u> that they have astounded millions of people around the world.	A. characterized by liveliness and lightheartedness
2. Van Gogh entered the most <u>productive</u> and creative period of his life.	B. understood someone's situation, problems, and feelings because you have been in a similar situation
3. He adopted more vibrant colors in his art and began <u>experimenting</u> with his skill.	C. made something less strong or less secure than it was before, often by a gradual process
4. Van Gogh blended himself with the miners and peasants with whom he deeply <u>empathized</u>.	D. producing abundantly
5. Some of the flowers are fresh and <u>perky</u>, ringed with halos of flickering and flame-like petals.	E. having a lot of influence over people or events
6. Van Gogh's nervous temperament made him a difficult companion and nightlong discussions combined with painting all day <u>undermined</u> his health.	F. doing a scientific test in order to discover what happens to it in particular conditions
7. Van Gogh began to alternate between fits of madness and <u>lucidity</u>.	G. a combination of different ideas or things that are created
8. This same shaken style is <u>visible</u> in all of his works during his time in the asylum.	H. affecting someone very strongly
9. Van Gogh is now viewed as one of the most <u>influential</u> artists who have helped lay the foundation of modern art.	I. describing something that people notice or recognize

10. Van Gogh's inimitable fusion of form and J. the ability to think clearly
 content is powerful and emotional.

Task 2 Fill in the blanks with the correct form of the words given below.

| form | draw | consume | emerge | personal |
| weak | establish | motivate | experiment | success |

Van Gogh was born on March 30, 1853 in Dutch. He was the son of a clergyman. The young Van Gogh made religion a **1.**_____ interest and during the next few years he traveled in Britain, Belgium and Holland, trying to **2.**_____ himself as a preacher, but without **3.**_____. His first artist impressions were **4.**_____ as a boy, from his uncle, an art dealer. The **5.**_____ bore early fruit and from the age of 12, the young Vincent was drawing.

In 1880, at the age of 27, he found himself **6.**_____ back to art. He had a job as an assistant evangelist in the mining village in Belgium but realized an artist drive which was to motivate him unceasingly until his death 10 years later.

In 1886, Van Gogh left Holland forever and travelled via Antwerp to Paris, and to major changes in artistic style. Van Gogh's work became more youthful in Paris. A new, more animated, painting style **7.**_____ and the impressionist tendencies of earlier work **8.**_____ somewhat. Van Gogh developed a taste for **9.**_____ brushwork and brilliant, unmixed colors. Among his most prominent **10.**_____ with color were a series of some 30 flower paintings, a fascination which stayed with him until his death.

Task 3 Translate the following sentences into English.
1. 梵高以色彩作为其创作的主要表现手法。（symbol）
2. 作为一名牧师的儿子，梵高在宗教的氛围中长大。（atmosphere）
3. 梵高容易情绪化，而且缺乏自信。（emotional）
4. 从那时起，梵高开始一时疯狂，一时清醒，两种情绪互相交替着。（alternate）
5. 梵高被认为是19世纪最具影响力的艺术家之一，他奠定了现代艺术的基础。（lay the foundation of）

Text B

Paul Cézanne

The French painter Paul Cézanne, who exhibited little in his lifetime and pursued his interests increasingly in artistic isolation, is regarded today as one of the greatest forerunners of modern

painting.

Cézanne was born at Aix-en-Provence in the south of France on January 19, 1839. When he was a little boy, he was sent to a local school. Against the implacable resistance of his father who wished his son to be a lawyer, Cézanne made up his mind that he would be a painter. His father's reluctant consent at that time brought him financial support and, later, a large inheritance on which he could live without difficulty. In Paris he met Camille Pissarro and came to know some impressionist artists, with whom he would exhibit in 1874 and 1877. Cézanne was a contemporary of the Impressionists, but he went beyond their interests in the individual brushstroke and the fall of light onto objects, to create, in his words, "something more solid and durable, like the art of the museums".

Cézanne is not an easy man to love, but professors and painters adore him. Art critics lavish him with superlatives, including "prophet of the 20th century", "the most sensitive painter of his time", "the greatest artist of the 19th century" and "the father of modern art". But he is not quite a household name, and his posters have never been best sellers at museum shops. In fact, most non-professionals wouldn't stand a chance of recognizing Cézanne unless it was clearly labeled.

Cézanne's pictures are restrained, impersonal and remote—they don't have the gut-wrenching appeal of Van Gogh's portraits. They can't compete with Monet's lush expanses of water lilies or Renoir's sensuous women with their come-hither looks. Bowls of fruit and the hills and trees of Provence—where Cézanne spent most of his life, are a hard sell against the Tahitian backdrops of Gauguin, with or without the naked women.

Cézanne is an artist's artist. He was obsessed with form rather than content, so subject matter was always secondary to the act of painting itself. He wanted the methods and skills of the painter to be more important than the image. That meant the subject of the painting couldn't be so dynamic as to overshadow the artist's act of creation. The more he concentrated on this, the less viewer-friendly his works became. But that suited his personality just fine. His goal was not to have a mass audience or sales appeal; it was to satisfy himself.

It's hard to imagine that the man who created such restrained, methodical and time-consuming works had a violent and volatile temper. Painting was his salvation, a way to balance the fires within. Rather than let his personalities shine in his art—that scared him too much—he suppressed it. He worked in virtual seclusion and seldom ventured out.

Cézanne was versatile; in his pursuit of perfection and a unique style, he experimented a lot. Art students often copy paintings—you still see them in museums with their sketchbooks—and Cézanne did just that, but unlike most, he never stopped copying. To him, it was an important form of discipline and inspiration. He felt he could understand art better through copying, and whenever he came to an impasse, he went off to the nearest museum with a sketchbook in hand.

His earliest works, from his first days in Paris, are expressionistic. In the early 1870s, he

experimented with Impressionism. He tried to combine the principles of light and air-based art with a more structured pictorial style. After that, he delved into Classicism, with more balanced and formal compositions. Toward the end of his life, he was at his most daring, reducing architecture and figures to geometric forms and paving the way for Cubism.

New Words

isolation	[ˌaɪsəˈleɪʃn]	n. 隔离；孤立
implacable	[ɪmˈplækəbl]	adj. 难和解的；不能缓和的；不能安抚的
reluctant	[rɪˈlʌktənt]	adj. 不情愿的，勉强的；顽抗的
consent	[kənˈsent]	n. 同意，赞成；（意见等的）一致
inheritance	[ɪnˈherɪtəns]	n. 遗产；继承；遗传
contemporary	[kənˈtempərerɪ]	n. 同时代的人 adj. 同时代的
durable	[ˈdʊrəbl]	adj. 持久的；耐用的
lavish	[ˈlævɪʃ]	vt. 慷慨给予；浪费；滥用
superlative	[suːˈpɜːrlətɪv]	n. 赞美之词，最高程度；最高级
prophet	[ˈprɑːfɪt]	n. 先知，预言者；提倡者
restrain	[rɪˈstreɪn]	vt. 抑制，控制；约束；制止
gut-wrenching	[ˈɡʌt rentʃɪŋ]	adj. 极度痛苦的，撕心裂肺的
lush	[lʌʃ]	adj. 丰富的；豪华的；苍翠繁茂的
sensuous	[ˈsenʃuəs]	adj. 感觉上的，依感观的；诉诸美感的
come-hither	[ˌkʌm ˈhɪðər]	adj. 诱惑人的；勾引的
backdrop	[ˈbækdrɑp]	n. 背景；背景幕；交流声
secondary	[ˈsekənderɪ]	adj. 第二的；次要的；中等的，中级的
dynamic	[daɪˈnæmɪk]	adj. 有活力的；动态的；动力的
overshadow	[ˌəʊvərˈʃædəʊ]	vt. 使失色；使阴暗；遮阴
methodical	[məˈθɑːdɪkl]	adj. 有系统的；有方法的
volatile	[ˈvɑlətl]	adj. 不稳定的；爆炸性的；反复无常的
salvation	[sælˈveɪʃn]	n. 拯救；救助
suppress	[səˈpres]	vt. 抑制；镇压；废止
seclusion	[sɪˈkluːʒn]	n. 隔离；隐退；隐蔽的地方
versatile	[ˈvɜːrsətl]	adj. 多才多艺的；通用的，万能的
impasse	[ˈɪmpæs]	n. 僵局；死路
pictorial	[pɪkˈtɔːrɪəl]	adj. 绘画的；形象化的 n. 画报，画刊
geometric	[ˌdʒiːəˈmetrɪk]	adj. 几何学的；[数] 几何学图形的

Useful Expressions

make up one's mind	下定决心
stand a chance of	很有可能，有……的希望
be obsessed with	痴迷于……
venture out	探险，冒险
delve into	钻研；深入研究
pave the way for	为……做准备，为……铺平道路

Proper Names and Cultural Notes

Aix-en-Provence	普罗旺斯地区艾克斯（法国城市名）
Renoir	雷诺阿，法国印象画派的著名画家、雕刻家
Tahitian	塔希提人（尤指该岛的波利尼西亚人）
Classicism	（本文中特指 18 世纪欧洲艺术界的）古典风格
Cubism	立体派；立体主义

Reading Comprehension

 Task 1 Read the text and decide whether each of the following statement is true or false.

1. Cézanne's father supported him to be a painter from the very beginning.
2. When Cézanne became famous, his pictures had always been best sellers at museum shop.
3. Cézanne paid more attention to forms rather than contents of the painting, so he attached more importance to the painter's skills and methods.
4. Cézanne believed that painting copy was an important form of discipline and inspiration so that he could understand art better.
5. At the end of Cézanne's life, his painting style became more daring and paved the way for Cubism by experimenting a lot.

Task 2 Read the text and choose the best answer to the questions.

1. Which title of Cézanne in the following was not given by art critics?
 A. The greatest artist of the 19th century. B. Prophet of the 20th century.
 C. The father of Classism. D. The most sensitive painter of his time.

Unit 1
Modern Painters I

2. What did Cézanne mainly paint during his time in Provence?
 A. Portraits.
 B. Bowls of fruit and the hills.
 C. Water lilies.
 D. Sensuous women.
3. What is the goal of a painter according to Cézanne?
 A. Having a mass audience.
 B. Being a great artist.
 C. Satisfying himself.
 D. Appealing sales.
4. Which following word is not a good one to describe Cézanne's works?
 A. Restrained.
 B. Time-consuming.
 C. Methodical.
 D. Dynamic.

Language in Use

 Task 1 Match the underlined words in Column I with their corresponding meanings in Column II.

I	II
1. The French painter Paul Cézanne is regarded today as one of the greatest <u>forerunners</u> of modern painting.	A. feel great love and admiration for someone
2. Against the <u>implacable</u> resistance of his father who wished his son to be a lawyer, Cézanne made up his mind that he would be a painter.	B. be likely to change suddenly and unexpectedly
3. Cézanne is not an easy man to love, but professors and painters <u>adore</u> him.	C. competent in many areas and able to turn with ease from one thing to another
4. He tried to combine the principles of light and air-based art with a more structured <u>pictorial</u> style.	D. having a lot of very healthy grass or plants
5. Cézanne was <u>versatile</u>; in his pursuit of perfection and a unique style, he experimented a lot.	E. people who go before or announce the coming of another
6. He worked in virtual <u>seclusion</u> and seldom ventured out.	F. simple and not too brightly coloured
7. It's hard to imagine that the man who created such restrained, methodical and time-consuming works had a violent and <u>volatile</u> temper.	G. having very strong feelings of disapproval that nobody can change
8. They can't compete with Monet's <u>lush</u> expanses of water lilies or Renoir's sensuous women with their come-hither looks.	H. using or relating to pictures

9. The subject of the painting couldn't be so <u>dynamic</u> as to overshadow the artist's act of creation.

10. Cézanne's pictures are <u>restrained</u>, impersonal and remote.

I. a quiet place away from other people

J. very active and energetic

Task 2 Fill in the blanks with the correct form of the words given below.

persist	move	dense	bright	surface
consequent	range	influence	analyze	capture

Cézanne was **1.**_____ by Impressionism in the 1870s. Camille Pissarro was one of Paul Cézanne's biggest influences and after spending time with him, his color palette **2.**_____ up and he began to work in the open air with a wider **3.**_____ of colors. He met Van Gogh around this time and was also influenced by his style. **4.**_____, Cezanne's brush strokes became less **5.**_____ and more fluid in style.

Even so, his interest in working indoors **6.**_____ and Paul Cézanne created a number of still-life paintings of flowers. In the late 1870s, Cézanne **7.**_____ away from Impressionism for good with the use of heavy and dark colors, and he wished to **8.**_____ the scene before him rather than copy it as Impressionists did.

Throughout his life, Cézanne became more and more influenced by nature and particularly the beauty of his home in Aix-en-Provence. He wanted to **9.**_____ the part of nature that was constant rather than the **10.**_____ beauty that changed with the seasons.

Task 3 Translate the following sentences into Chinese.

1. Cézanne always stayed more angular and more intense. He painted like a man working out a mathematical problem. Each brush stroke, each painting, reveals how he reached his conclusions.

2. Cézanne's fracturing of form and flattening of space, especially evident in his landscape and still life, paved way for Cubism.

3. Cézanne had painted the mountain so many times—a study in form, an exercise of style, and a realm of the imagination. Not just a mountain, but the idea of a mountain.

4. Critics and scholars may disagree about pinpointing the first stirrings of modern art, but few deny Cézanne's pivotal role.

5. Cézanne's influence was the strongest during the generation after he died, but it has proved remarkably persistent.

Part Three Practical Writing

Letters of Recommendation

A recommendation letter is written by a previous employer, colleague, client, teacher, or by someone else who can recommend an individual's work or academic performance. The goal of recommendation letters is to vouch for the skills, achievements, and aptitude of the person being recommended. Think of these letters as symbols, intended to represent an important person's vote of confidence in a candidate—without having to go in person to a hiring manager's office and make their case. Most often, a recommendation letter is sent to a hiring manager or an admission officer to facilitate an interview or introduction of the candidate.

Task 1 Read the following template of recommendation letters and focus on the information a recommendation letter should include.

Writer's Address

Your Contact Information

Your Name

Your Title

Company or School Name

Address

City

State, Zip Code

Date

Salutation

If you are writing a personal letter of reference, include a salutation (e.g. Dear Mr. Johnson, Dear Dr. Jameson, etc.). If you are writing a general letter, use "To Whom It May Concern" or don't include a salutation. If your letter doesn't include a salutation, start your letter with the first paragraph.

First Paragraph

The first paragraph of a recommendation letter explains your connection to the person you are recommending, including how you know him/her, and why you are qualified to recommend the person for employment or school.

Example: "I met Susan when she was a freshman in my Introductory Economics course at WVU. Throughout her studies in my department, I had the opportunity to work with her on several research projects where she acted as my assistant."

Second Paragraph

The second paragraph of a recommendation letter contains information about the individual you are writing about, including why they are qualified, what they can contribute, and why you are recommending them. If necessary, use more than one paragraph to provide details.

Example: "Bill graduated with honors in Philosophy, always focusing on how his future would progress. He knew he wanted to pursue a doctorate very early on, and has worked independently, in groups, and as a research assistant. I believe that Bill would be an asset to your department, as he brings a tremendous amount of energy and enthusiasm to his studies. He is a very bright and qualified individual, and a pleasure to work with."

Third Paragraph

When writing a letter recommending a candidate for a specific job opening, the recommendation letter should include information on how the person's skills match the position they are applying for. Ask for a copy of the job posting and a copy of the person's résumé so you can target your letter accordingly.

Example: "I believe that Christine would be an excellent addition to your international sales team. When I worked with her at XYZ Company, I was impressed by her ability to communicate the effectiveness of our products to our clients, and close a sale. During the two years I worked with her, she was personally responsible for adding several new clients in Asia and Africa."

Summary

This section of the recommendation letter contains a brief summary of why you are recommending the person. Use phrases like "strongly recommend", "recommend without reservation" or "Candidate has my highest recommendation" to reinforce your endorsement.

Example: "During my acquaintance with Joanne, she has been efficient, professional, organized, and a fantastic team leader. She has my highest recommendation for the position of office manager at DEF Inc."

Conclusion

The concluding paragraph of your recommendation letter contains an offer to provide more information. Include a phone number within the paragraph, and include the phone number and email address in the return address section of your letter, or in your signature.

Example: "Please feel free to contact me at 123-456-7890 if you need any additional information or clarification."

Closing

Sincerely,

Recommender's Name

Title

Unit 1
Modern Painters I

Task 2 Write an English letter of recommendation based on the following information.

李小梅今年夏天即将毕业了,她在报纸上看到一家公司的招聘广告。欲去应聘,于是她找到任课老师张志,请他为自己写一封推荐信。请根据李小梅以下的信息,写一封推荐信:

李小梅今年夏天毕业,欲在贵公司谋求一份销售助理的工作。李小梅同学成绩优良,勤奋努力,同学们都喜欢与她相处。为学生能有锻炼自己的机会,我极力推荐她到贵公司工作。推荐人:东方大学管理学院老师张志;时间:2017年5月17日;联系地址:滨海市人民路99号。

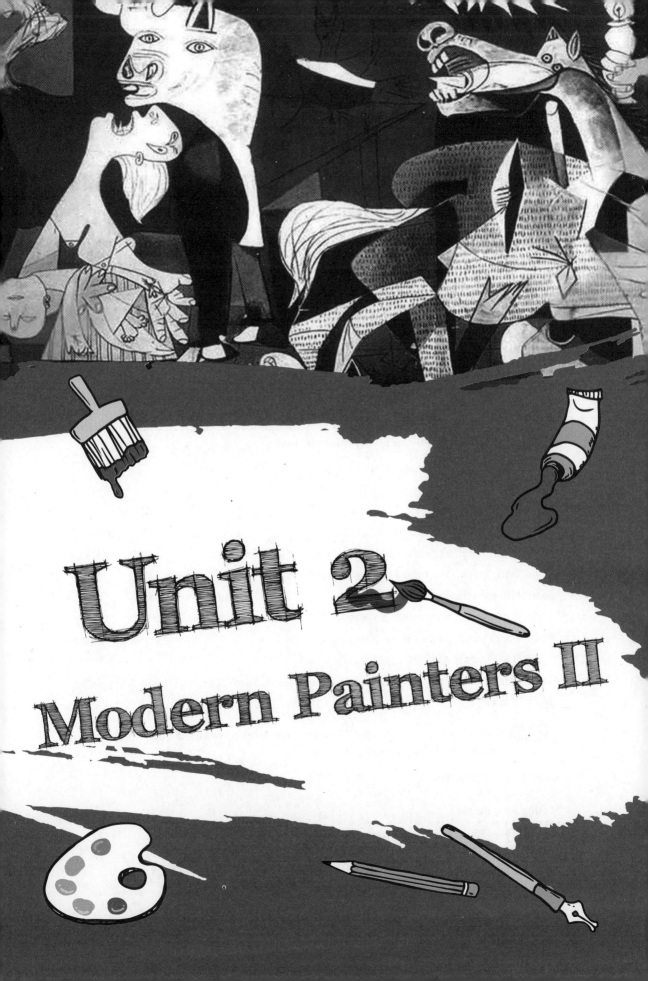

Part One Listening and Speaking

Task 1 Listen to a conversation about making an arrangement and answer the questions.

Questions:
1. What are the speakers talking about in the conversation?
2. Which month does Alice suggest at the beginning?
3. Does Steven agree with Alice's suggestion? Why?
4. What is Steven's suggestion?
5. Who will take care of the survey?

Task 2 Sam and Jane are at the Henri Matisse exhibition. Listen to their conversation and fill in the blanks with what you hear.

Sam: Oh, I don't expect there are so many people here.

Jane: Not 1._____. This is a Henri Matisse 2._____. What do you think of the paintings?

Sam: I don't think I can understand the 3._____ in the paintings. They are strange.

Jane: Strange? I don't think so. Matisse is one of the most 4._____ artists of the 20th century. He is most famous for his Fauvism art.

Sam: His use of colors and lines is 5._____. But can you understand what he wants to express through his painting? Look at this painting, *The Dance*.

Jane: That's what makes his paintings unique, his 6._____ uncompromisingly "pure" form and color.

Sam: Sorry. I can't agree with you about that. To be frank, I can't appreciate this style of painting.

Jane: That's a pity.

Task 3 Talk about a recent movie with your friend. Make a conversation with reference to the expressions below.

Useful Expressions

Stating an opinion

In my opinion...

The way I see it...

If you want my honest opinion....

According to Lisa…

As far as I'm concerned…

If you ask me…

Personally, I think…

I'd say that…

I'd suggest that…

I'd like to point out that…

I believe that…

What I mean is…

Asking for an opinion

What's your idea?

What are your thoughts on all of this?

How do you feel about that?

Do you have anything to say about this?

What do you think?

Do you agree?

Wouldn't you say…?

Agreeing with an opinion

Of course.

You're absolutely right.

Yes, I agree.

I think so too.

That's a good point.

Exactly.

I don't think so either.

So do I.

I'd go along with that.

That's true.

Neither do I.

I agree with you entirely.

That's just what I was thinking.

I couldn't agree more.

Disagreeing with an opinion

That's different.

I don't agree with you.

That's not entirely true.

On the contrary…

I'm sorry to disagree with you, but…

That's not the same thing at all.

I'm afraid I have to disagree.

I'm not so sure about that.

I must take issue with you on that.

It's unjustifiable to say that…

Acknowledging someone's opinion and presenting your viewpoint

Yes, but don't you think…

I agree with you, but…

That may be true, but…

I see your point, but…

I guess so, but…

That's not necessarily true because…

Not necessarily because…

Part Two Active Reading

The internationally renowned modern painters Pablo Picasso and Henri Matisse have made great contributions to the world of art. Back in those days, there were many who didn't understand the message conveyed by either the Picasso Cubist paintings or the Matisse Fauvism art, and even

frowned upon their paintings. Now, they are celebrated by both collectors and common people with a keen eye for beauty, and their paintings are hung in the best museums across the world.

Pablo Picasso

Pablo Picasso (1881–1973) was a modern painter and is probably the most important figure in the 20th-century realm of art. He was born on October 25, 1881 in a small town in Spain and by the time he died in France in 1973, he had created a staggering 22,000 works of art in a variety of mediums, including sculptures, ceramics, mosaics, stage design and graphic arts. To say that Pablo Picasso dominated Western art in the 20th century is a mere commonplace. As critic Hughes notes, "There was scarcely a 20th-century artistic movement that he didn't inspire, contribute to or beget." According to the *Art Market Trends* report, Picasso not only dominated Western art in his own lifetime, but also remains the top ranked artist (based on sales of his works at auctions).

Picasso displayed a prodigious talent for drawing at a very young age. Though he was a relatively poor student at school, he possessed a pair of piercing, watchful and black eyes that seemed to mark him destined for greatness. Picasso's father, who was a painter and art teacher, began to teach him to paint when he was a small child. In 1895, when Picasso was 14 years old, he moved with his family to Barcelona, where he quickly applied to the city's prestigious School of Fine Arts. Although the school typically only accepted students several years his senior, Picasso's entrance exam was so extraordinary that he was granted an exception and admitted to the school. Nevertheless, Picasso chafed at the School of Fine Arts' strict rules and formalities, and began skipping class so that he could roam the streets of Barcelona, sketching the city scenes he observed. In 1897, 16-year-old Picasso moved to Madrid to attend the Royal Academy of San Fernando. However, he again became frustrated with his school's singular focus on classical subjects and techniques. Once again, Picasso began skipping class to wander the city and paint what he observed: gypsies, beggars, and prostitutes, among other things.

In 1899, Picasso moved back to Barcelona and fell in with a crowd of artists and intellectuals. Inspired by the anarchists and radicals he met there, Picasso made his decisive break from the classical methods in which he had been trained, and began what would become a lifelong process of experimentation and innovation. In the early 1900s he visited and eventually settled in Paris, where he was part of a vibrant artistic community.

Although greatly influenced by other artists, Picasso was inventive and prolific. His enormous body of work spans so many years that art experts generally separate his career into distinct phases, such as the Blue Period, the Rose Period and the Period of Cubism.

In his "Blue Period", he depicted the world of the poor. Deeply depressed over the death of his

close friend Carlos, Picasso painted scenes of poverty, isolation and anguish, almost exclusively in shades of blue and green. The melancholy paintings from the Blue Period include the *Blue Nude*, *La Vie* and *The Old Guitarist*, all of which were completed in 1903.

By 1905, Picasso had largely overcome the depression that had previously debilitated him. His art creation won the generous patronage of a wealthy art dealer. The artistic manifestation of Picasso's improved spirits was the introduction of warmer colors—including beiges, pinks and reds. His most famous paintings from these years, which is known as "the Rose Period", include *Family at Saltimbanques*, *Gertrude Stein* and *Two Nudes*. Canvases from Picasso's "the Rose Period" are characterized by a lighter palette and greater lyricism, with subject matter often drawn from circus life.

In 1907, Pablo Picasso produced a painting unlike anything he or anyone else had ever painted before, a work that would profoundly influence the direction of art in the 20th century: *Les Demoiselles d'Avignon*, a chilling depiction of five nude prostitutes, abstracted and distorted with sharp geometric features and stark blotches of blues, greens and grays. This new artistic style is now known as Cubism.

In cubist paintings, objects are broken apart and reassembled in an abstracted form, highlighting their composite geometric shapes and depicting them from multiple, simultaneous viewpoints in order to create physics-defying and collage-like effects. At once destructive and creative, Cubism shocked, appalled and fascinated the art world. His later cubist works move even further away from artistic typicalities of the time, creating vast collages out of a great number of tiny, individual fragments.

From 1927 onward, Picasso was caught up in a new philosophical and cultural movement known as Surrealism. Picasso's most well-known surrealist painting is his 1937 depiction of the German bombing of Guernica (a Spanish town) during the Spanish Civil War—*Guernica*. This large canvas embodies for many the inhumanity, brutality and hopelessness of war. Painted in black, white and gray, the work is a surrealist testament to the horrors of war, and features a Minotaur and several human-like figures in various states of anguish and terror. *Guernica* remains one of the most moving and powerful anti-war paintings in history.

As a revolutionary artist, Picasso kept endlessly reinventing himself. Picasso continued to create art till his death on April 8, 1973, at the age of 91. His artistic legacy, however, has long endured.

New Words

staggering	['stægərɪŋ]	adj. 惊人的，令人震惊的
sculpture	['skʌlptʃər]	n. 雕塑；雕刻；刻蚀 vt. 雕塑；雕刻；刻蚀
ceramic	[sə'ræmɪk]	n. 陶瓷；陶瓷制品
mosaic	[moʊ'zeɪɪk]	n. 马赛克；镶嵌 adj. 镶嵌细工的；用拼花方式制成的

Unit 2
Modern Painters II

dominate	['dɑːmɪneɪt]	vt. 控制；支配；占优势；在……中占主要地位
commonplace	['kɑːmənpleɪs]	n. 老生常谈；司空见惯的事；普通的东西 adj. 平凡的；陈腐的
beget	[bɪ'get]	vt. 产生；招致；引起
prodigious	[prə'dɪdʒəs]	adj. 惊人的，异常的；奇妙的；巨大的
piercing	['pɪrsɪŋ]	adj. 敏锐的；刺穿的；尖刻的；打动人心的
watchful	['wɑːtʃfl]	adj. 警惕的，警醒的；注意的
destined	['destɪnd]	adj. 注定的；命定的；去往……的
prestigious	[pre'stɪdʒəs]	adj. 有名望的，享有声望的
chafe	[tʃeɪf]	vi. 激怒，恼怒 n. 气恼
formality	[fɔːr'mæləti]	n. 礼节；拘谨；仪式；正式手续
gypsy	['dʒɪpsi]	n. 吉卜赛人；吉卜赛语 adj. 吉卜赛人的
prostitute	['prɑːstətuːt]	n. 妓女
intellectual	[ˌɪntə'lektʃuəl]	n. 知识分子 adj. 智力的；聪明的；理智的
anarchist	['ænərkɪst]	n. 无政府主义者 adj. 无政府主义的
radical	['rædɪkl]	n. 激进分子；基础 adj. 激进的；根本的；彻底的
experimentation	[ɪkˌsperɪmen'teɪʃn]	n. 实验；试验；实验法；实验过程
prolific	[prə'lɪfɪk]	adj. 多产的；丰富的
isolation	[ˌaɪsə'leɪʃn]	n. 隔离；孤立
anguish	['æŋgwɪʃ]	n. 痛苦；苦恼
melancholy	['melənkɑːli]	adj. 忧郁的；使人悲伤的 n. 忧郁；悲哀；愁思
debilitate	[dɪ'bɪlɪteɪt]	vt. 使衰弱；使虚弱
patronage	['pætrənɪdʒ]	n. 赞助；光顾；任免权
manifestation	[ˌmænɪfe'steɪʃn]	n. 表现；显示；示威运动
beige	[beɪʒ]	n. 米黄色 adj. 浅褐色的；米黄色的；枯燥乏味的
canvases	['kænvəs]	n. 帆布；油画布；油画
palette	['pælət]	n. 调色板；颜料
lyricism	['lɪrɪsɪzəm]	n. 抒情性；抒情诗体；抒情方式抒情
chilling	['tʃɪlɪŋ]	adj. 冷漠的；寒冷的；使人恐惧的；令人寒心的 n. 冷却；寒冷
nude	[nuːd]	adj. 裸的，裸体的；无装饰的；与生俱有的 n. 裸体；裸体画
stark	[stɑːrk]	adj. 完全的；荒凉的；刻板的；光秃秃的；朴实的
blotch	[blɑːtʃ]	n. 斑点；污点；疙瘩 vt. 弄脏
reassemble	[ˌriːə'sembl]	vt. 重新装配；重新召集
composite	[kəm'pɑːzət]	adj. 复合的；合成的 vt. 使合成；使混合
defy	[dɪ'faɪ]	vt. 蔑视，挑衅；公然反抗；使落空

appall	[ə'pɔːl]	vt. 使惊骇；使胆寒
typicality	[ˌtɪpɪˈkælɪtɪ]	n. 典型性
embody	[ɪmˈbɑːdi]	vt. 体现，使具体化；具体表达
inhumanity	[ˌɪnhjuːˈmænəti]	n. 不人道，无人性；残暴
brutality	[bruːˈtæləti]	n. 无情；残忍；暴行
testament	[ˈtestəmənt]	n. [法] 遗嘱；圣约；确实的证明
terror	[ˈterər]	n. 恐怖；恐怖行动；恐怖时期；可怕的人
legacy	[ˈleɡəsi]	n. 遗赠，遗产

Useful Expressions

a variety of	种种，各种各样的……
break apart	使……分裂开

Proper Names and Cultural Notes

Pablo Picasso	巴勃罗·毕加索，西班牙画家、雕塑家，现代艺术的创始人，西方现代派画家的主要代表。
Fine Arts	美术
Blue Period	毕加索创作的蓝色时期，1900 年至 1903 年，这一时期其作品中弥漫着阴沉的蓝灰色，含有浓重的悲剧成分和民族特色，代表作有《蓝色自画像》《人生》《盲人的晚餐》和《年老的吉他演奏者》。
Rose Period	毕加索创作的玫瑰时期，1904 年至 1906 年，该时期画作用色转为粉红，色彩清新明快，笔法细腻，代表作有《拿烟斗的男孩》《斯坦因画像》和《马戏演员之家》。
Period of Cubism	毕加索创作的立体主义时期，1907 年至 1916 年，开始立体派风格创作，代表作有《亚威农少女》和《费尔南德头像》。
Surrealism	超现实主义，始于法国的文学艺术流派，于 1920 年至 1930 年盛行于欧洲文学及艺术界，对视觉艺术的影响极为深远。
Minotaur	弥诺陶洛斯，古希腊神话中的人身牛头怪物。传说是克里特岛国王弥诺斯之妻帕西法厄与海神波塞冬派来的牛的产物，拥有人的身体和牛的头，弥诺斯在克里特岛为它修建了一个迷宫。

Unit 2
Modern Painters II

Reading Comprehension

Task 1 Read the text and answer the following questions.

1. How does the critic Hughes comment on Picasso?
2. Why did Picasso skip class when he was at the School of Fine Arts in Barcelona?
3. Who inspired Picasso to make his decisive break from the classical methods in which he has been trained?
4. In his "Blue Period", what did Picasso depict and paint?
5. What are the features of the Cubist paintings?

Task 2 Read the text and choose the best answer to the questions.

1. In 1895, Picasso was admitted into the famous School of Fine Arts in Barcelona because _____.
 A. the school typically only accepted students several years his senior
 B. his father was a painter and art teacher
 C. his entrance exam was so extraordinary
 D. he displayed a prodigious talent for drawing at a very young age

2. Which one of the following is NOT a painting of Picasso's from the Blue Period?
 A. *Blue Nude.*
 B. *Two Nudes.*
 C. *La Vie.*
 D. *The Old Guitarist.*

3. Canvases from Picasso's "Rose Period" _____.
 A. include *Les Demoiselles d'Avignon*
 B. shocked the art world
 C. are characterized by a lighter palette and greater lyricism
 D. were influenced by the death of his close friend Carlos

4. Picasso's most well-known Surrealist painting *Guernica* _____.
 A. was completed in 1927
 B. depicts the bombing of an Italian town
 C. paints the scenes of poverty, isolation and anguish
 D. is one of the most powerful anti-war paintings in history

Language in Use

Task 1 Match the underlined words in Column I with their corresponding meanings in Column II.

I	II
1. Picasso had created a <u>staggering</u> 22,000 works of art in a variety of mediums.	A. very large or powerful and causing surprise or admiration
2. To say that Pablo Picasso <u>dominated</u> Western art in the 20th century is a mere commonplace.	B. producing many works
3. Picasso displayed a <u>prodigious</u> talent for drawing at a very young age.	C. so great, shocking or surprising that it is difficult to believe
4. He possessed a pair of <u>piercing</u>, watchful and black eyes that seemed to mark him destined for greatness.	D. the state of being separate
5. Picasso was inventive and <u>prolific</u>.	E. money or property that is given to you by some people when they die
6. Picasso painted scenes of poverty, <u>isolation</u> and anguish.	F. to be the most important or noticeable feature of something
7. Picasso produced a work that would <u>profoundly</u> influence the direction of art in the 20th century.	G. shocked someone very much
8. At once destructive and creative, Cubism shocked, <u>appalled</u> and fascinated the art world.	H. expresses or represents an idea or a quality
9. This large canvas <u>embodies</u> for many the inhumanity, brutality and hopelessness of war.	I. in a way that has a very great effect on someone or something
10. His artistic <u>legacy</u>, however, has long endured.	J. seeming to notice things about another person that would not normally be noticed, especially in a way that makes that person feel anxious or embarrassed

Task 2 Fill in the blanks with the correct form of the words given below.

prestige	attend	frustrate	grant	relative
typical	wander	talent	destine	formal

Picasso displayed a prodigious **1.**_____ for drawing at a very young age. Though he was a **2.**_____ poor student at school, he possessed a pair of piercing, watchful and black eyes that seemed to mark him **3.**_____ for greatness. Picasso's father, who was a painter and art teacher, began to teach him to paint when he was a small child. In 1895, when Picasso was 14 years old, he moved with his family to Barcelona, where he quickly applied to the city's **4.**_____ School of Fine Arts. Although the school **5.**_____ only

accepted students several years his senior, Picasso's entrance exam was so extraordinary that he was **6.** _____ an exception and admitted. Nevertheless, Picasso chafed at the School of Fine Arts' strict rules and **7.** _____ , and began skipping class so that he could roam the streets of Barcelona, sketching the city scenes he observed. In 1897, 16-year-old Picasso moved to Madrid to **8.** _____ the Royal Academy of San Fernando. However, he again became **9.** _____ with his school's singular focus on classical subjects and techniques. Once again, Picasso began skipping class to **10.** _____ the city and paint what he observed: gypsies, beggars, and prostitutes, among other things.

Task 3 Translate the following sentences into English.

1. 巴勃罗·毕加索主宰了20世纪的西方艺术这个说法只是个老生常谈。（dominate; commonplace）
2. 毕加索在幼年时期就展现出惊人的艺术天赋。（a prodigious talent）
3. 毕加索的入学考试成绩优异，被破格批准入学。（exception）
4. 这是一幅会对20世纪艺术发展方向产生深远影响的作品。（profoundly）
5. 作为一个革命性的艺术家，毕加索一直在不断地重塑自己。（reinvent）

Text B

Henri Matisse

Henri Matisse (1869–1954) was one of the most influential artists of the 20th century, whose stylistic innovations (along with those of Pablo Picasso) fundamentally altered the course of modern art and affected the art of several generations of younger painters. His vast oeuvre encompassed painting, drawing, sculpture, graphic arts, paper cutouts and book illustration. His varied subjects comprised landscape, still lifes, portraiture, domestic and studio interiors, and particularly focused on the female figure. Unlike Picasso, he was a late starter in art, and he was not quite so prolific or versatile, but for sensitivity of line and beauty of coloring he stands unrivalled among his contemporaries.

Matisse was born in a small town in northern France. He was the oldest son of a prosperous grain merchant. When he was young, he was sent to study law and later had a legal profession in Paris. He abandoned his legal career to study art at the age of 21, which deeply disappointed his father.

In 1891, he moved to Paris to study art and followed the traditional 19th-century academic path. Matisse's early work was tinged with academic manner. Discovering manifold artistic movements that coexisted or succeeded one another on the dynamic Parisian artistic scene, such as Neo-Classicism, Realism and Impressionism, he began to experiment with a diversity of styles, employing new kinds of brushwork, light, and composition to create his own pictorial language.

In its palette and technique, Matisse's early work showed the influence of an older generation of his compatriots: Édouard Manet and Paul Cézanne. In the summer of 1904, while visiting his artist friend Paul Signac at a small fishing village in Provence, Matisse discovered the bright light of southern France, which contributed to a change to a much brighter palette. As a result, Matisse produced his masterpiece *Luxe, Calme et Volupté*, titled after a poem by Charles Baudelaire, and exhibited at the Salon des Indépendants in Paris to great acclaim. The next summer, in Collioure, a seaport on the Mediterranean coast, where he vacationed in the company of André Derain, Matisse created brilliantly colored canvases structured by color applied in a variety of brushwork, ranging from thick impasto to flat areas of pure pigment, sometimes accompanied by a sinuous, arabesque-like line. Paintings such as *Woman with a Hat*, when exhibited in Paris, gave rise to the avant-garde movements named Fauvism (from the French word "fauves", meaning "wild beasts") by an art critic, referring to its use of arbitrary combinations of bright colors and energetic brushwork to structure the composition. During his brief Fauvist period, Matisse produced a significant number of remarkable canvases, such as the portrait of Madame Matisse, called *The Green Line, Marguerite Reading*, two versions of *The Young Sailor*, *Blue Nude* and two versions of *Le Luxe* among others. In those canvases Matisse developed a childlike or primitive simplicity of line. This search for uncompromisingly "pure" form and color culminated in the *Dance and Music*. The stark primitive outline and three basic colors of blue sky, green earth, and scarlet flesh employed by him can later be found in the canvases by Kandinsky or Mondrian.

The austere abstractions of *Dance and Music* were followed shortly afterwards by the fruits of his first visit to North Africa, a series of large scenes of Islamic life glowing with sensuous color. They appear effortlessly spontaneous, and their simple outlines could be mistaken as genuinely naïve. These were followed by a further advance towards abstract art in *Open Window, Collioure* in which vertical bands of green, gray, and pale blue that are the window shutters frame a plain black rectangle and an entirely opaque night sky.

Matisse became more and more widely recognized as master of modern painting. He worked in a growing variety of media. In addition to fine art painting and sculpture, he designed for the ballet and designed illustrated editions. The crowning achievement of Matisse's career was the commission for the Chapel of the Rosary, for which he created all the wall decorations, furniture, stained-glass windows, even the vestments and altar cloths.

After 1941, the aging Matisse suffered increasing ill health. He died on November 3, 1954 at Nice, shortly before his 85th birthday. Now, paintings by Henri Matisse are hung in the best art museums across the world.

Unit 2
Modern Painters II

New Words

stylistic	[staɪˈlɪstɪk]	adj. 风格上的；格式上的；文体论的
fundamentally	[ˌfʌndəˈmentəli]	adv. 根本地，从根本上；基础地
alter	[ˈɔːltər]	vt. 改变，更改
oeuvre	[ˈɜːvrə]	n. 全部作品；毕生之作
cutout	[ˈkʌtaʊt]	n.（布或纸上剪下的）图案花样；排气阀；保险开关
illustration	[ˌɪləˈstreɪʃn]	n. 说明；插图；例证；图解
portraiture	[ˈpɔːrtrətʃər]	n. 肖像画；肖像绘制；人像摄影
interior	[ɪnˈtɪriər]	n. 室内；内部 adj. 内部的；国内的
unrivalled	[ʌnˈraɪvld]	adj. 无与伦比的；无敌的
tinge	[tɪndʒ]	vt. 微染；使带气息 n. 淡色；些许味道；风味
manifold	[ˈmænɪfoʊld]	adj. 多方面的，有许多部分的；各式各样的 vt. 复写，复印；增多；使……多样化 n. 多种；复印本
brushwork	[ˈbrʌʃwɜːrk]	n. 绘画；笔法；画法；书法
compatriot	[kəmˈpeɪtriət]	n. 同胞；同国人 adj. 同胞的；同国的
acclaim	[əˈkleɪm]	n. 欢呼，喝彩；称赞 vt. 称赞；为……喝彩，向……欢呼
vacation	[vəˈkeɪʃn]	vi. 休假，度假 n. 假期
impasto	[ɪmˈpæstoʊ]	n. 厚涂的颜料；厚涂颜料的绘画法
pigment	[ˈpɪgmənt]	n. 色素；颜料 vt. 给……着色
sinuous	[ˈsɪnjuəs]	adj. 蜿蜒的；弯曲的；迂回的
arabesque	[ˌærəˈbesk]	n. 蔓藤花纹；阿拉伯式花纹
avant-garde	[ˌævãːˈgɑːrd]	n. 先锋派；前卫派 adj. 前卫的；先锋的
arbitrary	[ˈɑːrbətreri]	adj. 任意的；武断的；专制的
remarkable	[rɪˈmɑːrkəbl]	adj. 卓越的；非凡的；值得注意的
uncompromisingly	[ʌnˈkɑːmprəmaɪzɪŋli]	adv. 坚决地；不妥协地
culminate	[ˈkʌlmɪneɪt]	vt. 使结束；使达到高潮
austere	[ɔːˈstɪr]	adj. 严峻的；简朴的；苦行的；无装饰的
effortlessly	[ˈefərtləsli]	adv. 轻松地，毫不费劲地
spontaneous	[spɑːnˈteɪniəs]	adj. 自发的，自然的，无意识的
opaque	[oʊˈpeɪk]	adj. 不透明的；阴暗的
crowning	[ˈkraʊnɪŋ]	adj. 最高的；无比的
vestment	[ˈvestmənt]	n.（神职人员）法衣；官服；祭坛布；礼服；衣服
altar	[ˈɔːltər]	n. 祭坛；圣坛；圣餐台

Useful Expressions

in the company of	在……陪同下，与……一起
range from... to...	从……到……变动；从……到……范围
give rise to	使发生，引起

Proper Names and Cultural Notes

Henri Matisse	亨利·马蒂斯（1869—1954），法国著名画家、雕塑家、版画家，野兽派创始人和主要代表人物。
Parisian	巴黎人的；巴黎的；巴黎人
Neo-Classicism	新古典主义，兴起于18世纪的罗马，并迅速在欧美扩展蔓延的一场艺术运动。这场艺术运动一方面起于对巴洛克和洛可可艺术的反动；另一方面则是希望效仿古希腊、古罗马时期的艺术作品，追求典雅、端庄的美学趣味。
Realism	现实主义，是19世纪30年代以后出现于欧洲的一种文学艺术流派，它侧重客观、冷静、细腻地观察和摹写现实生活。现实主义的代表画家有卢梭、米勒等。
Fauvism	野兽派，野兽主义，1898—1908年在法国盛行一时的一个现代绘画潮流。野兽派画家热衷于运用鲜艳、浓重的色彩，直接从颜料管中挤出颜料，以直率、粗放的笔法，创造强烈的画面效果。野兽派画家代表人物有马蒂斯、弗拉曼克、德兰等。
Provence	普罗旺斯，法国东南部一地区。
Kandinsky	康定斯基（1866—1944），俄罗斯抽象表现主义的先驱、艺术理论家。
Mondrian	蒙德里安（1872—1944），荷兰画家，几何抽象画派的先驱，纯粹抽象艺术的倡导者。
Chapel of the Rosary	旺斯修道院，又称马蒂斯教堂，其正殿中墙面、圣坛等均为马蒂斯设计制作。
Nice	尼斯，法国东南沿海城市。

Unit 2
Modern Painters II

Reading Comprehension

 Read the text and answer the following questions.

1. What are the subjects of Henri Matisse's work?
2. What did Matisse experiment with when he was studying art in Paris?
3. Who have influenced Matisse's early work in the palette and technique?
4. What is Fauvism?
5. What is the greatest achievement of Matisse's career?

 Read the text and decide whether each of the following statements is true or false.

1. Henri Matisse was a very prolific and versatile artist like Picasso.
2. Henri Matisse studied law and had a legal profession before he started to study art.
3. Matisse's masterpiece *Luxe, calme et volupté*, was named after a poem by Charles Baudelaire.
4. The portrait of Madame Matisse was produced in Matisse's Fauvist period.
5. In Matisse's art work *Open Window, Collioure*, vertical bands of green, gray, and dark blue that are the window shutters frame a plain black rectangle and an entirely opaque night sky.

Language in Use

 Match the underlined words or phrases in Column I with their corresponding meanings in Column II.

I	II
1. The stylistic innovations led by Henri Matisse and Pablo Picasso <u>fundamentally</u> altered the course of modern art and affected the art of several generations of younger painters.	A. added a small amount of a particular emotion or quality to something
2. Matisse <u>abandoned</u> his legal career to study art at the age of 21.	B. caused something to happen or exist
3. Matisse's early work was <u>tinged</u> with academic manner.	C. ended with a particular result, or at a particular point
4. Matisse created brilliantly colored canvases structured by colors applied in <u>a variety of</u> brushwork.	D. in a way that is important; completely
5. Paintings such as *Woman with a Hat* <u>gave rise to</u> the avant-garde movements named "Fauvism".	E. very simple and old-fashioned
6. During his brief Fauvist period, Matisse produced a significant number of <u>remarkable</u> canvases.	F. done naturally, without being forced or practiced

7. In those canvases Matisse developed a childlike or <u>primitive</u> simplicity of line.
8. This search for uncompromisingly "pure" form and color <u>culminated</u> in the *Dance and Music*.
9. They appear effortlessly <u>spontaneous</u>, and their simple outlines could be mistaken as genuinely naive.
10. The <u>crowning</u> achievement of Matisse's career was the commission for the Chapel of the Rosary.

G. unusual or surprising in a way that causes people to take notice
H. making something perfect or complete
I. several different sorts of the same thing
J. stopped doing something

Task 2 Fill in the blanks with the correct form of the words given below.

comprise	unrivalled	influence	legal	fundamental
coexist	generation	experiment	prolific	unlike

Henri Matisse (1869–1954) was one of the most **1.**_____ artists of the 20th century, whose stylistic innovations (along with those of Pablo Picasso) **2.**_____ altered the course of modern art and affected the art of several **3.**_____ of younger painters. His vast oeuvre encompassed painting, drawing, sculpture, graphic arts, paper cutouts and book illustration. His subjects **4.**_____ landscape, still lifes, portraiture, domestic and studio interiors, and particularly focused on the female figure. **5.**_____ Picasso, he was a late starter in art, and he was not quite so **6.**_____ or versatile, but for sensitivity of line and beauty of coloring he stands **7.**_____ among his contemporaries.

Matisse was born in a small town in northern France. He was the oldest son of a prosperous grain merchant. When he was young, he was sent to study law and later had a **8.**_____ profession in Paris. He abandoned his legal career to study art at the age of 21, which deeply disappointed his father.

In 1891, he moved to Paris to study art and followed the traditional 19th-century academic path. Matisse's early work was tinged with academic manner. Discovering manifold artistic movements that **9.**_____ or succeeded one another on the dynamic Parisian artistic scene, such as Neo-Classicism, Realism and Impressionism, he began to **10.**_____ with a diversity of styles, employing new kinds of brushwork, light, and composition to create his own pictorial language.

Task 3 Translate the following sentences into Chinese.

1. Unlike Picasso, Matisse was a late starter in art, and he was not quite so prolific or versatile, but for sensitivity of line and beauty of coloring he stands unrivalled among his contemporaries.
2. He abandoned his legal career to study art at the age of 21, which deeply disappointed his father.
3. Matisse's early work was tinged with academic manner.

4. Matisse's paintings such as *Woman with a Hat* gave rise to the avant-garde movements named "Fauvism".
5. The crowning achievement of Matisse's career was the commission for the Chapel of the Rosary, for which he created all the wall decorations, furniture, stained-glass windows, even the vestments and altar cloths.

Part Three Practical Writing

Memos

A memo, or officially called a memorandum, is a written or typed document that helps the memory by recording events or observations on a topic. It is most often used in an office setting. It's a quick note to convey information to a small group of people. A memo can be a hard copy, but can also be in an electronic version.

In the business environment, there are several ways a memo can be written. It is typically considered an informal document. It is usually short in nature, on one page, but can be longer. For example, a memo might go out through an office to remind employees of the time of an upcoming meeting.

Memos are useful when other messaging, like email or texting, is not available. Of course, it is best that the message being sent is something not of a sensitive nature, where face-to-face contact or a phone call would be more appropriate.

 Task 1 Fill in the boxes with the corresponding components of a memo marked from A to F.

A. Message
B. Topic (what the memo is about)
C. Name of anyone else who receives a copy
D. Receiver's name (and job title)
E. Sender's name (and job title)
F. Complete and current date

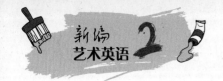

Task 2 Write a memo according to the given situation.

Please send a memo to remind all the staff in your company of the upcoming New Year party on December 28.

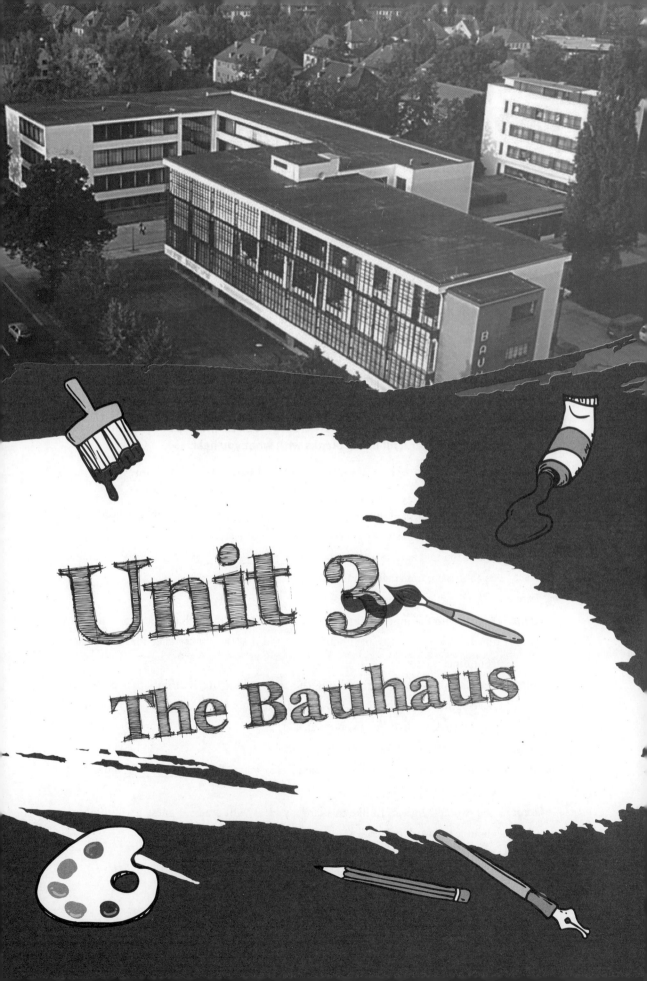

Unit 3
The Bauhaus

Part One Listening and Speaking

Task 1 Listen to a conversation about the preparation of a meeting and answer the questions.

Questions:
1. What is the meeting about?
2. Why does the man feel worried?
3. What does the woman mean when she says "You can't be too careful about the preparation"?
4. When will Sam and Jenny work as receptionists?
5. Why do they need two more paintings?

Task 2 Mrs. Johnson is talking with George about his report. Listen to their conversation and fill in the blanks with what you hear.

Mrs. Johnson: Hi, George. Do you have a few minutes? I'd like to talk about your report on the Bauhaus.

George: Sure, Mrs. Johnson. I hope you will **1.**_____ me for handing it a little bit late.

Mrs. Johnson: That's OK. But I'm still wondering what made you late.

George: Well, I found it hard to give a proper **2.**_____ on the Bauhaus's tenet, and it cost me more time than I thought.

Mrs. Johnson: Oh, tell me more about it, please.

George: I agree with the functionalist view of art, but I also think that they over-emphasized the **3.**_____ of functionality, and that their preference for architecture is confining.

Mrs. Johnson: I see. Have you thought about the time when the Bauhaus prospered? The development in technology, culture and people's **4.**_____ of art can be possible reasons to explain your puzzle.

George: Yes, you are right. Thank you. That is very helpful.

Mrs. Johnson: You did think a lot about this issue, and I'd like you to **5.**_____ your report in class next week.

George: That would be great. I'd like to share my ideas with others. I guess I will think more about it and work out a **6.**_____ version.

Mrs. Johnson: I am sure you will do a good job. See you next week.

George: See you, Mrs. Johnson.

Unit 3
The Bauhaus

Task 3 Role-play a conversation in pairs according to the following situations. You may refer to the expressions below to make apologies or accept them.

1. being late for an appointment
2. being absent from the class
3. being rude to a best friend
4. having blamed a family member wrongly

Useful Expressions

Making an apology

I'm sorry for…

I'm awfully/so/terribly/extremely sorry for…

Sorry about…

Pardon me for…

I really feel bad about…

Sorry. I'm the one to blame.

Sorry. Blame it on me.

Excuse me for…, please.

Please forgive me for…

I'm sorry, I didn't mean to…

It's all my fault.

How silly of me to…

I can't tell you how sorry I am.

I do beg your pardon.

I hope you'll pardon me for…

I owe you an apology for…

I must beg to apologize for…

I plead for your forgiveness.

I must make an apology for…

I've got to apologize for…

I must offer my sincerest apology for…

May I offer my profoundest apologies for…?

I just don't know what to say.

I'm afraid I've brought you too much trouble.

It was really quite unintentional.

I apologize for what I said just now.

Please accept my apologies for…

Accepting an apology

That's quite all right.

That's OK.

That's all right.

Never mind about that.

Don't worry about that.

Not a bit of it.

It doesn't matter at all, that's perfectly all right.

Forget it/Drop it.

Let's forget it.

Please think nothing of it.

Don't mention it, and don't think too much about it.

Don't think any more about it.

Don't let it worry you.

Please don't feel bad about it.

Don't let it distress you.

Please don't take it to heart.

What for…?

Well, it's just one of those things.

There's no need for you to worry in the least.

Unit 3
The Bauhaus

Part Two　Active Reading

The Bauhaus was the most influential modernist art school of the 20th century, whose approach to teaching, and understanding of art's relationship to society and technology, had a major impact on generations of modern architects and designers long after it closed. The major principle of the Bauhaus movement is that functionality gets to dictate the form. The Bauhaus went through three stages: first was founded in Weimar by architect Walter Gropius; then operated under the directorship of Hannes Meyer in Dessau; and was finally relocated in Berlin by the last director Ludwig Mies. The school shut down in 1933.

Text A

The Bauhaus

The Bauhaus was an art school founded in 1919 in Weimar, Germany by architect Walter Gropius. It was the most influential art school of modernity in the 20th century. Its approach to teaching, and understanding of art's relationship to society and technology, had a worldwide and lasting impact on design up till the present day.

The early Bauhaus was an expression of its time. It can be seen as a refined craft movement, which sought to level the distinction between fine and applied arts, and to reunite creativity and manufacturing. The Bauhaus stressed on uniting art and industrial design and made that fusion applied through a wide range of visual arts such as painting, sculpture, film, photography, and architecture, which was ultimately proved to be its most original and important achievement.

When Walter Gropius came to Weimer, he was 36 years old. He was blessed with a progressive mindset and a strong character. He initiated the merging of two schools of arts and made himself the director of the newly founded school. He immediately wrote some sort of rules and regulations for the new organization, which was the famous *Bauhaus Manifesto*. Gropius made his ideas pretty clear to every student and he himself set a plan for the first teaching semester. Gropius claimed that fine arts should be unified under the primacy of architecture. He also thought that craft quality actually was the ultimate source of creative design. For that purpose, both fine arts and applied arts, painters and architects, expressionists and constructivists were attached great importance to on the Bauhaus camp. The students received not only handicraft training, but artistic training for the purpose to free their creative powers and to express themselves. That preliminary course of the Bauhaus helped to build a solid foundation for a design education.

The school was a microcosm of movements vying more generally in Europe. There were

41

strong undercurrents and conflicting forces coursing through the early Bauhaus. In 1923, Gropius abandoned his previous interest in the craft-driven aesthetic, and turned instead to the world of the machine and a more functionalist view. Gropius decided to forge an ethos in the school that regarded the machine as an engine of, and for, modernity. Art and craft would be fused to create well-designed, marketable, mass-produced consumer goods that would be cheap, functional, simple, and pure, without decoration. The driving principle was a new unity of art and technology.

In 1925, the institution was moved from Weimer to Dessau. It was in Dessau that the Bauhaus definitively consolidated the functionalist direction with which it later became so heavily identified. Three years later, Hannes Meyer, a colleague of Gropius, became the new director. During the two years of Meyer's leadership, the school progressed immensely. New programs, courses, and workshops linked to architecture, photography, publication, urban planning, advertising and textile were introduced into the Bauhaus.

The hard-working Bauhaus was not an ivory tower but produced designs meant to be sold. Many of the intricately patterned and colored textiles, carpets, and wallpaper were sold, and architecture commissions were brought in. Meyer was in essence a functionalist, or in other words, a pragmatist. He maintained the emphasis on mass-producible design, and stressed the social function of architecture and design, favoring concern for the public good rather than private luxury. Advertising and photography continued to gain prominence under his leadership.

In 1930, director Meyer resigned, and that position was assumed by architect Ludwig Mies. When Nazi came into power, the political situation became unstable and even perilous. The Bauhaus, under the directorship of Mies, moved to Berlin, and operated on a reduced scale. The freedom and creative spirit that had characterized the school dimmed. In 1933, the Gestapo raided the school and denounced it for communist sympathies. Ultimately, the teachers and masters voted to shut down the school. The key figures of the Bauhaus emigrated to the United States, where their work and their teaching philosophies influenced generations of young architects and designers.

New Words

modernity	[məˈdɜːrnəti]	n. 现代性
architect	[ˈɑːrkɪtekt]	n. 建筑师
approach	[əˈproʊtʃ]	n. 方法，途径；接近
refined	[rɪˈfaɪnd]	adj. 精炼的；精确的；微妙的；有教养的
craft	[kræft]	n. 工艺；手艺
level	[ˈlevl]	vt. 使同等；对准；弄平
fusion	[ˈfjuːʒn]	n. 融合；熔化；熔接；融合物
progressive	[prəˈgresɪv]	adj. 进步的；先进的

mindset	['maɪndset]	n. 心态；倾向；习惯；精神状态
initiate	[ɪ'nɪʃɪeɪt]	vt. 开始，创始；发起；使初步了解
merge	[mɜːrdʒ]	vt. 合并
manifesto	[ˌmænɪ'festoʊ]	n. 宣言；声明；告示
primacy	['praɪməsɪ]	n. 首位；卓越
expressionist	[ɪk'spreʃənɪst]	n. 表现派作家；表现主义艺术家
constructivist	[kən'strʌktɪvɪst]	n. 结构主义艺术家
handicraft	['hændɪkræft]	n. 手工艺；手工艺品
preliminary	[prɪ'lɪmɪnerɪ]	adj. 初步的；开始的；预备的
microcosm	['maɪkroʊkɑːzəm]	n. 微观世界；小宇宙
vying	['vaɪɪŋ]	vi. 争夺（vie 的现在分词）
aesthetic	[es'θetɪk]	adj. 美的；美学的；审美的，具有审美趣味的
functionalist	['fʌŋkʃənəlɪst]	n. 实用主义者；机能主义者
ethos	['iːθɑːs]	n. 社会思潮；精神特质；民族精神；气质
marketable	['mɑːrkɪtəbl]	adj. 市场的；可销售的；有销路的
consolidate	[kən'sɑːlɪdeɪt]	vt. 巩固；使固定；联合
intricately	['ɪntrɪkətlɪ]	adv. 复杂地；错综地，缠结地
essence	['esns]	n. 本质，实质；精华；香精
pragmatist	['prægmətɪst]	n. 实用主义者
prominence	['prɑːmɪnəns]	n. 突出；显著；突出物；卓越
resign	[rɪ'zaɪn]	vt. 辞职；放弃；委托；使听从
assume	[ə'suːm]	vt. 承担；假定；设想；采取
perilous	['perələs]	adj. 危险的，冒险的
dim	[dɪm]	vt. 使暗淡，使失去光泽；使变模糊
raid	[reɪd]	vi. 对……进行突然袭击
denounce	[dɪ'naʊns]	vt. 谴责，公然抨击；告发；通告废除
emigrate	['emɪɡreɪt]	vi. 移居；移居外国

Useful Expressions

have... impact on	对……有影响
prove to be	结果是；证明为
be blessed with	赋有……的，享有……的；在……方面有福
attach importance to	重视，对……给予重视；着重于……
mean to	打算
come into power	当权；上台；执政

Proper Names and Cultural Notes

The Bauhaus	包豪斯，德国魏玛市"公立包豪斯学校"的简称，后改称"设计学院"，习惯上仍沿称"包豪斯"。两德统一后，位于魏玛的设计学院更名为"魏玛包豪斯大学"。"包豪斯"一词是瓦尔特·格罗皮乌斯创造出来的，是德语 Bauhaus 的译音，由德语 Hausbau（房屋建筑）一词倒置而成。包豪斯的成立标志着现代设计教育的诞生，对世界现代设计的发展产生了深远的影响；包豪斯也是世界上第一所完全为发展现代设计教育而建立的学院。
Weimar	魏玛，德国文化中心之一，歌德和席勒在此创作出许多不朽的文学作品。著名景点有歌德故居、包豪斯博物馆等。
Walter Gropius	瓦尔特·格罗皮乌斯（1883—1969），德国现代建筑师和建筑教育家，现代主义建筑学派的倡导人和奠基人之一，公立包豪斯学校的创办人。格罗皮乌斯积极提倡建筑设计与工艺的统一，艺术与技术的结合，讲究功能、技术和经济效益。
Hans Meyer	汉斯·迈耶，瑞士建筑师，1927—1930 年担任包豪斯学校校长。迈耶在包豪斯推进泛政治化，是一名纯粹功能主义者。他的作品主要有柏林 ADBG 的联邦学校教学大楼。
Dessau	德绍，德国中东部城市。
Ludwig Mies	卢德韦格·密斯（1886—1969），德国建筑师，与赖特、勒·柯布西耶、格罗皮乌斯并称四大现代建筑大师，曾任德绍和柏林包豪斯学校校长。
Nazi	纳粹党
Gestapo	盖世太保（德意志第三帝国时期的秘密警察）

Unit 3
The Bauhaus

Reading Comprehension

Task 1 Read the text and answer the following questions.

1. What artistic aim does the Bauhaus school seek?
2. What is the most original and influential achievement of the Bauhaus school?
3. What do you know about Walter Gropius's character?
4. What do you know about the famous *Bauhaus Manifesto*?
5. What was the ethos that Walter Gropius forged in 1923?

Task 2 Read the text and choose the best answer to the questions.

1. The Bauhaus school is important because _____.
 A. it was founded in 1919 in Germany
 B. it was founded by Walter Gropius
 C. it has great influence on designs later on
 D. the early Bauhaus was an expression of its time

2. The following statement about the Bauhaus are all true EXCEPT _____.
 A. it was a refined craft movement
 B. it tried to level the distinction between fine and applied arts
 C. it tried to combine creativity and manufacturing
 D. Walter Gropius felt stressed about uniting art and industrial design and refused to apply it through a wide range of visual arts

3. Both fine arts and applied arts, painters and architects, expressionists and constructivists were attached great importance to on the Bauhaus camp because _____.
 A. Walter Gropius thought that craft quality actually was the ultimate source of creative design
 B. Walter Gropius was blessed with a progressive mindset and a strong character
 C. Walter Gropius made himself director of the newly founded school
 D. the students received not only handicraft training, but artistic training for the purpose to free their creative powers and to express themselves

4. The Bauhaus moved to Berlin because _____.
 A. the political situation became unstable and even perilous
 B. architect Ludwig Mies assumed the position of director
 C. the Gestapo raided the school and denounced it for communist sympathies
 D. the teachers and masters voted to shut down the school

Language in Use

Task 1 Match the underlined words or phrase in Column I with their corresponding meanings in Column II.

I	II
1. The freedom and creative spirit that had characterized the school <u>dimmed</u>.	A. the showing of ideas or characters through words, actions, or artistic activities
2. The hard-working Bauhaus was not an <u>ivory tower</u> but produced designs meant to be sold.	B. recognized as the characteristic of something
3. Advertising and photography continued to gain <u>prominence</u> under his leadership.	C. a way of doing something
4. It was in Dessau that the Bauhaus definitively consolidated the functionalist direction with which it later became so heavily <u>identified</u>.	D. became or made darker
5. The school was a <u>microcosm</u> of movements vying more generally in Europe.	E. a small society, place, or activity which has all the typical features of a much larger one and so seems like a smaller version of it
6. That <u>preliminary</u> course of the Bauhaus helped to build a solid foundation for a design education.	F. to tear down so as to make flat with the ground
7. Its <u>approach</u> to teaching, and understanding of art's relationship to society and technology, had a worldwide and lasting impact on design up till the present day.	G. the state of being important, widely known or eminent
8. The early Bauhaus was an <u>expression</u> of its time.	H. taking place at the beginning of an event, often as a form of preparation
9. It can be seen as a refined craft movement, which sought to <u>level</u> the distinction between fine and applied arts, and to reunite creativity and manufacturing.	I. a place (like a university) where people have no knowledge or experience of the practical problems of everyday life

Task 2 Fill in the blanks with the correct form of the words given below.

attachment	initiate	set	unify	trainer
found	crafty	bless	creation	regulate

When Walter Gropius came to Weimer, he was 36 years old. He was 1._____ with a progressive mindset and a strong character. He 2._____ the merging of two schools of arts and made himself the director of the newly founded school. He immediately

wrote some sort of rules and 3._____ for the new organization, which was the famous *Bauhaus Manifesto*. Gropius made his ideas pretty clear to every student and he himself 4._____ a plan for the first teaching semester. Gropius claimed that fine arts should be 5._____ under the primacy of architecture. He also thought that 6._____ quality actually was the ultimate source of creative design. For that purpose, both fine arts and applied arts, painters and architects, expressionists and constructivists were 7._____ great importance to on the Bauhaus camp. The students received not only handicraft 8._____, but artistic training for the purpose to free their 9._____ powers and to express themselves. That preliminary course of the Bauhaus helped to build a solid 10._____ for a design education.

Task 3 Translate the following sentences into English.

1. 包豪斯学校关于艺术与社会、艺术与技术的关系的理解对世界范围内的设计产生了深远的影响。（have impact on; relationship）
2. 这可以看作是一项力争消除艺术和应用艺术之间区别的艺术升华运动。（refined; level）
3. 因此，艺术和应用艺术、画家和建筑师、表现主义艺术家和结构主义艺术家，在包豪斯学校都受到了同等的重视。（both... and; attach importance to）
4. 包豪斯学校早期充斥着暗流和冲突。（course through; undercurrent; conflict）
5. 迈耶本质上是一个功能主义者，换言之，他是一个实用主义者。（in essence; in other words）

Text B

Bauhaus Manifesto

The Bauhaus was a fertile ground shared by a great number of ingenious people. Some of these artists have left the most iconic pieces and designs behind, and some were great educators, lecturers, theorists—either way, all of them have inspired future generations of artists and designers, informing their sensibility and giving them guidelines to follow. It is no wonder that the movement is referred to as a school of thought, rather than a school of art. The legacy of Bauhaus goes far beyond individual intention, but each of the artists has, individually, made it possible for the movement to have such strong impact later on.

Walter Gropius, the founder of the Bauhaus, conducted the innovative program for the Bauhaus school. He upheld the principle of creating purely organic buildings, and boldly get rid of luxurious but useless ornamentation, which brought the Bauhaus significant attention and unique identity. Gropius also advocated a pro-industrial attitude, and was clearly supportive of mass-production, for the sake of better realization, financial advancement and the unification of all arts. His ideology was summarized in his famous *Bauhaus Manifesto*.

Art Should Be Building

"The ultimate goal of all art is the building!" Walter Gropius made his point right from the start of *Bauhaus Manifesto*. "Art is no profession," he claimed. Therefore, architects, sculptors, and painters must return to the work of craft. In other words, the artist and the artisan are the same. That is why he wanted to recreate craftsmanship and erase the artificial barrier between "noble" artists and "working" craftsmen. For the aim of future building, he claimed that every art discipline should unite as one. That was exactly what he was doing with Bauhaus. It was an ambitious program aimed at freeing the art world of its own isolation. Eventually, it became one of the most influential art movements in the history of art. Now, it is impossible to walk around any American city and not to be intrigued by the great amount of the Bauhaus influence on its architecture.

Functionality Dictates Form

The basic rule of the *Bauhaus Manifesto* is that functionality gets to dictate the form. It is all about products being functional and unique. Making things durable and economical while covering its essential functions is also very valuable. With the beginning of a massive use of the machines at the time, makers needed to re-imagine and re-create their visions and future goals. Using a lot of machines instead of people may have had a negative influence on the creativity, yet it led to positive results when it comes to mass production and saving a lot of time and money.

Smart Use of Space, Materials, and Money

It doesn't mean the penny-pinching or the cheeseparing, and it doesn't include the burning candles on both sides either. What they wanted to achieve was a controlled finance, productive time-consuming projects, precise material use, and a spare space. It is all about the smart use of resources, with a zero-waste ideal in mind.

All New, All the Time

The Bauhaus is all about new techniques, new materials, new ways of construction, and new attitude—all the time. It emphasizes going forward, strong progress, and constant evolution of architects, designers, artists, as well as their work. Evolving firms lead to the constant discovery of new, unusual, and surprisingly interesting findings.

Simplicity and Effectiveness

There is no need for additional or unnecessary ornamenting and making things more and more "beautiful". They are just fine as they are. It is all about so-called organic design, revealing the nature of objects. The Bauhaus celebrates pure forms, clean design, and functionality. Created product, whether it is an architectural project, craft work, design, or an art piece, should be functional. On the contrary, as to once cherished ornamentation of buildings, the Bauhaus movement was determined to clear the form and make it far more simple than it used to be.

Unit 3
The Bauhaus

New Words

fertile	['fɜːrtl]	*adj.* 富饶的，肥沃的；能生育的
ingenious	[ɪn'dʒiːnɪs]	*adj.* 有独创性的；机灵的；精制的；心灵手巧的
iconic	[aɪ'kɑːnɪk]	*adj.* 形象的，图标的
sensibility	[ˌsensə'bɪləti]	*n.* 情感；敏感性；感觉；识别力
uphold	[ʌp'hoʊld]	*vt.* 鼓励；赞成；支撑；举起
organic	[ɔːr'gænɪk]	*adj.* 有机的；组织的；器官的；根本的
ornamentation	[ˌɔːrnəmen'teɪʃn]	*n.* 装饰物
ideology	[ˌaɪdi'ɑːlədʒi]	*n.* 意识形态；思想意识
artisan	['ɑːrtəzn]	*n.* 工匠，技工
intrigue	[ɪn'triːg]	*vt.* 激起……的兴趣；用诡计取得
penny-pinching	['peniˌpɪntʃɪŋ]	*adj.* 小气的，吝啬的
cheeseparing	['tʃiːzˌperɪŋ]	*adj.* 小气的，吝啬的
evolution	[ˌiːvə'luːʃn]	*n.* 演变；进化；进展
reveal	[rɪ'viːl]	*vt.* 显示；透露；揭露；泄露

Useful Expressions

refer to	涉及；指的是；参考；适用于
get rid of	摆脱，除去
for the sake of	为了，为了……的利益
free... of...	使（某人心中）摆脱（某种想法等）
lead to	致使，导致，引起

Reading Comprehension

Task 1 Read the text and answer the following questions.

1. Why was the Bauhaus a fertile ground?
2. What was the guidelines that Walter Gropius proposed and that brought the Bauhaus significant attention and unique identity?
3. What does the statement "Art Should Be Building" mean?
4. What was the problem with using machines instead of people? Does it have any benefit?
5. What was the Bauhaus's attitude toward ornamentation of buildings?

Task 2 Read the text and decide whether each of the following statements is true or false.

1. The Bauhaus movement is referred to as a school of thought, not a school of art.
2. Gropius's attitude toward industry is negative.
3. According to the *Bauhaus Manifesto*, the buildings should be able to last for a long time, cost as less money as possible, and be useful as well.
4. The Bauhaus paid little attention to the waste of materials.
5. Designers don't have to make things more and more "beautiful", because even simple things are just fine as they are.

Language in Use

Task 1 Match the underlined words in Column I with their corresponding meanings in Column II.

I	II
1. Some of these artists have left the most <u>iconic</u> pieces and designs behind.	A. the amount of money that you have and how well it is organized
2. The <u>legacy</u> of Bauhaus goes far beyond individual intention, but each of the artists has, individually, made it possible for the movement to have such strong impact later on.	B. simple and healthful and close to nature
3. Gropius also advocated a pro-industrial attitude, and was clearly supportive of <u>mass-production</u>.	C. money or property (spiritual wealth) left by previous generations
4. Making things durable and economical while <u>covering</u> its essential functions is also very valuable.	D. including in scope
5. It doesn't mean the <u>penny-pinching</u> or the cheeseparing, and it doesn't include the burning candles on both sides either.	E. trying to spend as little money as possible
6. What they wanted to achieve was a controlled <u>finance</u>, productive time-consuming projects, precise material use, and a spare space.	F. a process in which something passes by degrees to a different stage (especially a more advanced or mature stage)
7. It emphasizes going forward, strong progress, and constant <u>evolution</u> of architects, designers, and artists, as well as their work.	G. the making of large quantities of a standardized article (often using assembly line techniques)
8. It is all about so-called <u>organic</u> design, revealing the nature of objects.	H. important or impressive; acting as a symbol of something

Unit 3
The Bauhaus

Task 2 Fill in the blanks with the correct form of the words given below.

| during | make | ambition | move | sculpture |
| eraser | function | essence | art | leading |

Art Should Be Building

"The ultimate goal of all art is the building!" Walter Gropius **1.**_____ his point right from the start of *Bauhaus Manifesto*. "Art is no profession", he claimed. Therefore, architects, **2.**_____, and painters must return to the work of craft. In other words, artist and **3.**_____ are the same. That is why he wanted to recreate craftsmanship and **4.**_____ the artificial barrier between "noble" artists and "working" craftsmen. For the aim of future building, he claimed that every art discipline should unite as one. That was exactly what he was doing with Bauhaus. It was an **5.**_____ program aiming at freeing the art world of its own isolation. Eventually, it became one of the most influential art **6.**_____ in the history of art. Now, it is impossible to walk around any American city and not to be intrigued by the great amount of the Bauhaus influence on its architecture.

7._____ **Dictates Form**

The basic rule of the *Bauhaus Manifesto* is that functionality gets to dictate the form. It is all about products being functional and unique. Making things **8.**_____ and economical while covering its **9.**_____ functions is also very valuable. With the beginning of a mass use of the machines at the time, makers needed to re-imagine and re-create their visions and future goals. Using a lot of machines instead of people may have had a negative influence on the creativity, yet it **10.**_____ to positive results when it comes to mass production and saving a lot of time and money.

Task 3 Translate the following sentences into Chinese.

1. Some of these artists have left the most iconic pieces and designs behind, and some were great educators, lecturers, and theorists.
2. Either way, all of them have inspired future generations of artists and designers, informing their sensibility and giving them guidelines to follow.
3. He upheld the principle of creating purely organic buildings, and boldly get rid of luxurious but useless ornamentation, which brought the Bauhaus significant attention and unique identity.
4. It is all about the smart use of resources, with a zero-waste ideal in mind.
5. The Bauhaus celebrates pure forms, clean design, and functionality. Any created product, whether it is an architectural project, craft work, design, or an art piece, should be functional.

Part Three Practical Writing

Minutes

Minutes, also known as protocols or, informally, notes, are the instant written record of a meeting or hearing. They typically describe the events of the meeting and may include a list of attendees, a statement of the issues considered by the participants, and related responses or decisions for the issues.

The minutes should contain mainly a record of what was done at the meeting, not what was said by the members. The organization may have its own rules regarding the content of the minutes. For most organizations or groups, it is important for the minutes to be terse and only include a summary of the decisions. The minutes of certain groups, such as a corporate board of directors, must be kept on file and are important legal documents.

Generally, minutes begin with the name of the body holding the meeting (e.g., a board) and may also include the place, date, list of people present, and the time that the chair called the meeting to order. Since the primary function of minutes is to record the decisions made, all official decisions must be included. If a formal motion is proposed, seconded, passed, or not, then this is recorded. The minutes may end with a note of the time that the meeting was adjourned.

Here are some tips for writing minutes of meetings:

1. Be sure to take attendance;

2. Be sure to document the start time and location of the meeting if necessary;

3. Determine your style of meeting minutes: action, discussion or verbatim;

4. Record all pertinent discussions, decisions, conclusion statements and action items.

Always remember: The formatting of minutes varies from association to association and it is a matter of personal style. For example, some secretaries use Roman numerals (I., II., III.) and others do not. The format is useful for readability but not critical. What is important is the information contained in the minutes.

Unit 3
The Bauhaus

 Task 1 Fill in the boxes with the corresponding components of two minutes respectively marked from A to F.

Sample 1

A. Result of the motion (conclusion of the discussion)
B. Members present and not present
C. Motion proposed (issue discussed)
D. Ending (with the time when the meeting adjourns)
E. Who called it to order
F. Topic and time of the meeting (name of the organization)

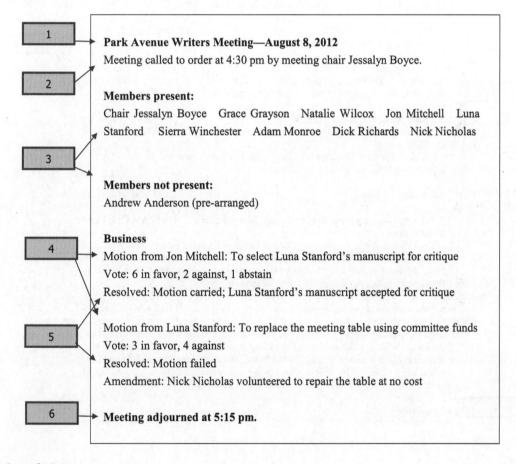

Sample 2

A. Members present
B. Topics and time of each stage
C. Discussions of each stage
D. Topic and time of the meeting (name of the organization)
E. Conclusion
F. Who called it to order

[1]

[2]

[3]

<center>**Sales Meeting**
January 12th, 2016 8:30 AM – 12:00 PM</center>

HOST: Anne Summers

ATTENDEES: Bob Johnson, Anne Summers, Greg Jorgenson, Tom Witworth, Dave Hamilton, Brandon Conrad, Christina Merrild, Rachel Ranscht

1. Welcome **8:30 AM – 8:45 AM**
We will be reviewing all sales performance for the sales reps in the US, UK, DE and FR offices.
General Comment
The sales performance was good, but we need to grow by 20%.

2. Budget forecast for 2016 **8:45AM – 9:30 AM**
Each manager will review their 2016 budget forecast.
Description
US & UK Manager Bob Johnson
The US & UK markets experienced a 15% growth from last year. Online sales increased, adding a positive number to the bottom line.

3. Problems and concerns from 2016 **9:30 AM – 10:15 AM**
Each manager will discuss what issues they experienced in the 2015 fiscal year.
Description
All in all, sales were good, the FR Market experienced a downturn, so we will need to address this for any possible solutions.

4. Break **10:15 AM – 10:30 AM**

5. Sales and management tips, tricks and best practices **10:30 AM – 11:15 AM**
Bob Johnson
It is mandatory that at minimum one day per week is set aside for new strategies. Each manager should evaluate what is working, and if there are any spin-off markets that could be focused on. That has proved successful in the US and UK. We are also leveraging our referral sources to stimulate new business.

6. New product ideas for development **11:15 AM – 12:00 AM**
General Comment
With our current product offering, we have seen a trend towards more cloud based systems. Desktop software is still a powerful asset to an organization, but cloud technology seems to be the trend for the future. We should make a module that ties in social media like with Google searches so that users can create custom search campaigns targeting specific requirements set for in an RFP.

[6] **Conclusion**

[4]

[5]

 Task 2 Write a minutes of a meeting that you recently attended.

Unit 4
The Man Who Reinvented World Urban Skyline

Part One Listening and Speaking

Task 1 Listen to a conversation between Mr. Coleridge, the technician of the school lecture hall and Mary Bradford, the lecturer of architecture, then answer the questions.

Questions:
1. Why is Mary calling Mr. Coleridge?
2. When is Mary's class and what device does she need in her class?
3. How will Mr. Coleridge solve the problem?
4. Does Mary need to adjust the class schedule?
5. How does Mary ask Mr. Coleridge to contact her?

Task 2 Jenny has ordered a book about Le Corbusier's life and art creation on Internet. Now she is calling the customer service agent. Listen to the conversation and fill in the blanks with what you hear.

Agent: Hi, this is Love Reading Bookshop. How can I help you?

Jenny: Eh, hi, I've **1.**_____ a book in your shop online. The title is *Le Corbusier's Life and Art Creation*.

Agent: Could you please tell me your **2.**_____?

Jenny: Yes, it is **3.**_____.

Agent: Ah, here it is. It is still on the way.

Jenny: But I ordered it 10 days ago. Why **4.**_____?

Agent: Let me contact the express company. Hold on for a second, please.

...

Agent: Sorry for keeping you on the phone. They told me just now that the **5.**_____ by the hurricane a few days ago. But it is expected to arrive at your hand tomorrow morning.

Jenny: Ah, I see. It's OK then. Thank you for dealing with it.

Agent: We are terribly sorry for the delay and next time we would **6.**_____.

Task 3 Role-play a conversation in pairs according to the given situations. You may refer to the expressions below.

1. Complaining to a restaurant manager about the bad service you got.
2. Complaining about the poor product you just bought from the store.

Useful Expressions

Making a complaint

I'm calling to report that…

I'm writing to inform you of…

The failure of… can be very troublesome.

I'm terribly furious about…

It is necessary for you to…

I hate to complain, but…

There is something wrong with…

I have a complaint to make. How much longer do we have to wait?

This isn't what I ordered.

I want a refund. This is the receipt.

I've had enough of it.

I'm about to explode!

Asking for an action

Would you please…?

I hope you could take measures as soon as possible.

I shall wait for your feedback.

… is needed.

I hope you can fix the situation.

I suggest you…

Responding to a complaint

We'll get it fixed as soon as we can.

Oh, sorry. But do you want to change it for another one?

We are terribly sorry for the inconvenience and discomfort caused by this.

We have taken measures and it is expected to be settled soon.

The report has been submitted and please be patient to wait for two work days.

The maintenance crew is on their way and they will contact you.

Part Two Active Reading

Widely considered as one of the most influential architects and urban planners of the 20th century, Le Corbusier has changed the face of modern architecture and urban skyline. He believed that a rationally planned city, using the standardized housing types he had developed, could offer a healthy and humane living environment for people of the technological age. Many of his ideas on urban living became the blueprint for post-war reconstruction, and the many failures of his would-be imitators led to Le Corbusier being blamed for the problems of Western cities in the 1970s. Corbusier was both credited with and criticized for his reinvention of the modern urban skyline.

Le Corbusier

Le Corbusier (1887–1965) is widely regarded as the most important architect of the 20th century. As a gifted architect, provocative writer, divisive urban planner, talented painter, and unparalleled polemicist, Le Corbusier was able to influence some of the world's most powerful figures, leaving an indelible mark on architecture that can be seen in almost any city worldwide.

Le Corbusier was the pseudonym of Charles-Édouard Jeanneret. He was born in the small Swiss city of La Chaux-de-Fonds. After studying architecture in his hometown, the young Jeanneret rejected the provincial atmosphere of Chaux-de-Fonds, traveling to Italy and then on to Budapest and Vienna. He finally came to Paris and spent some time working for a French firm, where he came into contact with some proto-modernist ideas of a couple of industrial designers. The engineer's ethic of mass production, logic design, and function over style became principles which he stuck to in his later design.

He returned to Switzerland to teach and remained there throughout the First World War. In 1914–15 he developed his first major theoretical work, the *Dom-Ino House*. This kind of house, as he envisaged, would be an affordable, prefabricated system. This house would be made of reinforced concrete and was intended for mass production, but was also flexible: none of the walls were load-bearing and so the interior could be re-arranged as the occupant wished.

After the war, Le Corbusier returned to Paris, where he began an architectural practice. He developed the manifesto of "Purism"—Purist rules would lead the architect always to refine and simplify design, dispensing with ornamentation. Architecture would be as efficient as a factory assembly line.

It was in *L'Esprit Nouveau* that Le Corbusier first developed his famous "five points of

architecture", which can be briefly summarized as follows:

Raise the building on "pilotis", freeing the walls of their structural function.

With the walls freed of their structural role, a free plan should be employed.

Similarly, the facade should be designed freely.

The horizontal ribbon window, enabled by the free facade, should be used to light rooms evenly.

The roof should be flat and host a roof garden, replacing the ground space that is occupied by the building.

In 1923, Le Corbusier published his seminal book *Towards a New Architecture*. In this book he elucidated his vision for architecture inspired by the emerging modern era. It was here that he proclaimed the house as a "machine for living in", summarizing his early approach to design and defining the fundamental attitude of modernist architecture.

Of the many structures completed by Le Corbusier in his early period, none is more successful in demonstrating his five points of architecture than the Villa Savoye, completed in 1931. Raising the main living spaces off the ground, the lowest floor features a swooping curve designed to accommodate the turning circle of a car, while the roof can be accessed by a ramp.

During the 1930s and the Second World War, Le Corbusier completed fewer buildings than in his fertile early years, but the end of the war saw an explosion in commissions. It was in this period of around 15 years that Le Corbusier completed many of his most admired works, including the Unité d'habition in Marseille, the chapel of Notre Dame du Haut in Ronchamp, and the Carpenter Center for the Visual Arts, his only building in the United States.

Throughout his career, alongside his architectural work Le Corbusier was a fierce and radical campaigner for new visions of modernist urban planning. Like his early architectural work, Le Corbusier's urban designs focused on purely functional design and gave great primacy to the automobile.

Using his power as a key member of the Congrès Internationaux d'Architecture Moderne, Le Corbusier presented his principles for the functional city in his *Athens Charter*. The *Athens Charter* became a foundational document for modern city planning, and in Le Corbusier's name cities all over the world were modernized—replacing traditional, organic and often impoverished neighborhoods with high-rise modernist social housing blocks, to varying degrees of success.

Le Corbusier's influence on contemporary architecture is immeasurable. He helped to form the basis of almost all modernist architecture and urban planning, with almost all contemporary theory essentially acting as a continuation of, or a rejection of, his ideals. Beyond that, he established the very way in which architecture is now practiced. Le Corbusier can be seen as an "architect-polemicist" who helped lay the groundwork for current figures such as Rem Koolhaas to emerge.

New Words

rationally	['ræʃnəli]	adv. 理性地
skyline	['skaɪlaɪn]	n. 天际线
standardize	['stændədaɪz]	vt. 标准化
provocative	[prə'vɑːkətɪv]	adj. 激发感情（或行动）的；令人振奋的
divisive	[dɪ'vaɪsɪv]	adj. 区分的；造成不和的
polemicist	[pə'lemɪsɪst]	n. 善辩论者；辩论家
indelible	[ɪn'deləbl]	adj. 难忘的；擦不掉的
pseudonym	['suːdənɪm]	n. 笔名；假名
ethic	['eθɪk]	adj. 伦理的，道德的
envisage	[ɪn'vɪzɪdʒ]	vt. 正视，重视
prefabricated	[ˌpriː'fæbrɪkeɪtɪd]	adj.（建筑物）预制的；组装的
occupant	['ɑːkjəpənt]	n. 居住者；占有者
ornamentation	[ˌɔːrnəmen'teɪʃn]	n. 装饰物
facade	[fə'sɑːd]	n. 建筑的正面
elucidate	[i'luːsɪdeɪt]	vt. 阐明，说明
swooping	['swuːpɪŋ]	adj.（表面）陡斜的
ramp	[ræmp]	n. 斜坡，坡道
campaigner	[kæm'peɪnər]	n. 斗士；老兵；参加者
impoverished	[ɪm'pɑːvərɪʃt]	adj. 无趣的；穷困的

Useful Expressions

come into contact with	接触到；联系
lay the groundwork for	为……奠定基础
dispense with	免除；没有……也行

Proper Names and Cultural Notes

Le Corbusier	勒·柯布西耶，20世纪最著名的建筑大师、城市规划家和作家，是现代主义建筑的主要倡导者，被称为"功能主义之父"。
La Chaux-de-Fonds	拉绍德封，位于瑞士西北部，汝拉山脚的法国边境附近，整个城市布局像棋盘一样，整齐有序。是连接纳沙泰尔、比尔、汝拉地区的交通枢纽，也是瑞士钟表的发展中心。
Budapest	布达佩斯，匈牙利首都
Dom-Ino House	多米诺系统，柯布西耶对空间的解放基于框架结构承重这一技术手段的支持之上。柯布西耶于1914年构想

Unit 4
The Man Who Reinvented World Urban Skyline

	出"多米诺系统",用钢筋混凝土柱承重,取代了承重墙结构。建筑师可以随意划分室内空间,设计出室内空间连通流动、室内外空间交融的建筑作品。
Unité d'habition in Marseille	马赛公寓,1952年在法国马赛市郊建成了一座举世瞩目的超级公寓住宅,它像一座方便的小城,被人们称为"马赛公寓"。该公寓是柯布西耶著名的设计作品之一。
Congrès Internationaux d'Architecture Moderne	国际现代派建筑师的国际组织,缩写为C.I.A.M.,1928年在瑞士成立,柯布西耶为其发起人之一。
Athens Charter	《雅典宪章》,即国际建筑协会(C.I.A.M.)于1933年8月在雅典会议上制定的一份关于城市规划的纲领性文件——《城市规划大纲》。
Rem Koolhaas	雷姆·库哈斯,1944年出生于荷兰鹿特丹,建筑师,OMA的首席设计师,哈佛大学设计研究所建筑与城市规划学教授。

Reading Comprehension

Task 1 Read the text and answer the following questions.

1. How is Le Corbusier's influence shown in architecture?
2. What did Le Corbusier learn when he was working for a French firm in Paris?
3. What was the "Dom-Ino House" like?
4. What was the manifesto of "Purism"?
5. What was Le Corbusier's "five points of architecture"?

Task 2 Read the text and choose the best answer to the questions.

1. Le Corbusier traveled to Italy and then to Budapest and Vienna when he was young because _____.
 A. he wanted to try another living style
 B. he rejected the provincial atmosphere of Chaux-de-Fonds
 C. he needed to attend school in other countries
 D. he wanted to earn more money
2. Where was Le Corbusier throughout the First World War?
 A. Budapest. B. Italy.
 C. Switzerland. D. Vienna.

3. Which of the following is NOT the feature of the Villa Savoye?
 A. The lowest floor raises the main living spaces off the ground.
 B. The lowest floor features a swooping curve designed to accommodate the turning circle of a car.
 C. The roof can be accessed by a ramp.
 D. The interior decoration is luxurious.
4. Le Corbusier's influence on contemporary architecture is immeasurable, including _____.
 A. helping to form the basis of almost all modernist architecture and rural planning
 B. establishing the very way in which architecture is now practiced
 C. reviving the architecture style in Romantic times
 D. helping lay the groundwork for current figures such as Santiago Calatrava to emerge

Language in Use

Task 1 Match the underlined words in Column I with their corresponding meanings in Column II.

I	II
1. He is a gifted architect, provocative writer, divisive urban planner, talented painter, and unparalleled polemicist.	A. someone who lives at a particular place for a prolonged period or who was born there
2. The engineer's ethic of mass production, logic design, and function over style became principles which he stuck to in his later design.	B. serving or tending to provoke, excite, or stimulate
3. This kind of house, as he envisaged, would be an affordable, and prefabricated system.	C. imagined that it is true, real, or likely to happen
4. Purist rules would lead the architect always to refine and simplify design.	D. an idea or moral belief that influences the behavior, attitudes, and philosophy of a group of people
5. The interior could be re-arranged as the occupant wished.	E. pieces of work that someone is asked to do and is paid for
6. The horizontal ribbon window, enabled by the free facade, should be used to light rooms evenly.	F. explained something to make it easier to understand
7. In this book he elucidated his vision for architecture inspired by the emerging modern era.	G. designed for or capable of a particular function or use
8. Le Corbusier's urban designs focused on purely functional design and gave great primacy to the automobile.	H. parallel to or in the plane of the horizon or a base line

Unit 4
The Man Who Reinvented World Urban Skyline

9. The end of the war saw an explosion in commissions.

10. Le Corbusier presented his principles for the functional city in his *Athens Charter*.

I. to make it clear and easy to understand; to remove the complex things to make it easier

J. the state of being first in importance

Task 2 Fill in the blanks with the correct form of the words given below.

| foundation | radical | architecture | measurable | continue |
| modern | presentation | establish | various | replace |

Throughout his career, alongside his architectural work Le Corbusier was a fierce and 1._____ campaigner for new visions of modernist urban planning. Like his early 2._____ work, Le Corbusier's urban designs focused on purely functional design and gave great primacy to the automobile.

Using his power as a key member of the Congrès Internationaux d'Architecture Moderne, Le Corbusier 3._____ his principles for the functional city in his *Athens Charter*. The *Athens Charter* became a 4._____ document for modern city planning, and in Le Corbusier's name cities all over the world were modernized—5._____ traditional, organic and often impoverished neighborhoods with high-rise modernist social housing blocks, to 6._____ degrees of success.

Le Corbusier's influence on contemporary architecture is 7._____. He helped to form the basis of almost all 8._____ architecture and urban planning, with almost all contemporary theory essentially acting as a 9._____ of, or a rejection of, his ideals. Beyond that, he 10._____ the very way in which architecture is now practiced. Le Corbusier can be seen as an "architect-polemicist" who helped lay the groundwork for current figures such as Rem Koolhaas to emerge.

Task 3 Translate the following sentences into English.

1. 勒·柯布西耶影响了世界上一些最伟大的建筑设计师，几乎在世界所有城市都留下了不可思议的建筑痕迹。（leave a mark on）
2. 他终于来到了巴黎，在一家法国公司工作，就是在那里，他接触到了几位工业设计师的原初现代派观点。（come into contact with）
3. 他设想，这种房子将会是一个人们支付得起的预制构件系统。（prefabricated）
4. 以勒·柯布西耶的名义，世界上所有的城市都变得现代化了——原来传统的、有机的，并且时常是贫困的街区，在不同程度上变成了高耸的现代化的社会住宅大厦。（impoverished）
5. 他帮助建构了所有现代化建筑和城市规划的基础，当代所有建筑理论几乎都是他的思想的延续或反叛。（a continuation of; or a rejection of）

Text B

Ronchamp

In the commune of Ronchamp, slightly south of east of Paris, sits one of Le Corbusier's most unusual projects of his career, Notre Dame du Ronchamp, or more commonly referred to as Ronchamp. In 1950, Le Corbusier was commissioned to design a new Catholic church to replace the previous church that had been destroyed during World War II.

The site of Ronchamp has long been a religious site of pilgrimage that was deeply rooted in Catholic tradition, but after World War II, the church wanted a pure space void of extravagant detail and ornate religious figures unlike its predecessors. In 1950, when Corbusier was commissioned to design Ronchamp, the church reformists wanted to clear their name of the decadence and ornamental past by embracing modern art and architecture. Spatial purity was one of Corbusier's main focuses.

Corbusier wanted the space to be meditative and reflective on purpose. The stark white walls add to this purist mentality that when the light enters into the chapel there assumes a kind of washed-out, ethereal atmosphere. The effect of the light evokes expressive and emotional qualities that create heightened sensations in tune with the religious activities.

Ronchamp sits among a wooded terrain secluded from the rest of the commune; the chapel is placed atop a hill on the site setting itself on a metaphorical pedestal. Unlike most of Corbusier's other works consisting of boxy, functional, and sterile volumes, Ronchamp is more of an irregular sculptural form where the walls, the roof, and the floor slope. Stylistically and formally it is fairly complex; however, programmatically it is relatively simple: two entrances, an altar, and three chapels.

The walls of Ronchamp give the building its sculptural character. The thick, gentle curving walls act as a practical method of supporting the concrete and masonry construction, as well as the massive curvilinear roof. However, the walls do not solely act as structural and sculptural elements; they also act as acoustic amplifiers.

The most striking part of Ronchamp is the curved roof that peels up towards the heavens. The curving roof appears to float above the building as it is supported by embedded columns in the walls, which creates a 10 cm gap between the roof and the walls, and which allows for a sliver of clerestory light. The roof is actually the only glimpse of mechanized influence in the overall design of Ronchamp; the roof's curvature mimics the curves of an airplane wing. It's aerodynamic in design and with all of its massive and heavy qualities, it still appears weightless.

One of the most interesting aspects of the design is the sporadic window placement on the walls. Corbusier implemented small puncturing apertures on the facade that amplified the light within the chapel by tapering the window well in the wall cavity. Each wall becomes illuminated

by these differing window frames, which in conjunction with the stark white washed walls gives the walls luminous qualities punctuated by a more intense direct light. On the wall behind the altar in the chapel, the lighting effects create a speckled pattern, almost like a starry night, of sparse openings that are complimented by a larger opening above the cross that emits a flood of light, creating a powerful religious image as well as a transformative experience.

From the field below Ronchamp, the curving walls and roof are what define the chapel formally. It appears as if it is growing directly from the hill itself, as the curve of the roof seems to be a mirror of the curve that the chapel sits on. However, once inside, the curving walls and roof no longer define the pure essence of the project, rather, the light is what defines and gives meaning to the chapel experientially.

Even though Ronchamp was a radical derivation from Le Corbusier's other works, it still maintains some of the same principles of purity, openness and communal sense of coming together. Ronchamp was less of a move away from the mechanistic and international style, as it was more of a contextual response to a religious site. Ronchamp is an architecture rooted in context that is based on modern principles, which makes Ronchamp one of the most interesting buildings of the 20th century and of Le Corbusier's career.

New Words

		
commune	[ˈkɑːmjuːn]	n. 群居团体；公社
pilgrimage	[ˈpɪlɡrɪmɪdʒ]	n. 朝圣之行；漫游
extravagant	[ɪkˈstrævəɡənt]	adj. 奢侈的；过度的
decadence	[ˈdekədəns]	n. 堕落，颓废；衰落
meditative	[ˈmedɪteɪtɪv]	adj. 冥想的，沉思的
chapel	[ˈtʃæpl]	n. 小礼拜堂，小教堂
ethereal	[iˈθɪriəl]	adj. 优雅的；缥缈的；超凡的
sterile	[ˈsterəl]	adj. 枯燥乏味的
masonry	[ˈmeɪsənri]	n. 石造建筑
curvilinear	[ˌkɜːrvɪˈlɪniər]	adj. 曲线的；由曲线组成的（亦作 curvilineal）
acoustic	[əˈkuːstɪk]	adj. 声学的；音响的；听觉的
amplifier	[ˈæmplɪfaɪər]	n. 放大器；扩音器
clerestory	[ˈklɪrstɔːri]	n. 天窗；长廊
mimic	[ˈmɪmɪk]	vt. 模仿，模拟
aerodynamic	[ˌeroʊdaɪˈnæmɪk]	adj. 空气动力学的
sporadic	[spəˈrædɪk]	adj. 零星的；分散的
aperture	[ˈæpərtʃər]	n. 孔，穴
amplify	[ˈæmplɪfaɪ]	vt. 放大，扩大；增强

taper	['teɪpər]	vt. 逐渐减少
cavity	['kævəti]	n. 腔；洞，凹处
luminous	['luːmɪnəs]	adj. 发光的；明亮的
emit	[i'mɪt]	vt. 发出；放射
derivation	[ˌderɪ'veɪʃn]	n. 引出物，派生物；转成物
contextual	[kən'tekstʃuəl]	adj. 前后关系的

Useful Expressions

be commissioned to do	被委任做某事
in tune with	与……一致；与……协调
in conjunction with	连同，共同；与……协力

Proper Names and Cultural Notes

| Notre Dame du Ronchamp | 朗香教堂，又译为洪尚教堂，位于法国东部索恩地区距瑞士边界几英里的浮日山区，坐落于一座小山顶上，1950—1953 年由法国建筑大师勒·柯布西耶设计建造，1955 年落成。与天主教哥特式教堂不同，朗香教堂在设计上采用了弯曲的墙面、沉重而翻卷的屋顶、带形空隙、矩形窗洞等几何构图元素，与现代绘画领域的立体主义相呼应。朗香教堂的设计对现代建筑的发展产生了重要影响，被誉为 20 世纪最为震撼、最具有表现力的建筑。 |

Reading Comprehension

 Task 1 Read the text and answer the following questions.

1. Where is the Notre Dame du Ronchamp?
2. Who was commissioned to design Ronchamp?
3. In what aspects is Ronchamp different from Corbusier's other works consisting of boxy, functional, and sterile volumes?
4. What is the most interesting aspect of the design of Ronchamp?
5. Does Ronchamp maintain the architect's usual principles?

Unit 4
The Man Who Reinvented World Urban Skyline

Task 2 Read the text and decide whether each of the following statements is true or false.

1. The site of Ronchamp has long been a religious site of pilgrimage that was deeply rooted in Islamic tradition, but after World War II, the church wanted a pure space void of extravagant detail and ornate religious figures unlike its predecessors.
2. Stylistically and formally it is fairly complex; however, programmatically it is relatively simple: two entrances, an altar, and three chapels.
3. The most striking part of Ronchamp is the curved roof that peels up towards the heavens. The portrait of Madame Matisse was produced in Matisse's Fauvist period.
4. From the field below Ronchamp, the plane walls and roof are what define the chapel formally.
5. Ronchamp is an architecture rooted in context that is based on modern principles, which makes Ronchamp one of the most interesting buildings of the 20th century and of Le Corbusier's career.

Language in Use

Task 1 Match the underlined words in Column I with their corresponding meanings in Column II.

I	II
1. In the commune of Ronchamp, slightly south of east of Paris, sits one of Le Corbusier's most unusual projects of his career.	A. a journey to a holy place for religious reasons
2. The site of Ronchamp has long been a religious site of pilgrimage that was deeply rooted in Catholic tradition.	B. enclosed firmly in a surrounding mass
3. The stark white walls add to this purist mentality.	C. a device that controls amount of light admitted
4. Ronchamp is more of an irregular sculptural form where the walls, the roof, and the floor slope.	D. a group of people who live together and share everything
5. The thick, gentle curving walls act as a practical method of supporting the concrete and masonry construction.	E. bricks or pieces of stone which have been stuck together with cement as part of a wall or building
6. The curving roof appears to float above the building as it is supported by embedded columns in the walls.	F. one's attitude and way of thinking
7. Corbusier implemented small puncturing apertures on the facade.	G. the most essential or most vital part of some idea or experience

8. Each wall becomes <u>illuminated</u> by these differing window frames.
9. The curving walls and roof no longer define the pure <u>essence</u> of the project.
10. It still maintains some of the same principles of <u>purity</u>.

H. not occurring at expected times
I. the quality of being undiluted or unmixed with extraneous material
J. shone light on it; made it brighter

Task 2 Fill in the blanks with the correct form of the words given below.

| mass | curve | embed | compliment | speckle |
| implement | different | mechanic | religion | luminous |

The most striking part of Ronchamp is the **1.**_____ roof that peels up towards the heavens. The curving roof appears to float above the building as it is supported by **2.**_____ columns in the walls, which creates a 10 cm gap between the roof and the walls and which allow for a sliver of clerestory light. The roof is actually the only glimpse of **3.**_____ influence in the overall design of Ronchamp; the roof's curvature mimics the curves of an airplane wing. It is aerodynamic in design and with all of its **4.**_____ and heavy qualities, it still appears weightless.

One of the most interesting aspects of the design is the sporadic window placement on the walls. Corbusier **5.**_____ small puncturing apertures on the facade that amplified the light within the chapel by tapering the window well in the wall cavity. Each wall becomes illuminated by these **6.**_____ window frames, which in conjunction with the stark white washed walls gives the walls **7.**_____ qualities punctuated by a more intense direct light. On the wall behind the altar in the chapel, the lighting effects create a **8.**_____ pattern, almost like a starry night, of sparse openings that are **9.**_____ by a larger opening above the cross that emits a flood of light, creating a powerful **10.**_____ image as well as a transformative experience.

Task 3 Translate the following sentences into Chinese.

1. In 1950, Le Corbusier was commissioned to design a new Catholic church to replace the previous church that had been destroyed during World War II.
2. Spatial purity was one of Corbusier's main focuses.
3. Corbusier wanted the space to be meditative and reflective on purpose.
4. However, the walls do not solely act as structural and sculptural elements; they also act as acoustic amplifiers.
5. Ronchamp is an architecture rooted in context that is based on modern principles, which makes Ronchamp one of the most interesting buildings of the 20th century and of Le Corbusier's career.

Part Three Practical Writing

Letters of Complaint

One of the essential Business English skills is to write a letter of complaint.

It is a difficult task to get perfectly right because you have to make sure that you remain sounding calm and polite, but at the same time you also want to show to the reader that you are angry (or at least dissatisfied and not happy) and want some action to be taken to resolve the problem. To be proper in Business English, your writing should be in a formal style, with all the appropriate phrases and correct vocabulary.

It is very easy to get lost in your emotion because you keep thinking about the bad service that you received and then your writing will become too aggressive or sarcastic.

 Task 1 **Fill in the boxes with the corresponding components of a letter of complaint marked from A to F.**

A. What would you like them to do?
B. Who are you writing to (be specific)?
C. When/How do you want them to respond?
D. Why are you complaining? Why are you unhappy with the company?
E. What is the purpose of your letter?
F. What evidence do you have?

Dear Mr Black:

Following our telephone conversation earlier today, I am writing to give details of my dissatisfaction with my stay at the New Hotel, Los Christianos, Tenerife, on 10-18 August 2010, which I booked with your company for me and my family.

My central complaint is that the hotel fell far short of the description in the brochure. We had booked two double suites, in rooms 213 and 214. Although the rooms were billed as four-star accommodation, they were very cramped, and the furnishings were worn and dirty. In addition, the shower in room 213 did not work. The hotel's grounds, descibed in the brochure as "pleasant, tranquil, and spacious", were in fact bordered on two sides by a very busy main road. The swimming pool was closed the entire week for repairs.

When we spoke to your representative, Tracey Mills, she promised to try to get the shower fixed, but this took an unacceptably long time to happen—three days from when we first complained. I asked her to fill out an accommodation report form detailing these issues and I enclose a copy for your information, together with photos of the bedrooms and the hotel grounds.

As I stated in my telephone call, I feel that we are due a full refund for this hotel stay as it failed to meet the description in the brochure, and it ruined our holiday. I am looking forward to hearing from you within the next two weeks.

Sincerely yours,

Maria Johnson

Task 2 **Write a letter of complaint according to the given situation.**

You bought a blackout shade for your bedroom window and the technician installed the device for you. But later it didn't work well. The technician came but the problem wasn't permanently solved, so you need the staff to provide help again. However, this time, the service was not guaranteed. You want to write a letter to the company to complain about the service.

Unit 5
Industrial Designer Raymond Loewy

Part One Listening and Speaking

Task 1 Listen to a conversation between the mother and the son and answer the questions.

Questions:

1. Where does the son want to go and why?
2. Why does the mother not allow Alex to go at first?
3. What's Raymond Loewy?
4. What is the status of Raymond Loewy in the areas of design?
5. Does the mother allow Alex to go in the end? Why?

Task 2 Alice wants to borrow the company bus for an exhibition. Now she is talking with her colleague Phil. Listen to their conversation and fill in the blanks with what you hear.

Alice: I was wondering if I could borrow the company Greyhound bus for an exhibition of **1.**_____ this weekend.

Phil: Sure, I think that would be possible. Where is the exhibition?

Alice: It is in the park **2.**_____.

Phil: Would you need it for both Saturday and Sunday?

Alice: We will need it for Sunday only.

Phil: Well, who will be driving the bus?

Alice: John and Frank will be driving it.

Phil: Could you **3.**_____ in the company parking lot before 9 o'clock on Monday morning?

Alice: Sure, no problem. Can we **4.**_____ the bus body with some **5.**_____ 3D paintings?

Phil: Yes, that would be fine. Just make sure that they are ripped off when it is returned.

Alice: We can do that. We will clean the bus after the exhibition. We also would like to set up the **6.**_____ of the bus. Would that be OK?

Phil: OK, but make sure that everything is back by Monday morning **7.**_____.

Unit 5
Industrial Designer Raymond Loewy

 Task 3 Role-play a conversation in pairs according to the following situation: Paul needs to ask his boss for permission to leave work early the next day. You may refer to the expressions below.

Useful Expressions

Asking for permission

Can I…, please?

Could I…, please?

May I…, please?

Do/Would you mind if…?

Is it OK if…?

Would it be all right if…?

Would it be a problem if…?

I wonder if I could…

If you don't mind, I'd like to…

Would it bother you if I…?

Giving permission

Yes, please do.

Yes, of course.

Sure, go ahead.

Sure.

Certainly.

No problem.

Please feel free.

By all means.

I can't see any objections.

You can if you want.

You have my permission.

Rejecting a request

No, please don't.

I'm afraid it is not possible.

I'm sorry, but that's not possible.

I'm afraid, but you can't.

I'm refusing.

I'm sorry, I cannot let you…

I'm sorry. I don't have the authority to let you…

I would prefer that you didn't.

I really wish you wouldn't.

Permission will not be granted.

Part Two Active Reading

Raymond Loewy is known as the "father of streamlining" and the "father of industrial design". From lipsticks to locomotives, Raymond Loewy and his industrial design firm created some of the most important design innovations in the 20th century. At once an engineer and a visionary, this master designer integrated artistic movement into his designs in an American way. Indeed, his drawings of the Coca Cola truck, the Greyhound bus, the package of Lucky Strike cigarettes, the Studebacker automobile, and the bullet-nose train molded our vision of 20th-century American iconography. Raymond Loewy shaped the image of an entire nation with his pencil strokes.

Raymond Loewy, the Man Who Gave Coca-Cola a Modern Look

Raymond Loewy, the world-renowned industrial designer, achieved fame for the magnitude of his design efforts across a variety of industries. At once an engineer and a visionary, this master designer integrated artistic movement into his designs in an American way. Raymond Loewy, who was noted for his graceful and clean aerodynamic designs, is often called the "father of modern design", and he played a significant role in the design of many of the classic items in the 20th century. Indeed, his drawings of the Coca Cola truck and vending machines, the Greyhound bus, the package of Lucky Strike cigarettes, the Studebacker automobile, the bullet-nose train, the logos of the Shell, the Exxon, etc., molded our vision of 20th-century American iconography.

Unit 5
Industrial Designer Raymond Loewy

Raymond Loewy was born in France. After completing his engineering studies at the Université de Paris and École de Laneau, he emigrated to the US in 1919. He first worked in New York as a shop window decorator; in 1929 he opened his own design firm.

Loewy was one of the most brilliant designers. He designed fluid and cutting-edge forms for a great many basic household goods and appliances, including refrigerators, vacuum cleaners, radios, cameras, and telephones. He also designed locomotives for the Pennsylvania Railroad Company as well as vehicles such as the "Hupmobile" for the Hupp Motor Company, the Studebaker "Champion", and the iconic Greyhound buses. The "Coldspot" refrigerator Loewy designed in 1934 is believed to be the first household appliance to be advertized for its good look rather than its performance.

Loewy's fundamental principle for product design was to free the outer casing from the mechanism inside and give the appliance an attractive appearance. Starting with vehicle design, where streamlined form is required to maximize speed and reduce wind resistance, Loewy proceeded to apply this design principle to all products. Loewy was also active as a design consultant who created corporate images of numerous firms. From 1935 Raymond Loewy received several commissions for redesigning large department stores. He designed new packaging for Lucky Strike cigarettes, the Coca Cola and Shell logos.

Loewy played a role in the design of some classics for the Coca-Cola Company. The company first hired Loewy to modernize its vending equipment, but he also worked on several items that are now considered classics, from the streamlined cooler to the Dole Deluxe fountain dispenser to the Hobbs truck body. Many people have mistakenly attributed the bottle design to Loewy. In fact, he did not play a role in the design of the original 1915 bottle, which was created by the Root Glass Company, but he was part of a team that created the King Size and Family Size packages in 1955 and worked to slenderize the quart-size package in the 1960s. Loewy did share his thoughts on the iconic bottle. In a letter from Loewy to the Coca-Cola Company, he described the contour bottle, saying, "The Coke Bottle is a masterpiece of scientific, functional planning. In simpler terms, I would describe the bottle as well thought out, logical, sparing of material and pleasant to look at. The most perfect 'fluid wrapper' of the day and one of the classics in packaging history."

Loewy's design philosophy is not a deeply intellectual one. He summarized it with the acronym MAYA (most advanced, yet acceptable). The proliferation of clean, functional, and dynamic products that emerged from the Loewy offices throughout his long career provides testimony to his success in correctly making the prediction "most advanced, yet acceptable".

It is difficult to measure precisely Loewy's impact on our contemporary environment, but he has certainly had a dynamic and significant one. His continuing vitality and international influence are demonstrated by his being retained as a major industrial design consultant in the 1970's by the government of the Soviet Union—this as he entered his eighties.

New Words

streamline	['striːmlaɪn]	vt. 把……做成流线型；使现代化；组织；使合理化；使简单化 n. 流线；流线型 adj. 流线型的
locomotive	[ˌloukə'moutɪv]	n. 机车；火车头 adj. 火车头的；运动的，移动的
innovation	[ˌɪnə'veɪʃn]	n. 创新，革新；新方法
visionary	['vɪʒəneri]	n. 空想家；梦想者；有眼力的人 adj. 梦想的；幻影的
integrate	['ɪntɪɡreɪt]	vt. 整合，使……成整体
iconography	[ˌaɪkə'nɑːɡrəfɪ]	n. 肖像研究；肖像学；图解
stroke	[strouk]	n. 笔画；（游泳或划船的）划；中风；（打、击等的）一下
renowned	[rɪ'naund]	adj. 著名的；有声望的
magnitude	['mæɡnɪtuːd]	n. 重要；大小；量级；（地震）震级
package	['pækɪdʒ]	n. 包；包裹 vt. 打包；将……包装
automobile	['ɔːtəməbiːl]	n. 汽车
mold	[mould]	vt. 塑造；使发霉；用模子制作 vi. 发霉
fluid	['fluːɪd]	adj. 流动的；流畅的；不固定的 n. 流体；液体
cutting-edge	[ˌkʌtɪŋ'edʒ]	adj. 先进的；尖端的 n. 尖端；前沿；（刀片的）刃口
vacuum	['vækjuəm]	n. 真空；空间；真空吸尘器 adj. 真空的
fundamental	[ˌfʌndə'mentl]	adj. 基本的；根本的 n. 基本原理，基本原则
resistance	[rɪ'zɪstəns]	n. 阻力；电阻；抵抗，反抗；抵抗力
proceed	[prou'siːd]	vi. 开始；继续进行；发生；行进 n. 收入，获利
consultant	[kən'sʌltənt]	n. 顾问；咨询者；会诊医生
commission	[kə'mɪʃn]	n. 佣金；委员会；委任；委任状 vt. 委任；使服役
dispenser	[dɪ'spensər]	n. 药剂师；施与者；分配者；自动售货机
attribute	[ə'trɪbjuːt]	vt. 归属，把……归于 n. 属性，特质
slenderize	['slendəˌraɪz]	vt. 使苗条；使成细长状
quart	[kwɔːrt]	n. 夸脱（容量单位）；一夸脱的容器
contour	['kɑːntʊr]	n. 轮廓；等高线；周线；电路；概要 vt. 画轮廓；画等高线
masterpiece	['mæstərpiːs]	n. 杰作；绝无仅有的人
sparing	['sperɪŋ]	adj. 节约的；贫乏的；保守的 n. 抽出；宽恕；免去；给予（spare 的现在分词形式）
acronym	['ækrənɪm]	n. 首字母缩略词
proliferation	[prəˌlɪfə'reɪʃn]	n. 增殖；扩散；分芽繁殖
dynamic	[daɪ'næmɪk]	adj. 有活力的；动态的；动力的；动力学的 n. 动态；动力

Unit 5
Industrial Designer Raymond Loewy

emerge	[ɪˈmɜːrdʒ]	vi. 浮现；摆脱；暴露
testimony	[ˈtestɪmoʊnɪ]	n. [法] 证词，证言；证据
vitality	[vaɪˈtælətɪ]	n. 活力，生气；生命力；生动性
demonstrate	[ˈdemənstreɪt]	vt. 证明；展示；论证 vi. 示威
retain	[rɪˈteɪn]	vt. 保持；记住

Useful Expressions

integrate into	成为一体，融入，使……并入
be noted for	以……闻名或著称
free... from	使摆脱；免于；解放
attribute... to	把……归因于
well thought out	经过周详考虑的；精心设计的；妥当的
emerge from	自……出现，从……显露出来

Proper Names and Cultural Notes

Raymond Loewy	雷蒙德·洛威，20世纪最著名的美国工业设计师之一，美国工业设计奠基人，在平面设计与企业识别系统设计上也颇有成就。
Greyhound	灰狗长途巴士，又名灰狗巴士，是美国跨城市的长途商营巴士，客运远及美国各州甚至加拿大的某些城市。1914年营业，公司总部在得克萨斯州达拉斯市。
Lucky Strike	美国好彩香烟，以传统美式方法制成，好彩香烟盒采用绿、红两色相间的包装设计。鲜明的美国形象及悦目红圈商标，使其成为美国烟草公司的一级牌号。
Studebaker	斯蒂旁克（汽车品牌），是一家美国汽车制造商，也为军队设计制造过装甲车辆。该公司由德国移民创建于1852年，1966年倒闭。
Shell	壳牌，目前世界第一大石油公司，总部位于荷兰海牙和英国伦敦，由荷兰皇家石油与英国壳牌两家公司合并组成。
Exxon	埃克森美孚公司（Exxon Mobil Corporation），世界最大的非政府石油天然气生产商，总部设在美国得克萨斯州爱文市。
Université de Paris	巴黎大学，欧洲最古老的大学之一，坐落在法国首都巴黎。1968年法国学生左翼运动之后，巴黎大学被拆分成13所独立的大学。

Hupmobile	休普莫拜尔小汽车，是获誉美国汽车阶层好评的首批车型之一，标志着对老式汽车的重大突破。
Coldspot	冰点冰箱，1934年洛威为冰点冰箱设计了新的外形，采用大圆弧与弧形，奠定了现代冰箱的基础。
fountain dispenser	汽水出售机

Reading Comprehension

Task 1 Read the text and answer the following questions.

1. What role does Raymond Loewy play in industrial design?
2. What was Raymond Loewy renowned for?
3. What was Loewy's fundamental principle for product design?
4. How did Loewy contribute to the design for the Coca-Cola Company?
5. What is Loewy's impact on the contemporary environment?

Task 2 Read the text and choose the best answer to the questions.

1. Which one of the following is NOT a design by Loewy?
 A. "Coldspot" refrigerator. B. Lucky Strike package.
 C. The logos of the Exxon. D. Coca-Cola bottle.
2. What was the "Coldspot" refrigerator in 1934 advertized for?
 A. Its performance. B. Its reasonable price.
 C. Its stylish look. D. Its popularity.
3. Loewy first applied the design principle of streamlining in his design of _____.
 A. household goods and appliances B. vending machines
 C. package of Lucky Strike cigarettes D. vehicles
4. Loewy's continuing vitality international impact was demonstrated by _____.
 A. being retained as a major industrial design consultant in the 1970's by the government of the Soviet Union at his eighties
 B. opening his own design firm in many countries
 C. creating corporate images for many international firms
 D. integrating international artistic movements into his design

Unit 5
Industrial Designer Raymond Loewy

Language in Use

Task 1 Match the underlined words in Column I with their corresponding meanings in Column II.

I	II
1. Raymond Loewy and his industrial design firm created some of the most important <u>innovations</u> in the 20th century.	A. books, films or songs which are well-known and considered to be of high quality, setting standards for others, etc.
2. He designed <u>fluid</u>, cutting-edge forms for a great many basic household goods and appliances.	B. (formal) (of movements, designs, music, etc.) smooth and elegant
3. His <u>fundamental</u> principle was to free the outer casing from the mechanism inside and give the appliance an attractive appearance.	C. new ideas, ways of doing something, etc. that have been introduced or discovered
4. Loewy <u>proceeded</u> to apply this design principle to all products.	D. serious and very important; affecting the most central and important parts of something
5. Loewy played a role in the design of some <u>classics</u> for the Coca-Cola Company.	E. continued to have something
6. Many people have mistakenly <u>attributed</u> the bottle design to Loewy.	F. believed that someone is responsible for doing something
7. The Coke Bottle is a <u>masterpiece</u> of scientific, functional planning.	G. belonging to the same time or belonging to the present time
8. It is difficult to measure precisely Loewy's impact on our <u>contemporary</u> environment.	H. continued to do something, after having done something else first
9. He was <u>retained</u> as a major industrial design consultant in the 1970's.	I. a work of art such as painting, film, book, etc. that is an excellent, or the best example of the artist's work

Task 2 Fill in the blanks with the correct form of the words given below.

significant	indeed	item	magnitude	mold
package	renown	variety	master	integrate

Raymond Loewy, the **1.** world-_____ industrial designer, achieved fame for the **2.** _____ of his design efforts across a **3.** _____ of industries. At once an engineer and a visionary, this **4.** _____ designer **5.** _____ artistic movement into his designs in an American way. Raymond Loewy, who was noted for his graceful and clean aerodynamic designs, is often called the "father of modern design", and he played a **6.** _____ role in the design of many of the classic **7.** _____ in the 20th century.

8._____, his drawings of the Coca Cola truck and vending machines, the Greyhound bus, the 9._____ of Lucky Strike cigarettes, the Studebacker automobile, the bullet-nose train and the logos of the Shell, the Exxon, etc., 10._____ our vision of 20th-century American iconography.

Task 3 Translate the following sentences into English.

1. 这位设计大师以独具美国特色的方式将艺术运动融入到他的设计当中。（master designer; integrate... into）
2. 雷蒙德·洛威用铅笔勾勒出了整个国家的形象。（shape; image; pencil strokes）
3. 这款冰箱广告展现了其良好的外观而非性能。（be advertized for; rather than）
4. 洛威继续将这一设计原理运用到所有产品中。（proceed）
5. 很难精确衡量洛威对当代设计产生的影响。（contemporary environment）

Text B

Paul Rand

If you haven't heard the name Paul Rand before, it's still possible you are seeing his graphic design work every day. Paul Rand is responsible for creating world-renowned logos for some of the largest corporations. You only need to look at the simplicity of the ABC television logo for American Broadcasting Company or the UPS logo for United Parcel Service. IBM and Westinghouse are classical and semi-timeless logos created by Paul Rand as well.

There is a unique simplicity that carries through the most famous corporate logo designs created by Paul Rand. As he once said, "Simplicity is not the goal. It is the by-product of a good idea and modest expectations." This statement seems fitting of the corporate identities he has helped to create over the years. His basic fundamentals can be found in the most identified corporate logos of today.

Without question, Paul Rand was one of the most influential pioneers of graphic design, well-respected for his uncanny ability to capture the essence of art, business and graphic design. Steve Jobs described him as "an interesting intertwining of a pure artist and somebody that is very astute at solving business problems… If you scratch the surface on any of his works, it is very emotional, and yet, when you study it, you find out the depth of the intellectual problem-solving that has taken place."

How did Rand help transform designers from accessories to mainstays in the business world? Here are a few lessons from the master:

Make a Pretty Picture Book Explaining Your Work to Clients

One of Rand's main strategies for explaining how his designs would help meet a client's

business needs was to write and illustrate beautiful presentation booklets for CEOs. They were "works of art in themselves". These booklets presented a logo design as some kind of rational, logical choice. Not as a science, but they laid out the thought process behind the designs in simple, persuasive language and images. Rand's patience and clear communication with clients helped non-visual thinkers understand the importance of the aesthetic aspects of products and corporate communications.

Channel Contemporary Artists' Styles Even in Corporate Work

Rand's pioneering work in advertising design in the early 1940s helped shift the way businesses approached branding. Rand knew an ad's point was to sell products, but believed that in visually conveying that message, a designer should be artistic. He can take the ideas of Picasso, Jean Arp, and Miro, and apply these fine art principles to the design of everyday objects and ads. As a result, he elevated the field of advertisements. People could look at an ad and have an aesthetic experience. And more compelling advertising, as corporations know well, leads to better business.

Don't Propose Something too Radical

When Thomas Watson Jr. took over IBM in 1956, he was struck by how poorly the company handled corporate design. The aesthetic was inconsistent across various platforms. Watson Jr. started a formal Corporate Design Program, which ultimately hired Paul Rand to design new logo and graphics.

Crucially, Rand didn't revamp IBM's old logo right off the bat—He made it look like a modernized version of the old logo. The bold and blocky letters signified modernity with their minimalism. Once they accepted Rand's new logo, and he got his foot in the door, then he started to modify it. The unusual purple and black stripes didn't come until 1962. "Rand would never propose something too radical on the first day." Soon, the power of IBM convinced other businesses such as Westinghouse, ABC, Cummins, etc., to go the IBM route.

Don't Be Pretentious

In the 1980s, the power of IBM's visual communications program inspired Steve Jobs, a longtime admirer of Rand's work, to hire Rand as a designer for NeXT, his educational computer company. One reason for Rand's success with clients, aside from the sheer beauty of his visual work, was that he was "one of the guys". He wasn't coming into boardrooms acting like an artist. He was very down-to-earth, and fit well into the corporate culture.

In a way, what Apple does today with design is what IBM was doing in the 1950s. It was about simplification and cohesiveness across all platforms of the brand—products, ads, and stores. These are all ideas in the modern vein that came about with Rand's work with IBM. It set a precedent. Now, Apple is perhaps the world's preeminent design-driven company. Everyone knows Apple products, but many people don't know the long history behind that kind of visual communication, or the things that Rand contributed invaluably to that history.

New Words

graphic	['græfɪk]	*adj.* 绘画似的；形象的；图表的
timeless	['taɪmləs]	*adj.* 永恒的；不受时间影响的
by-product	['baɪ prɑːdʌkt]	*n.* 副产品；附带产生的结果；意外收获
uncanny	[ʌn'kænɪ]	*adj.* 神秘的；离奇的；可怕的
capture	['kæptʃər]	*vt.* 俘获；夺得；捕捉；拍摄；录制 *n.* 捕获；战利品；俘虏
essence	['esns]	*n.* 本质，实质；精华；香精
intertwine	[ˌɪntər'twaɪn]	*vi.* 纠缠；编结 *vt.* 缠绕；纠缠
astute	[ə'stuːt]	*adj.* 机敏的；狡猾的，诡计多端的
scratch	[skrætʃ]	*vt.* 抓；刮；挖出；乱涂 *vi.* 抓；搔；发刮擦声 *n.* 擦伤；抓痕；刮擦声；乱写
emotional	[ɪ'moʊʃənl]	*adj.* 感动人的；情绪的；易激动的
transform	[trænsˈfɔːrm]	*vt.* 改变；使……变形；转换 *vi.* 变换；改变；转化
accessory	[ək'sesərɪ]	*n.* 配件；附件 *adj.* 副的；同谋的；附属的
mainstay	['meɪnsteɪ]	*n.* 支柱；中流砥柱；主要的依靠
client	['klaɪənt]	*n.* 客户，顾客；委托人
strategy	['strætədʒɪ]	*n.* 战略，策略
rational	['ræʃənəl]	*adj.* 合理的；理性的 *n.* 有理数
persuasive	[pər'sweɪsɪv]	*adj.* 有说服力的；劝诱的，劝说的
visual	['vɪʒuəl]	*adj.* 视觉的；视力的；栩栩如生的
channel	['tʃænl]	*vt.* 引导，开导；形成河道 *n.* 通道；频道；海峡
pioneering	[ˌpaɪə'nɪrɪŋ]	*adj.* 首创的；先驱的
visually	['vɪʒuəlɪ]	*adv.* 形象化地；外表上；看得见地
elevate	['elɪveɪt]	*vt.* 提升；举起；振奋（情绪等）；提升……的职位
compelling	[kəm'pelɪŋ]	*adj.* 引人注目的；强制的；激发兴趣的 *vt.* 强迫；以强力获得（compel 的现在分词形式）
inconsistent	[ˌɪnkən'sɪstənt]	*adj.* 不一致的；前后矛盾的
ultimately	['ʌltɪmətlɪ]	*adv.* 最后；根本；基本上
crucially	['kruːʃəlɪ]	*adv.* 关键地，至关重要地
revamp	['riːvæmp]	*vt.* 修补；翻新；修改 *n.* 改进
bold	[boʊld]	*adj.* 大胆的；英勇的；黑体的；厚颜无耻的；险峻的
blocky	['blɒkɪ]	*adj.* 块状的；短而结实的；浓淡不均匀的
signify	['sɪɡnɪfaɪ]	*vt.* 表示；意味；预示
minimalism	['mɪnɪməlɪzəm]	*n.* 极简派艺术；最低纲领；极保守行动
modify	['mɒdɪfaɪ]	*vt.* 修改；修饰；更改
stripe	[straɪp]	*n.* 条纹；斑纹；种类

Unit 5
Industrial Designer Raymond Loewy

pretentious	[prɪ'tenʃəs]	adj. 自命不凡的；炫耀的；做作的
sheer	[ʃɪr]	adj. 绝对的；透明的；峻峭的；纯粹的 adv. 完全地；陡峭地
boardroom	['bɔːrdruːm]	n. 会议室；交换场所
down-to-earth	[ˌdaʊn tu ˈɜːrθ]	adj. 实际的；现实的
cohesiveness	[koʊ'hɪːsɪvnəs]	n. 凝聚力；黏结性；内聚力
precedent	['presɪdənt]	n. 先例，前例 adj. 在前的，在先的
preeminent	[ˌprɪ'emɪnənt]	adj. 卓越的，超群的
invaluably	[ɪn'væljʊrblɪ]	adv. 非常贵重地，无价地

Useful Expressions

be responsible for	对……负责；是……的原因
carry through	贯彻；完成；坚持下去
without question	毫无疑问
lay out	展示；安排；花钱；为……划样；提议
off the bat	马上，立刻
get a foot in the door	为了达到一个目的而迈出了第一步
fit into	（使）适合，适应；符合；（使）合乎……的时间/空间；纳入

Proper Names and Cultural Notes

Paul Rand	保罗·兰德（1914—1996），美国艺术总监和平面设计师，他最出名的企业标识设计包括 IBM、UPS、ABC 以及史蒂夫·乔布斯的 NeXT 企业标识。他是美国第一个应用瑞士平面设计风格的商业艺术家，也是杰出的图形设计师、设计教育家。
ABC	美国广播公司（American Broadcasting Corporation, Inc.），美国三大商业广播电视公司之一
UPS	联合包裹速递服务公司（United Parcel Service），世界上最大的快递承运商与包裹递送公司，同时也是运输、物流、资本与电子商务服务的领导者。
IBM	国际商业机器公司（International Business Machines Corporation），总公司在纽约州阿蒙克市。
Westinghouse	西屋公司（Westinghouse Electric Corporation），1886年由威斯汀豪斯在美国宾夕法尼亚州创立。又译威斯汀豪斯公司。

Steve Jobs	史蒂夫·乔布斯（1955—2011），发明家、企业家，美国苹果公司联合创办人。
Jean Arp	让·阿尔普（1887—1966），法国雕塑家、画家、图形艺术家。
Miro	胡安·米罗（Joan Miro，1893—1983），西班牙画家、雕塑家、陶艺家、版画家，超现实主义的代表人物。米罗是和毕加索、达利齐名的20世纪超现实主义绘画大师。
Thomas Watson Jr.	小托马斯·沃森（1914—1993），IBM的开拓者
NeXT	一家电脑公司（后更名为NeXT软件公司），设立在美国加利福尼亚州红木城，由史蒂夫·乔布斯创建，专门制造和开发高等教育和商业市场上的工作站电脑。公司于1996年12月被苹果公司收购。

Reading Comprehension

Task 1 Read the text and answer the following questions.

1. What are Paul Rand's fundamentals in design?
2. How did Rand help transform designers from accessories to mainstays in the business world?
3. How did Rand's designs meet a client's business needs?
4. What was the significance of Rand's pioneering work in advertising design in the early 1940s?
5. Why did Rand win success with the clients?

Task 2 Read the text and decide whether each of the following statements is true or false.

1. BBC television logo is one of Rand's graphic design works.
2. The booklets for the CEOs presented a logo design as some kind of emotional and logical choice.
3. According to Rand, a designer should be artistic to help sell a product in designing the ad.
4. Thomas Watson Jr. appreciated the corporate design of IBM when he took over the company in 1956.
5. Many people don't know Rand's contribution to the history behind visual communication.

Unit 5
Industrial Designer Raymond Loewy

Language in Use

Task 1 Match the underlined words or phrases in Column I with their corresponding meanings in Column II.

I	II
1. There is <u>unique</u> simplicity that carries through the most famous corporate logo designs created by Paul Rand.	A. an official action or decision that has happened in the past and that is seen as an example or a rule to be followed in a similar situation later
2. Paul Rand was well-respected for his ability to capture the <u>essence</u> of art.	B. have been impressed or interested by someone or something
3. Rand's pioneering work in advertising design helped shift the way business <u>approached</u> branding.	C. complete and not mixed with anything else
4. A designer should be artistic to <u>convey</u> that message.	D. being the only of its kind; very special or unusual
5. More <u>compelling</u> advertising leads to better business.	E. started dealing with a problem, task, etc. in a particular way
6. He <u>was struck by</u> how poorly the company handled corporate design.	F. to suggest a plan, an idea, etc. for people to think about and decide on
7. Rand would never <u>propose</u> something too radical on the first day.	G. to make ideas, feelings, etc. known to someone
8. The power of IBM <u>convinced</u> other business to go to the IBM route.	H. the most important quality or features of something, that makes it what it is
9. Aside from the <u>sheer</u> beauty of his visual work, was that he was "one of the guys".	I. that makes you pay attention to it because it is so interesting and exciting
10. Rand's work with IBM set a <u>precedent</u>.	J. persuaded one to do something

Task 2 Fill in the blanks with the correct form of the words or phrase given below.

compel	strategy	illustrate	elevate	without question
shift	persuade	aesthetic	capture	convey

1._____, Paul Rand was one of the most influential pioneers of graphic design, well-respected for his uncanny ability to 2._____ the essence of art, business and graphic design.

One of Rand's main 3._____ for explaining how his designs would help meet a client's business needs was to write and 4._____ beautiful presentation booklets for CEOs. They were "works of art in themselves". These booklets presented a logo design as some kind of rational, logical choice. Not as a science, but they laid out the thought process behind the designs in simple, 5._____ language and images. Rand's patience and clear communication with clients helped non-visual thinkers understand the importance of the 6._____ aspects of products

and corporate communications.

Rand's pioneering work in advertising design in the early 1940s helped **7.**_____ the way businesses approached branding. Rand knew an ad's point was to sell products, but believed that in visually **8.**_____ that message, a designer should be artistic. He can take the ideas of Picasso, Jean Arp, and Miro, and apply these fine art principles to the design of everyday objects and ads. As a result, he **9.**_____ the field of advertisements. People could look at an ad and have an aesthetic experience. And more **10.**_____ advertising, as corporations know well, leads to better business.

Task 3 Translate the following sentences into Chinese.

1. There is a unique simplicity that carries through the most famous corporate logo designs created by Paul Rand.
2. Without question, Paul Rand was one of the most influential pioneers of graphic design, well-respected for his uncanny ability to capture the essence of art, business and graphic design.
3. Rand's pioneering work in advertising design in the early 1940s helped shift the way businesses approached branding.
4. More compelling advertising leads to better business.
5. He was very down-to-earth, and fit well into the corporate culture.

Part Three Practical Writing

Application Letters

An application letter (also known as cover letter) is a job document you send with your résumé to provide additional information about your skills and experience. The letter is intended to present why you are a qualified candidate for the job you are applying for.

Effective application letters explain the reasons for your interest in the specific organization and identify your most relevant skills or experiences. Your application letter should let the employer know what position you are applying for, what makes you a strong candidate, why they should select you for an interview, and how you will follow up. It is your chance to "sell" yourself to an employer, explaining why you are an ideal candidate for the position.

Unit 5
Industrial Designer Raymond Loewy

 Task 1 Fill in the boxes with the corresponding components of an application letter marked from A to F.

A. Signature
B. Follow-up actions
C. Name, title of the addressee, company address
D. Skills, experience, personal qualities
E. Date
F. Complimentary close
G. Reasons for the letter

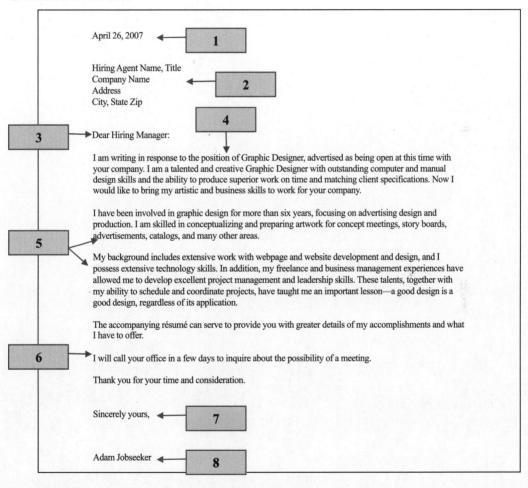

87

Task 2 Write an application letter according to the given situation.

You are writing to Andrew Johansson (15 Hilton Street Brighton GH3 5NX) to apply for the position of Graphic Designer which was advertised on the company website www.artdist.com.

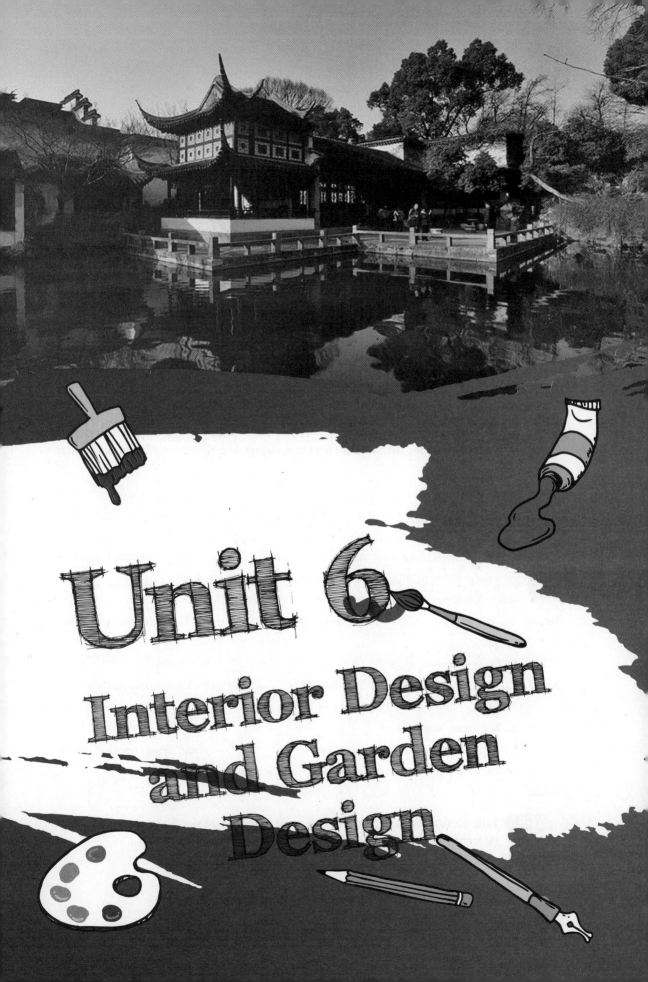

Unit 6
Interior Design and Garden Design

Part One　Listening and Speaking

Task 1　Listen to a conversation about asking for and giving opinions and answer the questions.

Questions:

1. What are the speakers talking about in the conversation?
2. What does Mary say about square dancing at first?
3. Why does Mary think Bridge Garden is a wrong place for square dancing?
4. What is Tom's opinion about square dancing?
5. When does square dancing stop?

Task 2　Susan and Peter are discussing whether they should send their son to a design training course. Listen to their conversation and fill in the blanks with what you hear.

Peter: I am considering sending our son to a **1.**_____. What's your opinion?

Susan: Don't you think that he is too young to take that kind of course? He is just 15 years old.

Peter: Well, I think the teachers in the training center would take care of him. Besides, he can make more friends and learn something about **2.**_____ there. You know, he is very interested in painting and designing and intends to be an **3.**_____ in the future. Don't you think this training course is good for him?

Susan: Yes, **4.**_____ it's better going there than staying at home during the summer vacation.

Peter: So I take it that you agree?

Susan: No, I need to think about it. Besides, I think you need to find more information about different courses, so that our son can have a better **5.**_____ of them and make a good choice.

Peter: OK. I will search online to find some **6.**_____ about design training courses so that we can have a plan for his summer vacation as soon as possible.

Susan: OK.

Task 3　Talk about a latest design with your partner. Make a conversation with reference to the expressions below.

Unit 6
Interior Design and Garden Design

Useful Expressions

Asking for opinions

What's your opinion?

What do you think?

What do you think about/of it?

What's your opinion on this matter?

How do you feel about it?

How would you like it to be?

How do you see things like this?

Will you let me know your comments on...?

Please tell me frankly your opinion.

We'd like you to give us your suggestions.

Do you agree to this change? I'd like to hear your opinion about it.

Giving opinions

I (really) think that...

I believe (that)...

I'm sure that...

In my opinion/My opinion is...

In my opinion, it's a good/bad idea.

I have no doubt that/I'm certain that...

I strongly believe that...

My personal opinion is that/Personally, my opinion is that...

To be honest/In my honest opinion, ...

I agree with the opinion of...

I could be wrong, but...

I'm absolutely certain that...

I'm fairly confident that...

It seems to me that...

It's a complicated/difficult issue, but...

After weighing up both sides of the argument, ...

Although I can see both points of view, ...

Although I can understand the opposite point of view, ...

Correct me if I'm wrong, but...

For me/From my point of view, ...

I reckon/suppose...

It seems clear to me that...

It would seem to me that...

Personally speaking/Speaking for myself, ...

After giving this matter some (serious) thought, ...

As far as I'm concerned, ...

As the old saying goes, ...

Having given this question due consideration, ...

I am of the opinion that...

I tend towards the opinion that...

I think it's fair/reasonable to say...

I'm entirely/quite convinced that...

I've come to the conclusion that...

My opinion was best expressed by... when she/he said/wrote...

My view/position on this issue is that...

My view on this issue is clear, that is, we should...

Off the top of my head, ...

To summarize my views on the matter, ...

Without a shred/shadow of doubt, I...

Part Two Active Reading

Interior design encompasses conceptual planning, aesthetics and technical solutions to achieve the desired result. Interior designer seeks to optimize and harmonize the uses to which the built environment will be put. Many factors such as the dimension of the place, the ease of access

to the place, lighting, acoustics, etc., come into playing in formulating the design solution. The designer must have an aesthetic, practical and technical appreciation for these elements. He or she must understand how people use and respond to these elements, not just individually but as the elements interact with one another. The designer must also be knowledgeable about many types and characteristics of furnishings, accessories and ornaments used in creating interiors. Furniture, carpeting and floor covering, paint and wall covering, glass, wrought metal, fixtures, art and artifacts are just some of the many items and materials designers select from. In addition, they must be familiar with various styles and history of styles of design, art and architecture.

Interior Designer and Interior Design

Need to change your living room into the dwellings of a Scottish castle? Well, that is when you call upon the services of an interior designer to help you realize that dream; however, at the same time, you might be sobered down to earth when he or she shows you the budget that your dream demands.

There is a lot to be said about those who work within the interior design industry—the lucrative business that is challenging and multi-dimensional in its very nature. To create a beautiful and comfortable space by making the best of what a home initially offers and improving on those not-so-nice aspects like poor natural lighting or awful room layout, it takes a special person with a set of special talents to excel in such a situation. Every company that offers interior decorating service should have a couple of talented interior designers, who form the backbone of the company.

So who are they, you might ask.

Well, for one thing, it is very hard to place the interior designers within a single industry, and this means that while they design, they are not just home renovators, although the home is one of the places that they specialize in. They have no background or history in construction or the many facets within it, but they have a keen knowledge on materials and the sort of elements that work well within functional spaces. They are also not artists, but they play with colors and textures, which when combined in the right fashion, can be a work of art in themselves. So an interior designer is really a jack of all trades, and a master of one—the one of turning a home into a castle, giving a house a personality and changing ideas and dreams into something tangible. In a crux, the work of an interior designer is to change the interior of a house or an office into something that is truly functional and fashionable. A good interior designer is familiar with fabrics, lighting, materials, colors, as well as technology like software programs, 3D applications and technological appliances in and around the house. These are some of the areas that the designers need to master, because these are the powers that they need to call upon when they are trying to turn your fantasy into a reality.

Interior design is the total creative solution for a specific built environment. It encompasses conceptual planning, aesthetics and technical solutions to achieve the desired result. Interior design is about both art and science and how to use these two disciplines in creating a beautiful outcome. The designer must be able to apply creative solutions to the space he is trying to design. He must have the technical expertise to know the vast array of options that he can apply to any space. The goal of an interior designer is to work to improve the surroundings and the quality of life of its occupants, so he must be creative, adaptable, informative and ingenious—all in one package, because he will have to deal with templates that are ever changing and demands that are ever increasing.

There are several things that need to be considered when working to make a home more appealing. The overall space of a home with its individual rooms is one of the first things that an interior designer will consider. What the dimensions of the space are and how it was constructed are key questions that an interior designer needs to answer before he can move forward. What are the limitations of the space and what is its potential? What will the space be used for—relaxation, family, entertaining, or business? The designer must also learn about the psychological or behavioral needs of its inhabitants and identify what amenities would be appropriate in better meeting the client's needs. Finally, the designer has to use objects such as artworks, photos, pillows, and floral arrangements to make a particular space more visually appealing.

New Words

aesthetics	[esˈθetɪks]	n. 美学；审美，具有审美趣味
optimize	[ˈɑːptɪmaɪz]	vt. 使最优化，使完善
acoustics	[əˈkuːstɪks]	n. 声学；音响效果，音质
formulate	[ˈfɔːrmjuleɪt]	vt. 制定；规划；用公式表示
furnishing	[ˈfɜːrnɪʃɪŋ]	n. 家具；供给；装备；服饰
carpeting	[ˈkɑːrpɪtɪŋ]	n. 毛毯，[纺] 地毯；地毯料
wrought	[rɔːt]	adj. 锻造的；加工的；精细的
fixture	[ˈfɪkstʃər]	n. 固定装置；设备
artifact	[ˈɑːrtɪfækt]	n. 人工制品，手工艺品
dwelling	[ˈdwelɪŋ]	n. 住处，寓所
lucrative	[ˈluːkrətɪv]	adj. 有利可图的，赚钱的；合算的
renovator	[ˈrenəuveɪtə]	n. 革新者，更新者；修理者
facet	[ˈfæsɪt]	n. 面；方面；小平面
tangible	[ˈtændʒəbl]	adj. 可触摸的；有形的；切实的
crux	[krʌks]	n. 关键；难题；十字架形
expertise	[ˌekspɜːrˈtiːz]	n. 专门知识；专门技术；专家的意见

array	[ə'reɪ]	n. 大批，一系列；排列，列阵
template	['templət]	n. 模板，样板
appealing	[ə'piːlɪŋ]	adj. 吸引人的；动人的；引起兴趣的
behavioral	[bɪ'heɪvjərəl]	adj. 行为的
amenity	[ə'menəti]	n. 便利设施；舒适；礼仪；愉快

Useful Expressions

call upon	号召；要求；拜访
excel in	在……方面胜过；在……方面很擅长
a jack of all trades	多面手；万金油

Proper Names and Cultural Notes

| interior design | 室内设计，是对建筑物的内部空间进行设计的独立的综合性学科。 |
| interior designer | 室内设计师，重点是在有限的空间、时间、成本等压力之下把客人的需求转化成事实。 |

Reading Comprehension

 Task 1 Read the text and answer the following questions.

1. What are the features of interior design industry?
2. What does interior design encompass?
3. What does an interior designer do?
4. What should a good interior designer be familiar with?
5. What are the things an interior designer needed to consider when working to make a home more appealing?

 Task 2 Read the text and choose the best answer to the questions.

1. Who form the backbone of an interior design company?
 A. Regular customers.　　　　　B. Sales managers.
 C. Talented interior designers.　　D. Investors.
2. Which of the following qualities is NOT a necessity of being an interior designer?
 A. A background or history in construction.
 B. Having a keen knowledge on materials and the sort of elements that work well within functional spaces.

C. Being able to apply creative solutions to the space he is trying to design.

D. Being creative, adaptable, informative and ingenious.

3. Which of the following statements is NOT true, according to the text?

 A. It is very hard to place the interior designers within a single industry.

 B. The interior designers are also artists who play with colors and textures.

 C. The goal of an interior designer is to work to improve the surroundings and the quality of life of its occupants, so he must be creative, adaptable, informative and ingenious.

 D. An interior designer is really a jack of all trades.

4. Which of the following objects can be used by an interior designer to make a particular space more visually appealing?

 A. Artworks. B. Photos.

 C. Floral arrangements. D. All the above.

Language in Use

 Task 1 Match the underlined words in Column I with their corresponding meanings in Column II.

I	II
1. Need to change your living room into the <u>dwellings</u> of a Scottish castle?	A. a central cohesive source of support and stability
2. There is a lot to be said about those who work within the interior design industry—the <u>lucrative</u> business that is challenging and multi-dimensional in its very nature.	B. special skill or knowledge that is acquired by training, study, or practice
3. To create a beautiful and comfortable space by making the best of what a home initially offers and improving on those not-so-nice aspects like poor natural lighting or awful room <u>layout</u>, it takes a special person with a set of special talents to excel in such a situation.	C. places where people live
4. Every company that offers interior decorating service should have a couple of talented interior designers, who form the <u>backbone</u> of the company.	D. clear enough or definite enough to be easily seen, felt, or noticed
5. They are not just home <u>renovators</u>, although the home is one of the places that they specialize in.	E. very profitable

Unit 6
Interior Design and Garden Design

6. So an interior designer is really a jack of all trades, and a master of one—the one of turning a home into a castle, giving a house a personality and changing ideas and dreams into something <u>tangible</u>.

7. He must have the technical <u>expertise</u> to know the vast array of options that he can apply to any one space.

8. He must be creative, adaptable, informative and <u>ingenious</u>—all in one package, because he will have to deal with templates that are ever changing and demands that are ever increasing.

9. There are several things that need to be considered when working to make a home more <u>appealing</u>.

10. The designer must also learn about the psychological or <u>behavioral</u> needs of its inhabitants and identify what amenities would be appropriate in better meeting the client's needs.

F. very clever, having new ideas, methods, etc.

G. pleasing and attractive

H. the way in which the parts of a park, building, or piece of writing are arranged

I. relating to the behavior of a person or animal, or to the study of their behavior

J. skilled workers who are employed to restore or refinish buildings or antique furniture

Task 2 Fill in the blanks with the correct form of the words given below.

limit	consider	psychology	arrange	dimension
entertain	meet	design	visual	construction

There are several things that need to be **1.**_____ when working to make a home more appealing. The overall space of a home with its individual rooms is one of the first things that an interior **2.**_____ will consider. What the **3.**_____ of the space are and how it was **4.**_____ are key questions that an interior designer needs to answer before he can move forward. What are the **5.**_____ of the space and what is its potential? What will the space be used for relaxation, family, **6.**_____, or business? The designer must also learn about the **7.**_____ or behavioral needs of its inhabitants and identify what amenities would be appropriate in better **8.**_____ the client's needs. Finally, the designer has to use objects such as artworks, photos, pillows, and floral **9.**_____ to make a particular space more **10.**_____ appealing.

 Task 3 Translate the following sentences into English.

1. 每一家提供室内装饰服务的公司都应该有几位富有才华的室内设计师作为公司的中流砥柱。（form the backbone of）
2. 室内设计师是一个多面手，他们深谙如何将家变成城堡，如何给房子赋予个性，如何将想法和梦想化为现实。（a jack of all trades）
3. 室内设计包含了为了达到预期效果所需要的概念规划、美学知识和技术方案。（encompass）
4. 他必须拥有专业技术知识，以做到在任何一个空间内都能有大量的可选方案。（technical expertise）
5. 当人们致力于把家变得更有吸引力时，有一些事情需要优先考虑。（appealing）

Text B

Garden Design

Garden design is the art and process of designing and creating plans for layout and planting of gardens and landscapes. Garden design may be done by the garden owners themselves, or by professionals of varying levels of experience and expertise. Most professional garden designers have some training in horticulture and the principles of design, and some are also landscape architects, with a more formal level of training that usually requires an advanced degree and often a state license. Amateur gardeners may also attain a high level of experience from extensive hours working in their own gardens, through casual study, or serious study in Master Gardener Programs, or by joining gardening clubs.

No matter a garden is designed by a professional or an amateur, certain principles form the basis of effective garden design, resulting in the creation of gardens to meet the needs, goals and desires of the users or owners of the gardens.

Elements of garden design include the layout of hard landscape, such as paths, walls, water features, sitting areas and decking; as well as the plants themselves, with consideration for their horticultural requirements, their season-to-season appearance, lifespan, growth habit, size, speed of growth, and combinations with other plants and landscape features. Consideration is also given to the maintenance needs of the garden, including the time or funds available for regular maintenance, which can affect the choice of plants in terms of speed of growth, spreading or self-seeding of the plants, whether annual or perennial, bloom-time, and many other characteristics.

Important considerations in garden design include how the garden will be used, the desired stylistic genre (formal or informal, modern or traditional, etc.), and the way the garden space will connect to the home or other structures in the surrounding areas. All of these considerations are subject to the limitations of the prescribed budget.

The importance of a unifying theme for landscape design cannot be overstated. Most of us

have seen gardens that contain a "hotchpotch" of materials, plants, and garden ornament. Choosing a style or theme for the garden is a very personal matter. It is more important that the style pleases the client than represents the taste of the designer. On some different areas of a property, somewhat different themes may co-exist, but there should be something unifying the scheme throughout the entire site. On very large properties this principle may be "bent" a bit, but transitions from one area to another need to be carefully thought out.

Generally, people are familiar with the Mediterranean garden, the English garden, the American colonial garden, the Chinese garden, etc. However, more and more people are getting interested in the modernist garden. The modernist garden is varied—no quick description can include all its possible aspects. In some cases it is simple, with clean lines and architectural plantings. On occasion, it borrows from the Far Eastern traditions of mastery of nature into small spaces. The designers appreciate the Chinese garden designing principle of "borrowing scenery" and "concealment and surprise", and learn to employ them effectively in their own designing. It has also incorporated, at times, the abstract forms of modern paintings. More recently, desire to contrast with urban life in general has brought a more natural and wild feel to the residential garden. In California, the modern tradition of the residential garden often features an intimate connection between indoor and outdoor spaces. This is accomplished through the use of enclosed courtyards, glass walls and doors, and kitchens and living rooms opening out onto outdoor eating entertainment areas.

New Words

layout	['leɪaʊt]	n. 布局；设计；安排；陈列
landscape	['lændskeɪp]	n. 风景；地形；风景画，山水画
horticulture	['hɔːrtɪkʌltʃər]	n. 园艺；园艺学
feature	[fiːtʃə]	n. 地势，地形
amateur	['æmətər]	adj. 业余的；外行的 n. 业余爱好者；外行
professional	[prə'feʃənl]	n. 专业人员；职业运动员
decking	['dekɪŋ]	n. 装饰；盖板；[交] 桥面板
lifespan	['laɪfspæn]	n. 寿命；预期生命期限；预期使用期限
maintenance	['meɪntənəns]	n. 维护，维修；保持；生活费用
perennial	[pə'renɪəl]	adj. 多年生的；常年的；四季不断的；常在的；反复的
stylistic	[staɪ'lɪstɪk]	adj. 体裁上的；格式上的；文体论的
prescribe	[prɪ'skraɪb]	vt. 规定；开处方
unify	['juːnɪfaɪ]	vt. 统一；使相同，使一致
overstate	[ˌoʊvər'steɪt]	vt. 夸张，夸大叙述
hotchpotch	['hɑːtʃpɑːtʃ]	n. 杂烩
ornament	['ɔːrnəmənt]	n. 装饰；[建][服装] 装饰物

scheme	[skɪm]	n. 计划；组合；体制；诡计
mastery	[ˈmæstərɪ]	n. 掌握；精通；优势；征服；统治权
concealment	[kənˈsɪːlmənt]	n. 隐藏，隐蔽；隐匿处
incorporate	[ɪnˈkɔːrpəreɪt]	vt. 包含；吸收；把……合并
residential	[ˌrezɪˈdenʃl]	adj. 住宅的；与居住有关的
accomplish	[əˈkɑːmplɪʃ]	vt. 完成，实现，达到
enclosed	[ɪnˈkloʊzd]	adj. 被附上的；与世隔绝的

Useful Expressions

think out	想出；仔细思考，全面考虑
on occasion	有时，偶尔
contrast with	与……形成对比，和……相对照

Proper Names and Cultural Notes

hard landscape	硬质景观。此概念由英国人麦克尔·盖奇（Michael Gage）和玛里察·凡登堡（Maritz Vandenberg）首次在《城市硬质景观设计》一书中提出，意指相对于植物的软质景观而言的道路、亭台楼阁、雕塑、假山等兼具功能性和装饰性的景观设计。
Mediterranean garden	地中海花园。地中海花园是以地中海风格装修的花园，是类海洋风格装修的典型代表，因富有浓郁的地中海人文风情和地域特征而得名。
English garden	英式花园。英式花园起源于18世纪的英国园艺造景。英式花园放弃了传统欧洲花园的几何式格局，强调草场、林木、池塘、溪流以及古堡残壁等的自然风味。
Chinese garden	中国古典园林。中国古典园林艺术是指以江南私家园林和北方皇家园林为代表的中国山水园林形式，强调师法自然，顺应自然，处理好形与神、意与境、虚与实、动与静等各种关系，实现移步换景、小中见大、天人合一等美学追求。

Unit 6
Interior Design and Garden Design

Reading Comprehension

 Task 1 Read the text and answer the following questions.

1. What is the definition of garden design in this text?
2. What elements should be considered in the garden design?
3. Why is it important to unify the theme for a garden design?
4. What are the Chinese garden designing principles employed by some western garden designers in their own designing?
5. What is the feature of modern tradition of the residential garden in California?

 Task 2 Read the text and decide whether each of the following statements is true or false.

1. Amateur gardeners usually cannot attain a high level of experience.
2. Most of us have seen gardens as a "hotchpotch" of materials, plants, and garden ornament.
3. On some different areas of a property, different themes still cannot co-exist and there should be a unifying theme throughout the entire site.
4. Nowadays, more and more people are getting interested in the Mediterranean garden.
5. More recently, desire to contrast with urban life in general has brought a more natural and wild feel to the residential garden.

Language in Use

 Task 1 Match the underlined words in Column I with their corresponding meanings in Column II.

I	II
1. Garden design may be done by the garden owner themselves, or by <u>professionals</u> of varying levels of experience and expertise.	A. the way in which the parts of something such as the page of a book, a garden or a building are arranged
2. <u>Amateur</u> gardeners may also attain a high level of experience from extensive hours working in their own gardens, through casual study, or serious study in Master Gardener Programs, or by joining gardening clubs.	B. the process of keeping a building, vehicle, road, or machine in good condition by regularly checking it and repairing it when necessary
3. Elements of garden design include the <u>layout</u> of hard landscape, such as paths, walls, water features, sitting areas and decking.	C. doing something for enjoyment or interest, not as a job

101

4. Consideration is also given to the <u>maintenance</u> needs of the garden.
5. Important considerations in garden design include how the garden will be used, the desired stylistic <u>genre</u> (formal or informal, modern or traditional etc.), and the way the garden space will connect to the home or other structures in the surrounding areas.
6. Most of us have seen gardens that contain a "hotchpotch" of materials, plants, and garden <u>ornament</u>.
7. On some different areas of a property, somewhat different themes may <u>co-exist</u>, but there should be something unifying the scheme throughout the entire site.
8. On occasion, it borrows from the Far Eastern traditions of <u>mastery</u> of nature into small spaces.
9. It has also <u>incorporated</u>, at times, the abstract forms of modern paintings.
10. More recently, desire to contrast with urban life in general has brought a more natural and wild feel to the <u>residential</u> garden.

D. exist together at the same time or in the same place
E. (of an area or a town) suitable for living in; consisting of houses rather than factories or offices

F. great knowledge about or understanding of a particular thing
G. people engaged in one of the learned professions

H. a particular method or technique used in creating a piece of writing, music, or art
I. included something so that it forms a part of a group, system, plan, etc.
J. an attractive object that you display in your home or in your garden

Task 2 Fill in the blanks with the correct form of the words given below.

material	transit	think	overstate	architecture
co-exist	unify	choose	represent	colony

The importance of a **1.**_____ theme for landscape design cannot be **2.**_____. Most of us have seen gardens that contain a "hotchpotch" of **3.**_____, plants, and garden ornament. **4.**_____ a style or theme for the garden is a very personal matter. It is more important that the style pleases the client than **5.**_____ the taste of the designer. On some different areas of a property, somewhat different themes may **6.**_____, but there should be something unifying the scheme throughout the entire site. On very large properties this principle may be "bent" a bit, but **7.**_____ from one area to another need to be carefully **8.**_____ out.

Generally, people are familiar with the Mediterranean garden, the English garden, the American **9.**_____ garden, the Chinese garden, etc. However, more and more people are getting interested in the modernist garden. The modernist garden is varied—no quick description can include all its possible aspects. In some cases it is simple, with clean lines and **10.**_____ plantings.

Unit 6
Interior Design and Garden Design

 Task 3 Translate the following sentences into Chinese.

1. Garden design may be done by the garden owner themselves, or by professionals of varying levels of experience and expertise.
2. It is more important that the style pleases the client than represents the taste of the designer.
3. On some different areas of a property, somewhat different themes may co-exist, but there should be something unifying the scheme throughout the entire site.
4. More recently, desire to contrast with urban life in general has brought a more natural and wild feel to the residential garden.
5. The designers appreciate the Chinese garden designing principle of "borrowing scenery" and "concealment and surprise", and learn to employ them effectively in their own designing.

Part Three Practical Writing

Résumé

A résumé is a document that summarizes your education, skills, abilities and experiences that are relevant to your qualifications for a particular job for which you are applying. It is a sort of self-advertisement. Résumé can be used for a variety of reasons, but most often they are used to get an interview. To help your résumé get the required notice by your employer, you must know how to write an effective résumé. In order to make you résumé flawless, you need to (1) keep it precise and legible; (2) include keywords like degrees, skills, software used, and techniques used; (3) pay attention to the design and fonts of your résumé; (4) customize your resume for every job that you apply for; (5) portray yourself as a strong candidate in your résumé; (6) use numbers to put forth your achievements; (7) check your résumé twice or three times for spelling or grammatical errors.

 Task 1 Fill in the boxes with the corresponding components of a résumé marked from A to G.

A. Career objective
B. Academic qualifications
C. Name and contact details
D. Work experience
E. Career summary
F. Skills
G. Interests

1 ☐

William Turner

2021 Industrial Park Rd # A,

14th Blvd,

Alexandria, LA-71303

Email: william.turner@email.com

Contact no.: (813) 478-1234

2 ☐

Aspire for the post of an Interior Designer in a professional and prestigious institution, where my knowledge and abilities can assist in enhancing the artistic approach in designing and contribute towards the institution's productivity; can bring in fresh ideas for documenting the entire process of interior designing for international clients.

3 ☐

Interior Designer with experience of 10 years in the field of interior designing; successfully handled the design presentation and the commercial selected designs; awarded Best Employee Award in Whiteleaf Associates.

4 ☐

Completed High School from British National School, in 1998 with Grade A in Science;

Completed graduation in Interior Designing from Boston Institute of Technology in 2001 Grade A;

Completed post graduation in Fine Arts from Phoenix Fashion Academy in March 2003 Grade A

5 ☐

Current Employer: Shepherd & Sloane Interior Associates (2007-till date)

Designation: Interior Designer

Job responsibilities:

Monitor and manage the inventory sector, elevations, etc.;

Present the blueprints and graphical designs for client approval;

Estimate the budget of the architectural and interior surroundings;

Efficiently select the designs and purchase the furnishings for commercial industrial and residential projects;

Assisted the seniors in drawings, paste ups and illustrations.

Previous Employer: White Leaf Associates (2006-2008)

Designation: Junior Interior Designer

Job responsibilities:

Monitor and manage the budget of the interior designing;

Responsible for presentations, site measurements, space planning, etc.;

Formulated the surrounding to be practical and conducted various tests;

Rendered help in designing the ideas in the form of paste ups and drawings;

Assisted the seniors in decorations for five clients commercial projects;

Achievements and Awards:

Awarded with "Best Employee Award" for redesigning the New York projects at workplace in White Leaf Associates;

Recurrent nominee and winner of awards for creating a paradise work in residential project;

Received awards for delivering projects on specified time;

Winner of the national football tournament.

6

Possess good communicational and writing abilities;

Outstanding creativity and vision in interior designing;

Proficient in building designs as per the clients choice and requirements;

Ability to handle 50 plus staff members;

Artistic ability in creating two and three dimensional renderings;

Computer literate and internet savvy: proficient in AutoCAD and AutoCAD Lite systems;

Well versed in staff training, drafting space plans, site measurements, utilization of furnishings, etc.

7

Active participant in Designer Club in leisure time;

Participated in football tournaments at school, inter college, state levels

 Task 2 Write a résumé according to the given situation.

Use the following information to write a résumé for an art designer.

Robert D

1479, Star Route

Bellwood, IL-60104

Phone: 708-615-6608

E-mail: RobertDKimzey@mailanator.com

2007 Master's Degree in Communications University of Georgia

2005 Bachelor's Degree in Arts Arts College of Georgia

2012 work as an art designer BOC advertisement agency in Georgia

2008-2011 work as an art designer ABC advertising agency in Georgia

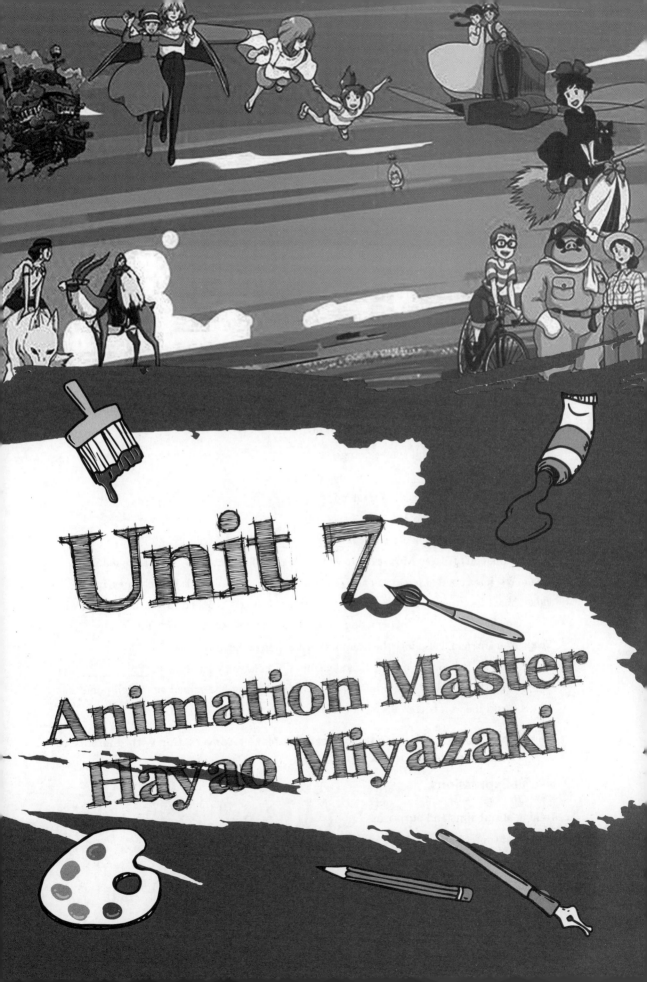

Unit 7
Animation Master Hayao Miyazaki

Part One　　Listening and Speaking

Task 1 Listen to a conversation about changing a plan and answer the questions.

Questions:

1. What did John plan to do in the coming holiday?
2. Why did John change his plan?
3. What program does John intend to apply for?
4. Why does John apply for this program?
5. Which university does John expect to study in?

Task 2 Tony and Luna are talking about movies. Listen to their conversation and fill in the blanks with what you hear.

Tony: Hey, Luna, what will you be doing?

Luna: Hi, Tony. I **1.**_____ to watch movies.

Tony: What kind of movies do you intend to watch?

Luna: I plan to choose one **2.**_____ film.

Tony: Then who is your favorite film **3.**_____?

Luna: I am fond of Hayao Miyazaki. Do you know about his famous work *Castle in the Sky*?

Tony: Yes, it is a good film. Do you also read the **4.**_____ book of the same name?

Luna: Yes, I love the book. And I read it five times. Miyazaki created this piece of work with the **5.**_____ of depicting an adventure of adolescents' striving for dreams.

Tony: You are right. I also love the beautiful theme song of the movie.

Luna: Me too. The song is named *Carrying You*. It is created by Japanese **6.**_____ Joe Hisaishi, who had won a lot of prizes. Now the song has gained very high popularity across the world.

Task 3 Talk about dreams with your partner. Make a conversation with reference to the expressions below.

Useful Expressions

Talking about aims and purposes

　　in order (not) to...

　　so that...

　　for/with the purpose of...

with the intention of…

so as (not) to…

for the sake of…

in case…

for fear that/of…

Asking about aims and purposes

Do you mean to…?

What do you mean to do?

Are you going to…?

What will you be doing?

Have you decided to…?

What's your intention?

Do you have any intention of…?

Stating one's aims and purposes

I expect I'll…

I'm thinking of…

I've decided not to…

I'm planning to…

I plan to…

I intend to…

Your intention is to…

I proposed to…

Part Two　Active Reading

Hayao Miyazaki is considered to be one of the greatest animators of all time, held in the same rank as Walt Disney and Ralph Bakshi. Miyazaki has attained international acclaim as a masterful storyteller and maker of anime feature films. Miyazaki and his partners at Studio Ghibli have created works of astonishing depth and artistry, such as *Kiki's Delivery Service*, *Princess Mononoke*, *Spirited Away* and *The Wind Rises*, which are also highest-grossing animation films of all time.

A Guide to the Films of Animation Master Hayao Miyazaki
The revered director earned an Oscar nomination for his controversial *The Wind Rises*

On February 21, *The Wind Rises*, director Hayao Miyazaki's 11th, and supposedly final, feature film hits American theaters. The movie is a departure for the legendary animation auteur, whose films are often fantasy tales set in imaginary worlds. This time around, he has produced a fictionalized biography of Jiro Horikoshi, the aeronautical designer behind the Mitsubishi A6M—the fighter plane used by the Japanese air force in the attack on Pearl Harbor. As Miyazaki tells it, Horikoshi was largely peaceful in nature, and merely aimed to design beautiful machines rather than weaponry. It was that tension that drew Miyazaki to the story, and that tension has made the film a source of controversy in Japan, where critics on the left have condemned *The Wind Rises* for celebrating a man who designed a tool of destruction, while those on the right have decried it for being anti-nationalistic.

Nonetheless, the film garnered Miyazaki his third Academy Award nomination for Best Animated Feature (an honor he won for 2001's *Spirited Away*), and solidified his place as one of the most esteemed animated film directors in the history. Indeed, the 73-year-old director is not just held in high esteem by cartoon buffs, he is arguably the most famous living Japanese filmmaker. He has reached this level of acclaim thanks to his beguiling use of whimsy, grace and compassion, whether his focus is a 10-year-old kid trying to hold onto a job in the spirit world or a teenage witch coming to grips with her powers. Like any artist, Miyazaki's work features recurring themes, imagery and narrative devices. With that in mind, for all you Miyazaki neophytes out there, here are five key elements of the master's films.

Hard-Nosed Heroines

The Wind Rises has a man for its protagonist, but that makes it something of an outlier in the

director's filmography. Miyazaki's most famous leads are tough-minded young women who refuse to bend to societal expectations. 1984's *Nausicaä of the Valley of the Wind* and 1997's *Princess Mononoke*, for example, center on tenacious young women, royals who must go to battle knowing that they're responsible for protecting their kingdoms. Below, in the Nausicaä trailer, we see the eponymous adolescent princess fearlessly dodging gunfire while soaring on her one-woman glider.

A Natural Beauty

Watch any Miyazaki film and it's clear how enthralled the director is by scenes of nature. In Miyazaki's world, you will never see a glossy skyscraper or a parking garage. He would much rather focus on the pastoral elegance of rolling vistas, the serene calm of moss-covered trees or the perfect ripple of a passing wave. In the below scene, from 1988's *My Neighbor Totoro*, two youngsters seek refuge in the forested surroundings of their new home and come across a magical entity. It's a good example of how nature is represented in Miyazaki's films as a place of wonder and enchantment.

Lovers not Fighters

Miyazaki's films show a clear contempt for war. That doesn't mean that the filmmaker is averse to depicting confrontation; it's just that the fights which interest him usually aren't fought on battlefields. Even in a film like *The Wind Rises*, which focuses on the creator of a weapon used prominently in World War II, Miyazaki is more concerned with the main character Horikoshi's domestic life and moral struggles than with destructive power. On those occasions when his characters do arrive at blows with their opponents, it's clear that victory comes at a cost. In the following scene, from 2004's *Howl's Moving Castle*, instead of fighting his attackers, the enigmatic and extremely powerful wizard, Howl, uses his magic as a distraction and thus allows others to escape unharmed.

The Villains Aren't So Bad

Miyazaki steers strongly away from the kinds of one-dimensional "bad" characters so often associated with children's entertainment. He is less concerned with passing moral judgment on his antagonists, whether they be misguided warriors, over-competitive rivals or confused parents, than he is with portraying them as conflicted beings who have simply made some bad choices. One of the best examples of this is the underwater-dwelling wizard Fujimoto from 2008's *Ponyo*. The character is an overprotective father who is willing to unleash a giant tsunami on a coastal town rather than figure out why his daughter desires to experience the surface world. Fujimoto is so driven by paternal love that he doesn't realize the consequences of his decisions, an attribute that, weirdly, has made him a favorite among Miyazaki fans and frequently the focus of compilation videos like this one.

Incredible Flying Machines

Just like Horikoshi in *The Wind Rises*, Miyazaki grew up in a changing Japanese culture that was obsessed with airplanes. As we have noted, the director does tend to emphasize natural beauty,

but he is also enamored with the intricacy of heavy machinery. Look at this Japanese trailer for 1992's *Porco Rosso*, where the lovingly recreated planes get as much screen time as the misanthropic hero of the film's title.

New Words

animation	[ˌænɪˈmeɪʃən]	n. 动漫
nomination	[ˌnɒmɪˈneɪʃən]	n. 提名；推荐
auteur	[oʊˈtɜːr]	n. 电影导演
aeronautical	[ˌerəˈnɔːtɪkl]	adj. 航空的；航空学的；飞行的（aeronautic）
tension	[ˈtenʃn]	n. 张力，拉力；紧张，不安
condemn	[kənˈdem]	vt. 谴责；判刑，定罪；声讨
decry	[dɪˈkraɪ]	vt. 责难，谴责；诽谤
garner	[ˈɡɑːrnər]	vt. 获得；储存
solidify	[səˈlɪdɪfaɪ]	vt. 团结；凝固
esteem	[ɪˈstiːm]	vt. 尊敬；认为；考虑；估价 n. 尊重，尊敬
buff	[bʌf]	n. 爱好者
beguiling	[bɪˈɡaɪlɪŋ]	adj. 令人陶醉的；欺骗的；消遣的
whimsy	[ˈwɪmzɪ]	n. 怪念头；反复无常
neophyte	[ˈniːəfaɪt]	n. 新信徒；新入教者；初学者
outlier	[ˈaʊtlaɪər]	n. 局外人；离开本体的部分
filmography	[fɪlˈmɑːɡrəfi]	n. 电影作品年表；影片集锦
tenacious	[təˈneɪʃəs]	adj. 顽强的；坚韧的；固执的；紧握的；黏着力强的
trailer	[ˈtreɪlər]	n.（电视）预告片；追踪者
eponymous	[ɪˈpɑːnɪməs]	adj. 使得名的，齐名的
dodge	[dɑːdʒ]	vt. 躲避，避开
enthrall	[ɪnˈθrɔːl]	vt. 迷住，使着迷
glossy	[ˈɡlɑːsɪ]	adj. 光滑的；有光泽的
pastoral	[ˈpæstərəl]	adj. 田园生活的，乡村的
vista	[ˈvɪstə]	n. 远景；狭长的街景；展望；回顾
ripple	[ˈrɪpl]	n. 波纹；涟漪
averse	[əˈvɜːrs]	adj. 反对的；不愿意的
unleash	[ʌnˈliːʃ]	vt. 发动；解开……的皮带；解除……的束缚
compilation	[ˌkɑːmpɪˈleɪʃn]	n. 编译；编辑；汇编
intricacy	[ˈɪntrɪkəsi]	n. 错综，复杂；难以理解
misanthropic	[ˌmɪsənˈθrɑːpɪk]	adj. 厌恶人类的；不愿与人来往的

Unit 7
Animation Master Hayao Miyazaki

Useful Expressions

bend to	屈从于
soar on	乘着；凭……高飞
seek refuge	寻求避难；寻求庇护
figure out	解决；算出；想出；理解；断定
be enamored with	迷恋，醉心于，倾心于，喜爱

Proper Names and Cultural Notes

Hayao Miyazaki	宫崎骏，1941 年出生于日本东京都文京区，动画师、动画制作人、动画导演、动画编剧。
Oscar nomination	奥斯卡奖提名。奥斯卡金像奖是由美国电影艺术科学院颁发的年度大奖。
The Wind Rises	《起风了》，由宫崎骏导演的最后一部动画片，是以同名漫画所改编的动画电影，于 2013 年 7 月 20 日在日本上映。该片讲述的是日本零式战斗机的开发者堀越二郎年轻时的故事，影片中没有不可思议的魔法、怪物等动漫常见的艺术形象，给人耳目一新之感。
feature film	剧情片，通常指运用现实生活中真实存在但往往不被大多数人所注意的事件而改编的故事性电影。
Jiro Horikoshi	堀越二郎（1903—1982），昭和时期日本航空工程师，因开发著名的零式舰载战斗机而享誉世界。
Mitsubishi A6M	日本零式战斗机的初期型号。后来，日本海军当局将其正式命名为"三菱 A6M 式舰载战斗机"，习惯上称"零式"战斗机。
Academy Award for Best Animated Feature	奥斯卡最佳动画片奖。2002 年，奥斯卡最佳动画奖被细分为最佳动画长片奖和最佳动画短片奖两个奖项。
Spirited Away	《千与千寻》，是宫崎骏执导、编剧，吉卜力工作室制作的动画电影，影片于 2001 年 7 月 20 日在日本正式上映，讲述了少女千寻意外来到灵异世界后发生的故事。该片荣获 2003 年奥斯卡金像奖最佳长篇动画奖，同时也是历史上唯一一部以动画电影身份获得德国柏林电影节最高奖项金熊奖的动画作品。
Nausicaä of the Valley of the Wind	《风之谷》，改编自宫崎骏的同名漫画，宫崎骏担任影片的导演。影片讲述千年前人类文明达致巅峰后，经历一场称为"火之七日"的战争而毁于一旦，人类生活在仅存的小面积土地上，在面对巨型昆虫和会释

Princess Mononoke	放瘴气的腐海森林包围的威胁下积极求存的故事。 《幽灵公主》，是吉卜力工作室于1997年推出的一部动画电影。《幽灵公主》传承自宫崎骏长久以来关于人与自然之间的深邃思考。影片不拘泥于人类对环境的破坏，而是从人与自然之间无从化解的天然矛盾出发，通过人类自身的生存角度，探寻人类与自然是否能够真正实现和谐共存这一终极命题。
My Neighbor Totoro	《龙猫》，是吉卜力工作室与德间书店于1988年推出的一部动画电影，由宫崎骏执导。电影描写的是日本在经济高度发展前存在的美丽自然，那个只有孩子才能看见的不可思议世界。电影讲述主人公小月在母亲生病住院后，父亲带着她与四岁的妹妹小梅到乡间居住。她们对那里的环境都感到十分新奇，也发现了一些有趣的事情。
Howl's Moving Castle	《哈尔的移动城堡》，是宫崎骏继动画电影《千与千寻》之后，在2004年冬推出的作品。该片改编自英国儿童小说家黛安娜·W. 琼斯的《魔法师哈威尔与火之恶魔》。该片以战争前夜为背景，描述住在小镇的三姐妹的传奇经历。
Ponyo	《悬崖上的金鱼姬》，是由吉卜力工作室制作，宫崎骏执导、编剧的长篇动画电影。该片讲述了住在深海里、一心想变成人类的人鱼波妞与信守承诺的五岁男孩宗介之间的故事。
Porco Rosso	《红猪》，是吉卜力工作室于1992年推出的一部动画电影，由宫崎骏担任导演。影片改编自宫崎骏漫画作品《飞行艇时代》，影片主要讲述了被自己诅咒而变成猪的主人公打击空中劫匪、保护身边的人的故事。

Reading Comprehension

 Task 1 Read the text and answer the following questions.

1. What honor did *The Wind Rises* garner Miyazaki?
2. What are the features of Hayao Miyazaki's films?
3. What tension made *The Wind Rises* a source of controversy in Japan?

4. What characteristics do heroines usually have in Miyazaki's films?
5. How does Miyazaki portray antagonists?

Task 2 Read the text and choose the best answer to the questions.

1. In *The Wind Rises*, Miyazaki produced a fictionalized biography of _____.
 A. Fujimoto
 B. Jiro Horikoshi
 C. Tatsuo Kusakabe
 D. Chihiro Ogino
2. In 2001, Hayao Miyazaki won the Academy Award for Best Animated Feature for _____.
 A. *The Wind Rises*
 B. *Princess Mononoke*
 C. *Spirited Away*
 D. *Kiki's Delivery Service*
3. In which of the following films did Miyazaki NOT portray a hard-nosed heroine?
 A. *The Wind Rises*.
 B. *Nausicaä of the Valley of the Wind*.
 C. *Princess Mononoke*.
 D. *Spirited Away*.
4. Which of the following statements is NOT true about Miyazaki?
 A. His films show a clear contempt for war.
 B. He is averse to depicting confrontation.
 C. He is more concerned with the domestic life and moral struggles.
 D. He tends to emphasize natural beauty.

Language in Use

Task 1 Match the underlined words in Column I with their corresponding meanings in Column II.

I	II
1. The movie is a departure for the legendary animation <u>auteur</u>, whose films are often fantasy tales set in imaginary worlds.	A. an account of the series of events making up a person's life
2. This time around, he has produced a fictionalized <u>biography</u> of Jiro Horikoshi, the aeronautical designer behind the Mitsubishi A6M.	B. highly attractive and able to arouse hope or desire
3. It was that <u>tension</u> that drew Miyazaki to the story.	C. expressed strong disapproval of
4. Those on the right have <u>decried</u> it for being anti-nationalistic.	D. acquired or deserved by one's efforts or actions
5. The film <u>garnered</u> Miyazaki his third Academy Award nomination for Best Animated Feature.	E. ardent followers and admirers

115

6. Indeed, the 73-year-old director is not just held in high esteem by cartoon buffs, he is arguably the most famous living Japanese filmmaker.
7. He has reached this level of acclaim thanks to his beguiling use of whimsy, grace and compassion, whether his focus is a 10-year-old kid trying to hold onto a job in the spirit world or a teenage witch coming to grips with her powers.
8. Like any artist, Miyazaki's work features recurring themes, imagery and narrative devices.
9. With that in mind, for all you Miyazaki neophytes out there, here are five key elements of the master's films.
10. *The Wind Rises* has a man for its protagonist, but that makes it something of an outlier in the director's filmography.

F. a filmmaker who has a personal style and keeps creative control over his or her works
G. new participants in some activity
H. a balance between and interplay of opposing elements or tendencies (especially in art or literature)
I. the principal character in a work of fiction
J. coming back

Task 2 Fill in the blanks with the correct form of the words given below.

concern	conflict	parent	associate	experience
favorite	attribute	steer	rival	unleash

Miyazaki **1.** _____ strongly away from the kinds of one-dimensional "bad" characters so often **2.** _____ with children's entertainment. He's less **3.** _____ with passing moral judgment on his antagonists, whether they be misguided warriors, over-competitive **4.** _____ or confused parents, than he is with portraying them as **5.** _____ beings who have simply made some bad choices. One of the best examples of this is the underwater-dwelling wizard Fujimoto from 2008's *Ponyo*. The character is an overprotective father who is willing to **6.** _____ a giant tsunami on a coastal town rather than figure out why his daughter desires to **7.** _____ the surface world. Fujimoto is so driven by **8.** _____ love that he doesn't realize the consequences of his decisions, an **9.** _____ that, weirdly, has made him a **10.** _____ among Miyazaki fans and frequently the focus of compilation videos like this one.

Task 3 Translate the following sentences into English.
1. 他达到这般交口赞誉的高度，全在于他将奇思妙想、雅致格调和悲悯情怀魔幻般地融于一体。（acclaim; beguiling）
2. 在宫崎骏的世界里，你永远不会看到闪光的摩天大楼或停车场。（glossy）
3. 宫崎骏的电影对战争表现出了明显的厌弃之感。（contempt）

4. 这并不意味着电影制作人不喜欢描绘对抗，只是因为他感兴趣的战斗通常不是战场上的打斗场面。（confrontation; battlefield）
5. 导演确实倾向于强调自然美，但他也迷恋于复杂的重型机械。（enamor; intricacy）

Hayao Miyazaki

Hayao Miyazaki is a Japanese film director, animator and manga (comic) artist. Through a career that has spanned five decades, Miyazaki has been acclaimed as Japan's greatest manga artist and anime master. As a masterful storyteller and comic drawer, his films always attract us with entertaining plots, compelling characters and breathtaking animations.

Hayao Miyazaki was born in Tokyo on January 5, 1941. He started his career in 1963 as an animator at the Toei Animation, and was subsequently involved in many early classics of Japanese animation. From the beginning, he caught attention with his incredible drawing ability and the seemingly endless stream of movie ideas he proposed.

In 1971, Hayao Miyazaki moved to the A-Pro studio, then to Nippon Animation in 1973, where he worked as an animator, and directed the television series *Future Boy Conan*. He joined Telecom Animation Film in 1979, where he directed his first feature films, *The Castle of Cagliostro* in 1979 and *Nausicaä of the Valley of the Wind* in 1984, as well as the television series *Sherlock Hound*.

Miyazaki co-founded Studio Ghibli along with his partner Isao Takahata in 1985. He directed several films with Ghibli, including *Castle in the Sky* in 1986, *My Neighbor Totoro* in 1988, *Kiki's Delivery Service* in 1989, and *Porco Rosso* in 1992. The films were met with commercial and critical success in Japan. In 1997, Miyazaki's film *Princess Mononoke* was the first animated film to win the Japan Academy Prize for Picture of the Year; its distribution to the western world greatly increased Ghibli's popularity and influence outside Japan. His 2001 film *Spirited Away* became the highest-grossing film in Japanese history, winning the Academy Award for Best Animated Feature at the 75th Academy Awards. Miyazaki's later films—*Howl's Moving Castle*, *Ponyo*, and *The Wind Rises*—also enjoyed huge success.

The thought-provoking, aesthetically pleasing animated films of Hayao Miyazaki attract audiences well beyond the director's native Japan.

Hayao Miyazaki's art style is unique and distinct, and combines both Japanese (anime/manga) and American animation together. Many of his films are diversely stylized. He uses a mix of innovative animation techniques to produce amazing landscapes, scenery, and characters.

Miyazaki's works are characterized by the recurrence of themes such as humanity's relationship with nature and technology, the wholesomeness of natural and traditional patterns of living, the

importance of art and craftsmanship, and the difficulty of maintaining a pacifist ethic in a violent world. Miyazaki feels frustrated when he sees "nature—the mountains and rivers—was being destroyed in the name of economic progress". Miyazaki is also described as a feminist in reference to his attitude to female workers. Miyazaki has described his female characters as "brave, self-sufficient girls that don't think twice about fighting for what they believe in with all their heart", stating that they may "need a friend, or a supporter, but never a savior" and that "any woman is just as capable of being a hero as any man". It can be easily noted that the female characters in Miyazaki's films are not objectified or sexualized, and possess complex and individual characteristics absent from Hollywood productions.

Miyazaki is concerned with the sense of wonder in young people, seeking to maintain themes of love and family in his films. Miyazaki "fears Japanese children are dimmed by a culture of overconsumption, overprotection, utilitarian education, careerism, techno-industrialism, and a secularism that is swallowing Japan's native animism". Several of Miyazaki's works feature themes of love and romance, but emphasis is placed on "the way lonely and vulnerable individuals are integrated into relationships of mutual reliance and responsibility, which generally benefit everyone around them".

New Words

animator	[ˈænɪmeɪtə]	n. 动漫画家
comic	[ˈkɑːmɪk]	n. 喜剧；漫画
span	[spæn]	vt. 跨越；持续；以手指测量
subsequently	[ˈsʌbsɪkwəntli]	adv. 随后，其后；后来
aesthetically	[esˈθetɪkli]	adv. 审美地；美学观点上地
thought-provoking	[ˈθɔːt prəvoʊkɪŋ]	adj. 发人深省的；引起思考的
recurrence	[rɪˈkɜːrəns]	n. 重视，反复出现
pacifist	[ˈpæsɪfɪst]	n. 和平主义者
feminist	[ˈfemənɪst]	n. 女权主义者
savior	[ˈseɪvjər]	n. 救世主；救星；救助者
objectify	[əbˈdʒektɪfaɪ]	vt. 对象化；物化
utilitarian	[ˌjuːtɪlɪˈteriən]	adj. 功利的；功利主义的；实利的
secularism	[ˈsekjələrɪzəm]	n. 世俗主义；现世主义；宗教与教育分离论
animism	[ˈænɪmɪzəm]	n. 万物有灵论
vulnerable	[ˈvʌlnərəbl]	adj. 易受攻击的；易受伤害的；有弱点的

Useful Expressions

involve in	参与；涉及；卷入，陷入
in reference to	关于
be dimmed by	因……而黯淡

Proper Names and Cultural Notes

Toei Animation	东映动画，是日本最大、历史最悠久的动画制作公司之一。
Nippon Animation	日本动画公司，成立于1975年，前身为瑞鹰，以制作世界名作剧场而闻名于世。
Future Boy Conan	《未来少年柯南》，是宫崎骏第一次真正担任监督的作品，被称作宫崎骏的开山之作。此动画讲述了未来世界，科技高速发展，地球在核子战争中重生，荒岛上幸存者的后代少年柯南和神秘少女拉娜的冒险故事。
Telecom Animation Film	1975年由东京电影新社设立，主要针对美国市场，该公司的动画电影多根据漫画、小说或游戏原作改编。
The Castle of Cagliostro	《卡里奥斯特罗之城》，是《鲁邦三世》系列动画电影第二部作品，也是宫崎骏首次执导的动画长片。
Sherlock Hound	《名侦探福尔摩斯》是由宫崎骏制作的一部动漫作品，改编自柯南道尔的侦探小说《福尔摩斯探案集》。
Studio Ghibli	吉卜力工作室，是一家日本动画工作室。成立于1985年，原附属于德间书店，位于日本东京都近郊的小金井市，由导演宫崎骏以及他的同事高畑勋、铃木敏夫等一起统筹。
Isao Takahata	高畑勋，东映动画导演
Castle in the Sky	《天空之城》，是日本吉卜力工作室制作的动画电影，宫崎骏担任原作、监督、脚本设计、角色设定及导演。该片讲述的是少女希达和少年巴鲁以及海盗、军队、穆斯卡等寻找天空之城拉普达（Laputa）的历险故事。
Kiki's Delivery Service	《魔女宅急便》，是吉卜力工作室以角野荣子的同名小说为蓝本改编的动画电影，也是首部由吉卜力工作室与迪士尼公司合作发行的动画电影。由宫崎骏担任导演。该影片讲述的是魔法少女琪琪离开家进行独立修行的经历。
Japan Academy Prize	日本电影学院奖，又称日本电影奥斯卡，是日本唯一通过电视直播颁奖典礼的电影大奖。

Reading Comprehension

Task 1 Read the text and answer the following questions.

1. What career has Hayao Miyazaki had?
 A. Film director.
 B. Animator.
 C. Comic artist.
 D. All the above.
2. When did Hayao Miyazaki start his career as an animator?
 A. In his 20s.
 B. In his 30s.
 C. In 1970s.
 D. In 1980s.
3. Where did Miyazaki direct his first feature film?
 A. Toei Animation.
 B. A-Pro studio.
 C. Nippon Animation.
 D. Telecom Animation Film.
4. Which of the following animated films first won the Japan Academy Prize for Picture of the Year?
 A. *The Castle of Cagliostro.*
 B. *Nausicaa of the Valley of the Wind.*
 C. *Princess Mononoke.*
 D. *Castle in the Sky.*
5. Which film became the highest-grossing film in Japanese history?
 A. *The Wind Rises.*
 B. *Spirited Away.*
 C. *Howl's Moving Castle.*
 D. *My Neighbor Totoro.*

Task 2 Read the text and decide whether each of the following statements is true or false.

1. Through a career that has spanned four decades, Miyazaki has been acclaimed as Japan's greatest manga artist and anime master.
2. The thought-provoking, aesthetically pleasing animated films of Hayao Miyazaki attract audiences just within the director's native Japan.
3. Miyazaki is also described as a feminist in reference to his attitude to female workers.
4. Hayao Miyazaki's art style is unique, distinct and combines both Japanese (anime/manga) and American animation together.
5. Miyazaki never placed emphasis on the way lonely and vulnerable individuals are integrated into relationships of mutual reliance and responsibility.

Unit 7
Animation Master Hayao Miyazaki

Language in Use

Task 1 Match the underlined words or phrase in Column I with their corresponding meanings in Column II.

I	II
1. Through a career that has <u>spanned</u> five decades, Miyazaki has been acclaimed as Japan's greatest manga artist and anime master.	A. being or producing something like nothing done or experienced or created before
2. His 2001 film *Spirited Away* became the highest-<u>grossing</u> film in Japanese history, winning the Academy Award for Best Animated Feature at the 75th Academy Awards.	B. a supporter of advocating equal rights for women
3. The <u>thought-provoking</u>, aesthetically pleasing animated films of Hayao Miyazaki attract audiences well beyond the director's native Japan.	C. capable of being wounded or hurt
4. He uses a mix of <u>innovative</u> animation techniques to produce amazing landscapes, scenery, and characters.	D. the quality of being beneficial and generally good for you
5. Miyazaki's works are characterized by the recurrence of themes such as humanity's relationship with nature and technology, the <u>wholesomeness</u> of natural and traditional patterns of living, the importance of art and craftsmanship, and the difficulty of maintaining a pacifist ethic in a violent world.	E. covered or extended over an area or time period
6. Miyazaki feels <u>frustrated</u> when he sees "nature—the mountains and rivers—was being destroyed in the name of economic progress".	F. became vague or indistinct
7. Miyazaki is also described as a <u>feminist</u> in reference to his attitude to female workers.	G. stimulating interest or thought
8. Miyazaki is concerned with the sense of <u>wonder</u> in young people, seeking to maintain themes of love and family in his films.	H. a state in which you want to learn more about something
9. Miyazaki "fears Japanese children are <u>dimmed</u> by a culture of overconsumption, overprotection, utilitarian education, careerism, techno-industrialism, and a secularism that is swallowing Japan's native animism".	I. earn before taxes, expenses, etc.

10. Several of Miyazaki's works feature themes of love and romance, but emphasis is placed on "the way lonely and vulnerable individuals are integrated into relationships of mutual reliance and responsibility, which generally benefit everyone around them".

J. disappointingly unsuccessful

Task 2 Fill in the blanks with the correct form of the words given below.

| wholesome | maintain | support | note | relationship |
| individual | capable | characterize | female | economy |

Miyazaki's works are **1.**_____ by the recurrence of themes such as humanity's **2.**_____ with nature and technology, the **3.**_____ of natural and traditional patterns of living, the importance of art and craftsmanship, and the difficulty of **4.**_____ a pacifist ethic in a violent world. Miyazaki feels frustrated when he sees "nature—the mountains and rivers—was being destroyed in the name of **5.**_____ progress". Miyazaki is also described as a feminist in reference to his attitude to **6.**_____ workers. Miyazaki has described his female characters as "brave, self-sufficient girls that don't think twice about fighting for what they believe in with all their heart", stating that they may "need a friend, or a **7.**_____, but never a savior" and that "any woman is just as **8.**_____ of being a hero as any man". It can be easily **9.**_____ that the female characters in Miyazaki's films are not objectified or sexualized, and possess complex and **10.**_____ characteristics absent from Hollywood productions.

Task 3 Translate the following sentences into Chinese.

1. As a masterful storyteller and comic drawer, his films always attract us with entertaining plots, compelling characters and breathtaking animations.
2. From the beginning, he caught attention with his incredible drawing ability and the seemingly endless stream of movie ideas he proposed.
3. He uses a mix of innovative animation techniques to produce amazing landscapes, scenery, and characters.
4. It can be easily noted that the female characters in Miyazaki's films are not objectified or sexualized, and possess complex and individual characteristics absent from Hollywood productions.
5. Several of Miyazaki's works feature themes of love and romance, but emphasis is placed on "the way lonely and vulnerable individuals are integrated into relationships of mutual reliance and responsibility, which generally benefit everyone around them".

Part Three Practical Writing

Personal Statement

A personal statement is an essay you write to introduce yourself to a selection committee who you are and why you deserve to be admitted to their school or department. The most important role of the essay is to give the committee a sense of your personality and what kind of addition you'd be to their community.

A personal statement for your CV should be no more than 150 words, while personal statements for university are slightly longer and more detailed (from 500 words to 4000 words).

An effective personal statement will answer the following questions:

- Who am I?
- Who do I want to be?
- What kind of contribution do I want to make, and how?
- Why is this the right place and program? Is it consistent with the supervisor's studies and activities to date?

Remember the goal: grab the reader's interest, and make him or her want to meet you for an interview.

 Task 1 Choose the correct answer marked from A to D to each of the following statement.

1. Why is this the right place?
2. Who do I want to be?
3. What kind of contribution do I want to make, and how?
4. Who am I?

 A. My interest in science dates back to my years in high school, where I excelled in physics, chemistry, and math. When I was a senior, I took a first-year calculus course at a local college (such an advanced-level class was not available in high school) and earned an A. It seemed only logical that I pursue a career in electrical engineering.

 B. When I began my undergraduate career, I had the opportunity to be exposed to the full range of engineering courses, all of which tended to reinforce and solidify my intense interest in engineering. I've also had the opportunity to study a number of subjects in the humanities and they have been both enjoyable and enlightening, providing me with a new and different perspective on the world in which we live.

C. In the realm of engineering, I have developed a special interest in the field of laser technology and have even been taking a graduate course in quantum electronics. Among the 25 or so students in the course, I am the sole undergraduate. Another particular interest of mine is electromagnetics, and last summer, when I was a technical assistant at a world-famous local lab, I learned about its many practical applications, especially in relation to microstrip and antenna design. Management at this lab was sufficiently impressed with my work to ask that I return when I graduate. Of course, my plans following completion of my current studies are to move directly into graduate work toward my master's in science. After I earn my master's degree, I intend to start work on my Ph.D. in electrical engineering. Later I would like to work in the area of research and development for private industry. It is in R&D that I believe I can make the greatest contribution, utilizing my theoretical background and creativity as a scientist.

D. I am highly aware of the superb reputation of your school, and my conversations with several of your alumni have served to deepen my interest in attending. I know that, in addition to your excellent faculty, your computer facilities are among the best in the U.S. I hope you will give me the privilege of continuing my studies at your fine institution.

Task 2 Write a personal statement according to the given situation.

Suppose you want to apply for an art school. Write a personal statement to the admission committee of the university/college.

Part One Listening and Speaking

Task 1 Listen to a conversation about taking the language course abroad and answer the questions.

Questions:
1. Why does Lisa congratulate Sam?
2. Where is Sam going?
3. Why does Lisa say that is a chance of a lifetime?
4. What does Sam worry about?
5. How is the problem solved?

Task 2 Frank and Kelly are expressing their congratulations to each other. Listen to their conversation and fill in the blanks with what you hear.

Frank: Hey, Kelly! How was the **1.**_____ design competition? Did you and your team go home with the **2.**_____?

Kelly: Thank God, we did. **3.**_____, we succeeded and got the first place. We are the champion!

Frank: Wow! That's a good job, Kelly. Congratulations on your team success!

Kelly: Thank you very much for saying so, Frank. So, how about you and your team in **4.**_____ design competition?

Frank: Unfortunately, my team wasn't the first prize winner. We got the **5.**_____. But I was really delighted since we had won over many other teams and gone that far.

Kelly: That's the spirit, Frank! I am sure you and your friend did it very well. I still congratulate you on your achievement.

Frank: Thanks a lot, Kelly. We still have to learn more to be the first like your teams did. Team spirit and **6.**_____ can really make a great difference.

Kelly: Cool! Let's fight for the next competition!

Task 3 Work in pairs. Suppose you and your friend meet on the road and congratulate to one another for the success or achievement. You may refer to the expressions below.

Useful Expressions

Expressing one's congratulations

Congratulations! Good for you!

Unit 8
Andy Warhol and Pop Art

Congratulations to you! I'm really happy for you!

Congratulations on your success/achievement.

Congratulations on winning the football game.

Warm congratulations on successful experiment.

Congratulations on your latest promotion.

Congratulations on your engagement/marriage/wedding.

Congratulations on your complete recovery.

Giving one's further recognition

I'd like to present this little gift as a token of appreciation for all that you have done. (formal)

It's a pleasure to know that you have reached the goal you set for yourself. (formal)

You're worthy of success! I'm sure you deserve it! I think this is what you've been waiting for!

I'm glad that your outstanding work is being recognized.

The recognition you have obtained is well deserved. Your work has paid off!

You deserve the honor! That's great/outstanding/marvelous! That's a good job!

I'm delighted that you have completed the dream of a lifetime.

I admire your ingenuity and perseverance.

Responding to one's congratulations

Thanks. Maybe I'm fortunate.

Thanks a lot for saying so. I'm lucky indeed.

It's very kind of you to say so.

Thank you for your support and help.

Thank you very much. Maybe it's only my luck.

Many thanks. Without your constant help, I couldn't succeed.

Thank you. My achievement owes a lot to you.

How nice of you to say so. I owe a lot to you.

Part Two Active Reading

Andy Warhol was one of the artists obsessed with consumer culture and everyday objects. He brought popular styles and subjects into the exclusive salons of high art. His screen-printed images of Marilyn Monroe, soup cans, and sensational newspaper stories, quickly became synonymous with Pop Art. Now artists can take anything ordinary and stick them in a gallery and declare it art. Today, his work has moved out of the gallery and into our everyday lives. With Warhol's efforts, the division line between high art and everyday life began to blur.

Andy Warhol and Pop Art

By the mid-20th century, popular culture and mass marketing had begun employing imagery on a scale unparalleled in history. The world was ablaze with billboards, advertisements, magazines, television commercials, comic strips and product packaging; to many artists, it possessed a graphic dynamism and popular appeal, which rendered the prevailing artistic trend of Abstract Expressionism elitist and increasingly irrelevant.

Born to Slovakian immigrants in Pittsburgh, Pennsylvania, Andy Warhol's career as the foremost proponent of Pop Art began during his days as a commercial artist for newspapers and magazines. Over the 1950s and 1960s he rose to become the king of the New York avant-garde, and one of the most important and iconic artists of the 20th century.

Key Ideas

Warhol's early commercial illustration has recently been acclaimed as the arena in which he first learned to manipulate popular tastes. His drawings were often comic, decorative, and whimsical, and their tone is entirely different from the cold and impersonal mood of his Pop Art.

Much debate still surrounds the iconic screen-printed images with which Warhol established his reputation as a Pop artist in the early 1960s. Some view his *Death and Disaster* series, and his *Marilyn* pictures, as frank expressions of his sorrow at public events. Others view them as some of the first expressions of "compassion fatigue"—the way the public loses the ability to sympathize with events from which they feel removed. Still others think of his pictures as screens—placed between us and horrifying events—which attempt to register and process shock.

Although artists had drawn on popular culture throughout the 20th century, Pop Art marked an important new stage in the breakdown between high and low art forms. Warhol's paintings from

the early 1960s were important in pioneering these developments, but it is arguable that the diverse activities of his later years were just as influential in expanding the implications of Pop Art into other spheres, and further eroding the borders between the worlds of high art and popular culture.

Warhol went on to create paintings intermittently throughout his career, however, in 1965 he "retired" from the medium to concentrate on making experimental films. Despite years of neglect, these films have recently attracted widespread interest, and Warhol is now seen as one of the most important filmmakers of the period, a forefather of independent film.

In his later years, Warhol was absorbed in activities such as parties, collecting, publishing, and painting commissioned portraits. Some critics believe that all these ventures make up Warhol's most important legacy because they prefigure the diverse interests, activities, and interventions that occupy artists today.

Most Important Artworks

Campbell's Soup Cans

By the 1960s, the New York art world was in a rut, the very original and popular canvases of the Abstract Expressionist of the 1940s and 1950s have become cliché. Warhol was one of the artists who felt the need to bring back imagery into his work. The gallery owner and interior designer Muriel Latow gave Warhol the idea of painting soup cans, when she suggested to him that he should paint objects that people use every day.

Warhol was an extremely successful consumer ad designer. He used the techniques of his trade to create an image that is both easily recognizable, but also visually stimulating. Why have 32 very ordinary canvases take up a huge wall of an expensive gallery space? Consumer goods and ad imagery were flooding the lives of Americans with the prosperity of that age and Warhol set out to subtly recreate that abundance, via images found in advertising. He recreated on canvas the experience of being in a well-stocked supermarket. So, Warhol is credited with envisioning a new type of art that glorified the consumption habits of his contemporaries.

Coca-Cola

"I just paint things I always thought were beautiful, things you use every day and never think about." Warhol's statement epitomizes his ethos; his works put ordinary items to the front and center. This idea applies the hand-painted portrait of a Coca-Cola bottle. Another challenge to the domination of Abstract Expressionism, Warhol's *Coca-Cola* is equal in size to many of the popular canvases of the time (6ft × 5ft) but is devoid of their abstractions. The bottle jumps out at the viewer, demanding the kind of attention that one gives to traditional artworks.

Gold Marilyn Monroe

After her sudden death from an overdose of sleeping pills in August 1962, superstar Marilyn Monroe's life, career, and tragedy became a worldwide obsession. Warhol, being infatuated with fame and pop culture, obtained a black-and-white publicity photo of her and used the photo to

create several series of images. A common idea to all the Marilyn works was that her image was reproduced over and over again as one would find it reprinted in newspapers and magazines at the time. After viewing dozens, or hundreds of such images, a viewer stops seeing a person depicted, but is left an icon of popular, consumer culture. The image (and the person) becomes another cereal box on the supermarket shelf, one of hundreds of boxes which are all exactly the same.

In the *Gold Marilyn Monroe*, Warhol further plays on the idea of an icon, placing Marilyn's face on a very large golden-colored background. The background is reminiscent of Byzantine religious icons that are the central focus in Orthodox faiths to this day. Only instead of a god, we are looking at an image (that becomes a bit garish upon closer inspection) of a woman that rose to fame and died in horrible tragedy. Warhol subtly comments on our society, and its glorification of celebrities to the level of the divine. Here again the Pop artist uses common objects and images to make very pointed insights into values and surroundings of his contemporaries.

Legacy

Andy Warhol created some of the most recognizable images ever produced. Challenging the idealist visions and personal emotions conveyed by abstraction, Warhol embraced popular culture and commercial processes to produce works that appealed to the general public. He was one of the founding fathers of the Pop Art movement, expanding the ideas of Duchamp by challenging the very definition of art. His artistic risks and constant experimentation with subjects and media made him a pioneer in almost all forms of visual art. His unconventional sense of style and his celebrity entourage helped him reach the mega-star status to which he aspired.

New Words

unparalleled	[ʌnˈpærəleld]	*adj.* 无比的；无双的；空前未有的
graphic	[ˈgræfɪk]	*adj.* 形象的；图表的；绘画似的
dynamism	[ˈdaɪnəmɪzəm]	*n.* 活力；动态
appeal	[əˈpiːl]	*n.* 吸引力，感染力；呼吁，请求；上诉
render	[ˈrendər]	*vt.* 使成为；使变得；使处于（某种状态）
elitist	[ɪˈliːtɪst]	*adj.* 精英主义的
irrelevant	[ɪˈrelәvənt]	*adj.* 不相干的；不切题的，无关紧要的
proponent	[prəˈpoʊnənt]	*n.* 支持者；建议者
manipulate	[məˈnɪpjuleɪt]	*vt.* 操纵；操作；巧妙地处理
whimsical	[ˈwɪmzɪkl]	*adj.* 古怪的；异想天开的；滑稽可笑的
register	[ˈredʒɪstər]	*vt.* 记录；登记，注册
process	[ˈprɑːses]	*vt.* 处理；加工
pioneer	[ˌpaɪəˈnɪr]	*vt.* 开辟，倡导，提倡 *n.* 先锋；拓荒者
diverse	[daɪˈvɜːrs]	*adj.* 不同的；多种多样的；变化多的

Unit 8
Andy Warhol and Pop Art

influential	[ˌɪnfluˈenʃl]	*adj.* 有影响力的；有势力的
implication	[ˌɪmplɪˈkeɪʃn]	*n.* 含义；暗示；牵连，卷入；可能的结果，影响
sphere	[sfɪr]	*n.* 范围，领域；球体
erode	[ɪˈroʊd]	*vi.* 侵蚀；受腐蚀
intermittently	[ˌɪntərˈmɪtəntli]	*adv.* 间歇地
commissioned	[kəˈmɪʃnd]	*adj.* 受委托的；受委任的
venture	[ˈventʃər]	*n.* 企业；风险；冒险
prefigure	[ˌpriːˈfɪgjər]	*vt.* 预示；预想
intervention	[ˌɪntərˈvenʃn]	*n.* 干涉，干预，介入
cliché	[kliːˈʃeɪ]	*n.* 陈词滥调，老生常谈，老一套 *adj.* 陈腐的
stimulating	[ˈstɪmjuleɪtɪŋ]	*adj.* 刺激的；有刺激性的
prosperity	[prɑːˈsperəti]	*n.* 繁荣，兴隆，发达，昌盛
subtly	[ˈsʌtli]	*adv.* 巧妙地；精细地；敏锐地
abundance	[əˈbʌndəns]	*n.* 充裕，丰富
via	[ˈvaɪə]	*prep.* 通过；经由，经过；借助于
envision	[ɪnˈvɪʒn]	*vt.* 想象；展望（尤指美好的事）
glorify	[ˈglɔːrɪfaɪ]	*vt.* 赞美；美化
contemporary	[kənˈtempəreri]	*n.* 同时代的人；同时期的东西 *adj.* 当代的；同时代的
epitomize	[ɪˈpɪtəmaɪz]	*vt.* 成为……的缩影；摘要；概括
devoid	[dɪˈvɔɪd]	*adj.* 缺乏的；全无的
abstraction	[æbˈstrækʃn]	*n.* 抽象；抽象概念；抽象手法，抽象艺术
overdose	[ˈoʊvərdoʊs]	*n.* 药量过多（亦写作 overdosage）
obsession	[əbˈseʃn]	*n.* 痴迷；困扰
infatuated	[ɪnˈfætʃueɪtɪd]	*adj.* 入迷的；昏头昏脑的
publicity	[pʌbˈlɪsəti]	*n.* 宣传，宣扬；公众
cereal	[ˈsɪriəl]	*n.* 谷类，谷物；谷类食品；谷类早餐食物，麦片
reminiscent	[ˌremɪˈnɪsnt]	*adj.* 怀旧的，回忆往事的；耽于回想的
garish	[ˈgeərɪʃ]	*adj.* 炫耀的；过分装饰的；过分鲜艳的
divine	[dɪˈvaɪn]	*adj.* 神圣的；非凡的；天赐的；极好的
pointed	[ˈpɔɪntɪd]	*adj.* 尖锐的，犀利的
insight	[ˈɪnsaɪt]	*n.* 洞察力；洞悉
convey	[kənˈveɪ]	*vt.* 表达，传递，传达；传送
entourage	[ˈɑːnturɑːʒ]	*n.* 周围；环境；随从
mega-star	[ˈmegəstɑːr]	*n.* 巨星，超级明星

Useful Expressions

be ablaze with	充满着；闪耀着
compassion fatigue	同情疲劳（症）（由于过分暴露于他人痛苦而造成的怜悯心之衰退或丧失）
draw on	利用，动用
concentrate on	专注于，专心致志于
be absorbed in	专心于；全神贯注于
in a rut	一成不变，千篇一律，老一套；墨守成规
appeal to	对……有吸引力
aspire to	渴望，向往，追求

Proper Names and Cultural Notes

Andy Warhol	安迪·沃霍尔（1928—1987），波普艺术的倡导者和领袖人物。
Pop Art	波普艺术，通俗艺术，大众艺术
Abstract Expressionism	抽象表现主义（简写成 Ab-Ex），又称纽约画派（The New York School），产生于"二战"后的美国。这个名词最初用于形容美国画家 Arshile Gorky 的作品，画家利用作画时随意滴洒颜料产生的偶然效果表达自我与作品的关系，结合了"抽象艺术"与"表现主义"的概念。
Slovakian	斯洛伐克人的；斯洛伐克语的
Pittsburgh	匹兹堡（美国新英格兰地区一工业城市）
Pennsylvania	宾夕法尼亚州（美国州名）
Campbell's Soup Cans	《金宝汤罐头》，亦被称作《32 罐金宝汤罐头》（*32 Campbell's Soup Cans*），是安迪·沃霍尔于 1962 年所创作的艺术作品。
Gold Marilyn Monroe	《金色的玛丽莲·梦露》，沃霍尔的一幅波普艺术作品，使用了丝网印刷技术。
Marilyn Monro	玛丽莲·梦露（1926—1962），美国女演员，参演的电影包括《濒于崩溃》《不合时宜的人》《让我们相爱吧》等。
Byzantine	拜占庭式的；东罗马帝国的
Orthodox	东正教
Duchamp	马塞尔·杜尚（Marcel Duchamp, 1887—1968），移民美国的法裔艺术家。他是达达主义艺术运动（颠覆传统精英主义艺术观，混淆艺术品与实物界限的反艺术潮流）的领袖人物。

Unit 8
Andy Warhol and Pop Art

Reading Comprehension

Task 1 Read the text and answer the following questions.

1. What kind of family was Andy Warhol born of and what kind of person was he?
2. What was the feature of Warhol's early commercial drawings?
3. What do people think of Warhol's *Death and Disaster* series and his *Marilyn* pictures?
4. How do some critics comment on Warhol's activities in his later years?
5. Who gave Andy Warhol the idea of painting soup cans and what suggestion did the person make?

Task 2 Read the text and choose the best answer to the questions.

1. Why did the prevailing trend of Abstract Expressionism become elitist and increasingly irrelevant?
 A. Because it was employing imagery on a scale unparalleled in history.
 B. Because it was filled with too many commercial activities.
 C. Because it was influenced by popular culture and mass marketing.
 D. Because the world was full of dynamism and popular appeal.

2. Which of the following is NOT true, according to the text?
 A. Pop Art marked an important new stage in the breakdown between high and low art forms throughout the 20th century.
 B. Artists made use of popular culture for creation throughout the 20th century.
 C. Andy Warhol once focused on experimental films and achieved great success.
 D. Andy Warhol never changed his artistic fields and switched to other areas.

3. What was Andy Warhol highly praised for?
 A. For imaging a new type of art that glorified the consumption habits of his contemporaries and consumers today.
 B. For having the experience of being in a well-stocked supermarket.
 C. For having 32 very ordinary canvases take up a huge wall of an expensive gallery space.
 D. For consumer goods and ad imagery flooding the lives of Americans with abundance.

4. How did Andy Warhol challenge the domination of Abstract Expressionism?
 A. By painting beautiful things used in everyday life.
 B. By applying hand-painted portraits.
 C. By demanding same kind of attention that one gives to traditional artworks.
 D. By avoiding abstraction.

Language in Use

Task 1 Match the underlined words or phrases in Column I with their corresponding meanings in Column II.

I	II
1. By the mid-20th century, popular culture and mass marketing had begun employing imagery on a scale <u>unparalleled</u> in history.	A. unusual or strange and often amusing
2. To many artists, it possessed a graphic dynamism and popular appeal, which <u>rendered</u> the prevailing artistic trend of Abstract Expressionism elitist.	B. record and treat
3. Andy Warhol's career as the foremost <u>proponent</u> of Pop Art began during his days as a commercial artist for newspapers and magazines.	C. advocate, supporter or exponent
4. His drawings were often comic, decorative, and <u>whimsical</u>.	D. people living at the same time or of the same age
5. Still others think of his pictures as screens—placed between us and horrifying events—which attempt to <u>register and process</u> shock.	E. completely lacking in
6. The diverse activities of his later years were just as influential in expanding the implications of Pop Art into other <u>spheres</u>.	F. marked by foolish or unreasoning fondness
7. Some critics believe that all these <u>ventures</u> make up Warhol's most important legacy because they prefigure the diverse interests, activities, and interventions that occupy artists today.	G. made or caused to become
8. Warhol is credited with envisioning a new type of art that glorified the consumption habits of his <u>contemporaries</u> and consumers today.	H. radically distinctive without equal; incomparable
9. Warhol's *Coca-Cola* is equal in size to many of the popular canvases of the time but is <u>devoid of</u> their abstractions.	I. bold actions or risks
10. Warhol, being <u>infatuated</u> with fame and pop culture, obtained a black-and-white publicity photo of her and used the photo to create several series of images.	J. fields, areas, domains or arenas

Unit 8
Andy Warhol and Pop Art

Task 2 Fill in the blanks with the correct form of the words given below.

public	reproduce	reprint	view	icon
cereal	infatuate	obsess	overdose	depict

After her sudden death from an **1.**_____ of sleeping pills in August 1962, superstar Marilyn Monroe's life, career, and tragedy became a worldwide **2.**_____. Warhol, being **3.**_____ with fame and pop culture, obtained a black-and-white **4.**_____ photo of her and used the photo to create several series of images. A common idea to all the Marilyn works was that her image was **5.**_____ over and over again as one would find it **6.**_____ in newspapers and magazines at the time. After **7.**_____ dozens, or hundreds of such images, a viewer stops seeing a person **8.**_____, but is left an **9.**_____ of popular, consumer culture. The image (and the person) becomes another **10.**_____ box on the supermarket shelf, one of hundreds of boxes which are all exactly the same.

Task 3 Translate the following sentences into English.

1. 世界上满是广告牌、广告、杂志、电视商业广告、连环漫画和各种产品包装。（ablaze with）
2. 到了20世纪60年代，纽约艺术界陷入了停滞，即20世纪四五十年代有着原创品质的、流行的抽象表现主义作品变得老套了。（in a rut; cliché）
3. 尽管艺术家们在整个20世纪都从流行文化中汲取养分，但波普艺术是标志着高雅和低俗艺术形式界限崩塌的一个重要的新阶段。（draw on）
4. 挑战理想主义者的艺术眼光和抽象艺术所传达的个人情感，沃霍尔欣然接受了大众文化和商业进程，创作了吸引大众的作品。（appeal to）
5. 他的非传统的风格和所处的名人环境助力其达到了一直渴望的巨星地位。（aspire to）

 Text B

The Top Five Luxury Auction Houses

Auction houses are the source of many of the world's luxury goods. They sell Old and New Master paintings, jewelry that once belonged to celebrities, vintage cars, antiques, old coins, and other rare items that are not on the marketplace.

Auction houses with international reputations have the largest, most valuable inventories, offices around the world, and steady, astronomical sales. They are also leaders in the field of fine arts, since they bring new valuables to light and feature their collections in publications of interest to museum and gallery professionals, artists and art historians. So which auction houses are the ones that get the most attention for their item selection?

5. China Guardian

The luxury industry is growing in China, so it's no surprise that the country is now home to the world's fourth largest auction house. China Guardian, Beijing is also the second largest auctioneer in its homeland. It was founded in 1993; from then until the mid-2000's, Guardian led the Chinese art market.

Indeed, the house's largest category is exclusive Asian art. It sells Chinese oil paintings, sculptures and calligraphy, as well as Asian furniture and decorative arts: porcelain, jade, and silk screens. The rest of the inventory comprises mostly coins, rare manuscripts, and watches. In 2012, the $6 million sale of Qi Baishi's *Album of Mountains and Rivers* captured international attention and intensified the house's prestige. Even more impressive was 2013's $5.86 billion in sales.

China Guardian is now seeking to attract more art collectors, museums, and dealers around the world with its large selection of exquisite Asian art. It's likely that the house will also enlarge its fine art inventory as it competes with other global auction companies.

4. Poly International Auction Company

Beijing Poly International Auction is China's largest and strongest state-holding auction company, having overtaken China Guardian shortly after its establishment in 2005. Now, it has offices in Shanghai, Tokyo, Taiwan, New York and other international cities. Last year Poly International raked in $7.88 billion in sales, many of which were arts related.

Poly International's extensive art collection includes ancient paintings, calligraphies, antiques, ink paintings, and decorative arts (ceramics, porcelain, etc.). Plus, it offers rare books and manuscripts, clocks, wines and liquors, and scientific instruments.

Naturally, Poly International, like China Guardian, is interested in advancing the global presence of Asian art, although it does have a North America and International Department as well. It continues to grow at full speed as it accumulates rarities of interest with high market value.

Auction catalogs can be purchased through Poly International's website, where you'll also find a schedule of their upcoming events and information on how to sell to them.

3. Heritage Auctions

Heritage Auctions is the world's largest collectibles house. Based in Dallas, Texas, it specializes in U.S. and world coins, Western art, vintage comic books and comic art, jewelry and watches, rare books and manuscripts, Civil War memorabilia, space memorabilia, and much more.

Heritage Auctions's earnings for the year 2013 were nearly $917 million. Some of its most impressive sales were $1.2 million for a rare, 1792 penny, the first ever made by the Philadelphia mint, and a ground-breaking $1.7 million for a collection of Lalique crystals at auction.

Many of Heritage's sales are conducted online, even though it has offices throughout the world. In fact, nearly half of the money it earns is from internet purchases. Just consider that Heritage

Auctions gets three times as many unique visitors to its site as Christie's does and nearly thirteen times as many unique visitors as Sotheby's site receives. The number of visitors to Heritage Auctions online is 725,000 per month.

What sets Heritage Auctions apart from other big auction companies is the fact that it was established on American soil and has never moved its headquarters overseas. It is, in this way, the largest all-American auction house in history.

2. Sotheby's

Founded in London on March 11, 1744, Sotheby's is the fourth oldest auction house. Sotheby's is divided into three units: Auction, Finance, and Dealer, and has over fifty categories, including jewelry, Old Master paintings, fine wine, furniture and watches. The house's 2013's total earnings for all categories was $5.2 billion.

Sotheby's International Realty specializes in luxury real estate around the world. Potential buyers can browse a great selection of what's for sale or for rent on SIR's webpage (part of Sotheby's main site).

Sotheby's is the largest art business in the world. In May, 2012 it sold Edvard Munch's *The Scream* for nearly $120 million, a record price for an auctioned work of art.

Sotheby's also offers private (non-auction) sales and purchasing opportunities, as well as corporate art storage and appraisal services. The house also has a vast collection of digital images available for licensing and its own auction catalogs for purchase. You'll find these publications at fine art libraries belonging to elite universities.

1. Christie's

Christie's has long been the world's top auction house. Founded in 1766, the company now has 85 offices in 43 countries, including China, Japan, Spain, South Korea, Italy, Singapore, Israel, France, Russia, Germany and the United States. Its two main sales offices are located on King Street, London and Rockefeller Street, New York. Christie's office in South Kensington, London is one of the world's busiest auction rooms.

Christie's has been a private company since 1988, when billionaire François Pinault's private holding group known as Artemis bought it. (In 2003 Pinault's son François-Henri became president of Artemis.)

In 1995 Christie's founded its subsidiary Christie's International Real Estate (CIRE) as a result of clients' requests for real estate services. CIRE is an international network of top brokers who market and sell luxury properties in more than 40 countries.

Apart from art and real estate, jewelry and antiques feature among the most popular items at Christie's auctions. One of the house's most publicized events was the show held in December, 2011 for Elizabeth Taylor's personal jewelry collection. The Manhattan session sold eighty pieces from the late Hollywood icon, totaling almost $116 million, a record for an auctioned private jewelry

collection. One of the priciest pieces, Elizabeth's pearl, ruby and diamond pendant choker, sold for $11.8 million.

Christie's recently established an online auction service, which the company is encouraging clients to trust.

For those who love to keep up with Christie's events, the house publishes seasonal, theme-based brochures, both online and in print. The average print catalog costs $60–$100. However, if you are not willing to pay a price, you can find Christie's auction catalogs at elite academic libraries for the fine arts.

New Words

auction	[ˈɔːkʃn]	n. 拍卖 vt. 拍卖；竞卖
luxury	[ˈlʌkʃərɪ]	n. 奢侈，奢华；奢侈品；享受
vintage	[ˈvɪntɪdʒ]	adj. 老式的；过时的
feature	[ˈfiːtʃə]	vt. 主要展示，特写；以……为特色；由……主演
antique	[ænˈtiːk]	n. 古董，古玩
inventory	[ˈɪnvəntɔːrɪ]	n. 存货；存货清单；详细目录；财产清册
steady	[ˈstedɪ]	adj. 稳定的，持续的
astronomical	[ˌæstrəˈnɑːmɪkl]	adj. 极大的；天文的，天文学的
auctioneer	[ˌɔːkʃəˈnɪr]	n. 拍卖商
exclusive	[ɪkˈskluːsɪv]	adj. 独有的；排外的；专一的
porcelain	[ˈpɔːrsəlɪn]	n. 瓷；瓷器
jade	[dʒeɪd]	n. 翡翠；碧玉
manuscript	[ˈmænjuskrɪpt]	n. 手稿；原稿
intensify	[ɪnˈtensɪfaɪ]	vt. 使加强，使强化；使激烈
exquisite	[ɪkˈskwɪzɪt]	adj. 精致的；细腻的；优美的；高雅的
rake	[reɪk]	vi. 轻易挣得
accumulate	[əˈkjuːmjəleɪt]	vt. 积累，积聚
rarity	[ˈrerətɪ]	n. 珍品（需用复数）；罕见；珍贵
heritage	[ˈherɪtɪdʒ]	n. 遗产；传统；继承物；继承权
collectible	[kəˈlektəbl]	n. 收藏品
memorabilia	[ˌmemərəˈbɪlɪə]	n.（复数）纪念品，收藏品
conduct	[kənˈdʌkt]	vt. 进行
potential	[pəˈtenʃl]	adj. 潜在的；可能的 n. 潜能；可能性
browse	[braʊz]	vi. 浏览
corporate	[ˈkɔːrpərət]	adj. 公司的，企业的；社团的
appraisal	[əˈpreɪzl]	n. 评价；估价

elite	[eɪˈliːt]	adj. 出类拔萃的，精锐的，精英的
subsidiary	[səbˈsɪdɪərɪ]	n. 子公司；附属公司 adj. 附属的；辅助的
pearl	[pɜːrl]	n. 珍珠
ruby	[ˈruːbi]	n. 红宝石
pendant	[ˈpendənt]	n. 垂饰，挂件，吊坠
choker	[ˈtʃoʊkər]	n. 短项链，颈链
brochure	[broʊˈʃʊr]	n. 手册，小册子，宣传册
academic	[ˌækəˈdemɪk]	adj. 学术的

Useful Expressions

belong to	属于
bring... to light	使……曝光，为世人所知
specialize in	专门研究；专门经营
set... apart from...	把……与……分开
apart from	除……之外；且不说
keep up with	赶上（某思想、风尚等）；跟上，不落在……后面

Proper Names and Cultural Notes

China Guardian	中国嘉德拍卖行
Album of Mountains and Rivers	《山河之歌》（齐白石的作品）
Poly International Auction Company	保利国际拍卖公司（总部北京）
Heritage Auctions	遗产拍卖行（总部达拉斯）
Dallas	达拉斯（美国得克萨斯州东部城市）
Philadelphia	费城（美国宾夕法尼亚州东南部港市）
Lalique Crystals	拉里克水晶（法国珠宝设计大师勒内·拉里克设计的系列作品）
Sotheby's	苏富比拍卖行（总部伦敦）
Sotheby's International Realty	苏富比国际地产
The Scream	《呐喊》，挪威画家爱德华·蒙克（Edvard Munch）的作品
Christie's	佳士得拍卖行（总部伦敦）
François Pinault	弗朗克斯·皮诺特，法国富商
Artemis	阿耳特弥斯（控股集团公司）
François-Henri	弗朗索瓦·亨利（弗朗克斯·皮诺特之子，法国开云集团董事长兼首席执行官）
Christie's International Real Estate	佳士得国际地产

| Elizabeth Taylor | 伊丽莎白·泰勒，美国女演员 |
| Manhattan | 曼哈顿（美国纽约市中心区） |

Reading Comprehension

 Task 1 Read the text and answer the following questions.

1. When was China Guardian founded? What sale captured international attention in 2012?
2. What does Poly International's extensive art collection include?
3. Which auction house is the world's largest collectibles house? How are the online visitors it gets compared with those Christie's does and Sotheby's does?
4. When was Sotheby's founded? What units and how many categories does it have?
5. Which company has long been the world's top auction house? How come it has become a private company?

 Task 2 Read the text and decide whether each of the following statements is true or false.

1. Auction houses are the source of many of the world's less expensive goods.
2. China Guardian, Beijing is also the largest auctioneer in China.
3. China Guardian will also reduce its fine art inventory as the global competition is intense.
4. Auction catalogs are available through Poly International's website.
5. Christie's had one of the priciest pieces, Elizabeth's pearl, ruby and diamond pendant choker, sold for $11.8 million.

Language in Use

 Task 1 Match the underlined words in Column I with their corresponding meanings in Column II.

I	II
1. They sell Old and New Master paintings, jewelry that once belonged to celebrities, <u>vintage</u> cars, antiques, old coins, and other rare items not on the marketplace.	A. the most influential, outstanding or best
2. Auction houses with international reputations have the largest, most valuable inventories, offices around the world, and steady, <u>astronomical</u> sales.	B. assessment or evaluation

Unit 8
Andy Warhol and Pop Art

3. The luxury industry is growing in China, so it's no surprise that the country is now home to the world's fourth largest auction house.
4. It sells Chinese oil paintings, sculptures and calligraphy, as well as Asian furniture and decorative arts: porcelain, jade, and silk screens.
5. China Guardian is now seeking to attract more art collectors, museums, and dealers around the world with its large selection of exquisite Asian art.
6. It continues to grow at full speed as it accumulates rarities of interest with high market value.
7. Many of Heritage's sales are conducted online, even though it has offices throughout the world.
8. Potential buyers can browse a great selection of what's for sale or for rent on SIR's webpage (part of Sotheby's main site).
9. Sotheby's also offers private (non-auction) sales and purchasing opportunities, as well as corporate art storage and appraisal services.
10. You'll find these publications at fine art libraries belonging to elite universities.

C. likely to become or be

D. collects or gathers together

E. carried out

F. a hard shiny white substance that is used for making expensive plates, cups, etc.

G. delicate and beautiful

H. huge

I. something that is an indulgence rather than a necessity

J. old and of high quality

 Task 2 Fill in the blanks with the correct form of the words or phrases given below.

keep up with	academic	icon	auction	brochure
publicize	real estate	subsidiary	apart from	luxury

In 1995 Christie's founded its **1.**_____ Christie's International Real Estate (CIRE) as a result of clients' requests for **2.**_____ services. CIRE is an international network of top brokers who market and sell **3.**_____ properties in more than 40 countries.

4._____ art and real estate, jewelry and antiques feature among the most popular items at Christie's auctions. One of the house's most **5.**_____ events was the show held in December, 2011 for Elizabeth Taylor's personal jewelry collection. The Manhattan session sold eighty pieces from the late Hollywood **6.**_____, totaling almost $116 million, a record for an **7.**_____ private jewelry collection.

For those who love to **8.**_____ Christie's events, the house publishes seasonal, theme-based **9.**_____, both online and in print. The average print catalog costs $60-$100. However, if you are not willing to pay a price you can find Christie's auction catalogs at elite **10.**_____libraries for the fine arts.

Task 3 Translate the following sentences into Chinese.

1. They sell Old and New Master paintings, jewelry that once belonged to celebrities, vintage cars, antiques, old coins, and other rare items that are not on the marketplace.
2. They are also leaders in the field of fine arts, since they bring new valuables to light and feature their collections in publications of interest to museum and gallery professionals, artists and art historians.
3. Based in Dallas, Texas, it specializes in U.S. and world coins, Western art, vintage comic books and comic art, jewelry and watches, rare books and manuscripts, Civil War memorabilia, space memorabilia, and much more.
4. What sets Heritage Auctions apart from other big auction companies is the fact that it was established on American soil and has never moved its headquarters overseas.
5. Apart from art and real estate, jewelry and antiques feature among the most popular items at Christie's auctions.

Part Three Practical Writing

Congratulation Letters

Congratulation letters are written when there are joyous and happy events, moments or achievements, such as celebrating your friend's birthday, marriage, graduation, and promotion; receiving a prize, degree, and scholarship; opening a business, etc. The following points and sample phrases can help you get started.

A. Greeting.

Dear Mr. Smith (formal); Dear Lily and Sue (informal); Dear Simon (informal)

B. Expressing your congratulations on the event and your happy feeling.

I'm delighted to hear or learn that… Please accept my heartfelt congratulations.

I'm so glad to hear that… Congratulations on your recent promotion.

I am writing this letter to congratulate you on your marriage. I'm so happy for you.

I'd like to send my hearty congratulations on your achievement. I'm so proud of you.

I would like to extend to you my utmost congratulations on your graduation. It gives me so much joy and pride.

Unit 8
Andy Warhol and Pop Art

C. **Saying your comment on the event and your praise to the receiver.**

You've worked so hard. You deserve the honor.

Your dynamic style of leadership will be a major asset in that position.

It's an outstanding achievement. Your success is the result of your hard work.

Your success is a great inspiration to me.

Owing to your quality of leadership and good character, you have got recognition from your teachers and schoolmates.

It's so amazing that everybody should thumb up for your talent!

D. **Saying your blessing to the receiver.**

I am looking forward to a great future for you.

With this gift goes my deep affection and admiration.

I wish you greater success in university and live a happy and fruitful life.

I take pride in your achievements and avail myself of this opportunity to extend to you my best wishes for your success and happiness.

Wish you all the best!

May you adapt yourself to the college life as soon as possible!

E. **Expressing again your congratulations at the end of the letter.**

Sincere congratulations to you again.

Congratulations again.

I do hope to express my congratulations to you face to face.

Best congratulations to you again

Congratulate you again.

F. **Signing your name below the expressions.**

Sincerely; Sincerely yours; Yours; Love, etc.

Task 1 Identify and circle the basic components of the following two congratulation letters.

Dear Lily,

I am writing to congratulate you on having been admitted to Hubei University and majoring in Ad Design.

I am sure your parents are greatly proud of you. I just want you to know how pleased I am to witness your success. I learnt a lot from you, and all that you have gained is the result of your hard work. Even today I often remember how hard you studied. You told me that you were determined to be an expert in Ad Design and now you are beginning to realize your dream. Your success tells me that hard work will pay off in the end. I wish you would continue your efforts and gain further success in the new environment.

Congratulations again.

Love,
Rose

Dear Ms. Evans,

Congratulations! I got the news of your promotion to the position of Chief Financial Officer last week. It is indeed great news and I'm really happy for you. You have reached this position in your career through sheer hard work and dealing with new challenges. You have reached the pinnacle of success due to your determination and vision. You are a real idol to young women who want to have illustrious career.

I have seen your journey for last twenty years. I have silently observed your transition from a fresh graduate to a Finance Executive. You are a great team leader and good decision maker. Achieving such success is not a simple task. I understand you had to make various personal sacrifices. You may have to go a long way, but the organization will scale new heights under your leadership. I hope to see this happening in the near future. I am eagerly waiting for that day.

Unit 8
Andy Warhol and Pop Art

> I will personally come down to your corporate office to congratulate you when I am in the town. I will fix up an appointment with you in the next fortnight. My best wishes for all your future endeavors.
>
> Yours sincerely,
> Peter Ness

 Task 2 Write a congratulation letter to your friend who has been elected as Monitor of the class in no less than 120 words.

Glossary

abstraction	[æbˈstrækʃn]	n. 抽象；抽象概念；抽象手法，抽象艺术	U8TA
abundance	[əˈbʌndəns]	n. 充裕，丰富	U8TA
academic	[ˌækəˈdemɪk]	adj. 学术的	U8TB
accessory	[əkˈsesəri]	n. 配件；附件	
		adj. 副的；同谋的；附属的	U5TB
acclaim	[əˈkleɪm]	n. 欢呼，喝彩；称赞	
		vt. 称赞；为……喝彩，向……欢呼	U2TB
accomplish	[əˈkɑːmplɪʃ]	vt. 完成，实现，达到	U6TB
accumulate	[əˈkjuːmjəleɪt]	vt. 积累，积聚	U8TB
acoustic	[əˈkuːstɪk]	adj. 声学的；音响的；听觉的	U4TB
acoustics	[əˈkuːstɪks]	n. 声学；音响效果，音质	U6TA
acronym	[ˈækrənɪm]	n. 首字母缩略词	U5TA
aerodynamic	[ˌeroʊdaɪˈnæmɪk]	adj. 空气动力学的	U4TB
aeronautical	[ˌerəˈnɔːtɪkl]	adj. 航空的；航空学的；飞行的	U7TA
aesthetic	[esˈθetɪk]	adj. 美的；美学的；审美的，具有审美趣味的	U3TA
aesthetics	[esˈθetɪks]	n. 美学；审美，具有审美趣味	U6TA
aesthetically	[esˈθetɪkli]	adv. 审美地；美学观点上地	U7TB
altar	[ˈɔːltər]	n. 祭坛；圣坛；圣餐台	U2TB
alter	[ˈɔːltər]	vt. 改变，更改	U2TB
alternate	[ˈɔːltərneɪt]	vi. 交替；轮流	U1TA
amateur	[ˈæmətər]	adj. 业余的；外行的	
		n. 业余爱好者；外行	U6TB
amenity	[əˈmenəti]	n. 便利设施；舒适；礼仪；愉快	U6TA
amplifier	[ˈæmplɪfaɪər]	n. 放大器；扩音器	U4TB
amplify	[ˈæmplɪfaɪ]	vt. 放大，扩大；增强	U4TB
anarchist	[ˈænərkɪst]	n. 无政府主义者	
		adj. 无政府主义的	U2TA
anguish	[ˈæŋɡwɪʃ]	n. 痛苦；苦恼	U2TA

animation	[ˌænɪˈmeɪʃn]	n. 动漫	U7TA
animator	[ˈænɪmeɪtər]	n. 动漫画家	U7TB
animism	[ˈænɪmɪzəm]	n. 万物有灵论	U7TB
antique	[ænˈtiːk]	n. 古董，古玩	U8TB
aperture	[ˈæpərtʃər]	n. 孔，穴	U4TB
appall	[əˈpɔːl]	vt. 使胆寒；使惊骇	U2TA
appeal	[əˈpiːl]	n. 吸引力，感染力；呼吁，请求；上诉	U8TA
appealing	[əˈpiːlɪŋ]	adj. 吸引人的；动人的；引起兴趣的	U6TA
appraisal	[əˈpreɪzl]	n. 评价；估价	U8TB
approach	[əˈproʊtʃ]	n. 方法，途径；接近	U3TA
arabesque	[ˌærəˈbesk]	n. 蔓藤花纹；阿拉伯式花纹	U2TB
arbitrary	[ˈɑːrbətreri]	adj. 任意的；武断的；专制的	U2TB
architect	[ˈɑːrkɪtekt]	n. 建筑师	U3TA
array	[əˈreɪ]	n. 大批，一系列；排列，列阵	U6TA
artifact	[ˈɑːrtɪfækt]	n. 人工制品，手工艺品	U6TA
artisan	[ˈɑːrtəzn]	n. 工匠，技工	U3TB
assume	[əˈsuːm]	vt. 承担；假定；设想；采取	U3TA
astound	[əˈstaʊnd]	vt. 使惊骇，使震惊	U1TA
astronomical	[ˌæstrəˈnɑːmɪkl]	adj. 极大的；天文的，天文学的	U8TB
astute	[əˈstuːt]	adj. 机敏的；狡猾的，诡计多端的	U5TB
asylum	[əˈsaɪləm]	n. 收容所，救济院；庇护	U1TA
attribute	[əˈtrɪbjuːt]	vt. 归属，把……归于	
		n. 属性，特质	U5TA
auction	[ˈɔːkʃn]	n. 拍卖	
		vt. 拍卖；竞卖	U8TB
auctioneer	[ˌɔːkʃəˈnɪr]	n. 拍卖商	U8TB
austere	[ɔːˈstɪr]	adj. 严峻的；简朴的；苦行的；无装饰的	U2TB
auteur	[oʊˈtɜːr]	n. 电影导演	U7TA
automobile	[ˈɔːtəməbiːl]	n. 汽车	U5TA
avant-garde	[ˌævãːˈɡɑːrd]	n. 先锋派；前卫派	
		adj. 前卫的；先锋的	U2TB
averse	[əˈvɜːrs]	adj. 反对的；不愿意的	U7TA
backdrop	[ˈbækdrɑp]	n. 背景；背景幕；交流声	U1TB

beget	[bɪˈget]	vt. 产生；招致；引起	U2TA
beguiling	[bɪˈgaɪlɪŋ]	adj. 令人陶醉的；欺骗的；消遣的	U7TA
behavioral	[bɪˈheɪvjərəl]	adj. 行为的	U6TA
beige	[beɪʒ]	n. 米黄色	
		adj. 浅褐色的；米黄色的；枯燥乏味的	U2TA
blazing	[ˈbleɪzɪŋ]	adj. 闪耀的；强烈的；燃烧的	U1TA
blocky	[ˈblɒkɪ]	adj. 块状的；短而结实的；浓淡不均匀的	U5TB
blotch	[blɑːtʃ]	n. 斑点；污点；疙瘩	
		vt. 弄脏	U2TA
boardroom	[ˈbɔːrdruːm]	n. 会议室；交换场所	U5TB
bold	[boʊld]	adj. 大胆的；英勇的；黑体的；厚颜无耻的；险峻的	U5TB
brochure	[broʊˈʃʊr]	n. 手册，小册子，宣传册	U8TB
browse	[braʊz]	vi. 浏览	U8TB
brushwork	[ˈbrʌʃwɜːrk]	n. 绘画；笔法；画法；书法	U2TB
brutality	[bruːˈtæləti]	n. 无情；残忍；暴行	U2TA
buff	[bʌf]	n. 爱好者	U7TA
by-product	[ˈbaɪ prɑːdʌkt]	n. 副产品；附带产生的结果；意外收获	U5TB
campaigner	[kæmˈpeɪnər]	n. 斗士；老兵；参加者	U4TA
canvases	[ˈkænvəs]	n. 帆布；油画布；油画	U2TA
capture	[ˈkæptʃər]	vt. 俘获；夺得；捕捉；拍摄；录制	
		n. 捕获；战利品；俘虏	U5TB
carpeting	[ˈkɑːrpɪtɪŋ]	n. 毛毯，[纺]地毯；地毯料	U6TA
cavity	[ˈkævəti]	n. 腔；洞，凹处	U4TB
ceramic	[ˈskʌlptʃər]	n. 陶瓷；陶瓷制品	U2TA
cereal	[ˈsɪriəl]	n. 谷类，谷物；谷类食品；谷类早餐食物，麦片	U8TA
chafe	[tʃeɪf]	vi. 激怒，恼怒 n. 气恼	U2TA
channel	[ˈtʃænl]	vt. 引导，开导；形成河道	
		n. 通道；频道；海峡	U5TB
chapel	[ˈtʃæpl]	n. 小礼拜堂，小教堂	U4TB
cheeseparing	[ˈtʃiːz perɪŋ]	adj. 小气的，吝啬的	U3TB
chilling	[ˈtʃɪlɪŋ]	adj. 寒冷的；冷漠的；使人恐惧的；令人寒心的	

		n. 冷却；寒冷	U2TA
choker	[ˈtʃoʊkər]	n. 短项链，颈链	U8TB
clerestory	[ˈklɪrstɔːri]	n. 天窗；长廊	U4TB
cliché	[kliːˈʃeɪ]	n. 陈词滥调，老生常谈，老一套	
		adj. 陈腐的	U8TA
client	[ˈklaɪənt]	n. 客户，顾客；委托人	U5TB
cohesiveness	[koʊˈhiːsɪvnəs]	n. 凝聚力；黏结性；内聚力	U5TB
collectible	[kəˈlektəbl]	n. 收藏品	U8TB
come-hither	[ˌkʌm ˈhɪðər]	adj. 诱惑人的；勾引的	U1TB
comic	[ˈkɑːmɪk]	n. 喜剧；漫画	U7TB
commission	[kəˈmɪʃn]	n. 佣金；委员会；委任；委任状	
		vt. 委任；使服役	U5TA
commissioned	[kəˈmɪʃnd]	adj. 受委托的；受委任的	U8TA
commonplace	[ˈkɑːmənpleɪs]	n. 老生常谈；司空见惯的事；普通的东西	
		adj. 平凡的；陈腐的	U2TA
commune	[ˈkɑːmjuːn]	n. 群居团体；公社	U4TB
compatriot	[kəmˈpeɪtriət]	n. 同胞；同国人	
		adj. 同胞的；同国的	U2TB
compelling	[kəmˈpelɪŋ]	adj. 引人注目的；强制的；激发兴趣的	
		vt. 强迫；以强力获得（compel 的现在分词形式）	
			U5TB
compilation	[ˌkɑːmpɪˈleɪʃn]	n. 编译；编辑；汇编	U7TA
composite	[kəmˈpɑːzət]	adj. 复合的；合成的	
		vt. 使合成；使混合	U2TA
concealment	[kənˈsiːlmənt]	n. 隐藏，隐蔽；隐匿处	U6TB
condemn	[kənˈdem]	vt. 谴责；判刑，定罪；声讨	U7TA
conduct	[kənˈdʌkt]	vt. 进行	U8TB
consent	[kənˈsent]	n. 同意，赞成；（意见等的）一致	U1TB
consolidate	[kənˈsɑːlɪdeɪt]	vt. 巩固；使固定；联合	U3TA
constructivist	[kənˈstrʌktɪvɪst]	n. 结构主义艺术家	U3TA
consultant	[kənˈsʌltənt]	n. 顾问；咨询者 adj. 会诊医生	U5TA
contemporary	[kənˈtempərerɪ]	n. 同时代的人 adj. 同时代的	U1TB
contextual	[kənˈtekstʃuəl]	adj. 前后关系的	U4TB

词	音标	释义	位置
contour	[ˈkɑːntʊr]	n. 轮廓；等高线；周线；电路；概要 vt. 画轮廓；画等高线	U5TA
convey	[kənˈveɪ]	vt. 表达，传递，传达；传送	U8TA
corporate	[ˈkɔːrpərət]	adj. 公司的，企业的；社团的	U8TB
craft	[kræft]	n. 工艺；手艺	U3TA
crowning	[ˈkraʊnɪŋ]	adj. 最高的；无比的	U2TB
crucially	[ˈkruːʃəli]	adv. 关键地，至关重要地	U5TB
crux	[krʌks]	n. 关键；难题；十字架形	U6TA
culminate	[ˈkʌlmɪneɪt]	vt. 使结束；使达到高潮	U2TB
curvilinear	[ˌkɜːrvɪˈlɪniər]	adj. 曲线的；由曲线组成的（亦作 curvilineal）	U4TB
cutout	[ˈkʌtaʊt]	n.（布或纸上剪下的）图案花样；排气阀；保险开关	U2TB
cutting-edge	[ˌkʌtɪŋˈedʒ]	adj. 先进的；尖端的 n. 尖端；前沿；（刀片的）刃口	U5TA
dealer	[ˈdiːlər]	n. 经销商；商人	U1TA
debilitate	[dɪˈbɪlɪteɪt]	vt. 使衰弱；使虚弱	U2TA
decadence	[ˈdekədəns]	n. 堕落，颓废；衰落	U4TB
decking	[ˈdekɪŋ]	n. 装饰；盖板；[交] 桥面板	U6TB
decry	[dɪˈkraɪ]	vt. 责难，谴责；诽谤	U7TA
defy	[dɪˈfaɪ]	vt. 藐视，挑衅；公然反抗；使落空	U2TA
demonstrate	[ˈdemənstreɪt]	vt. 证明；展示；论证 vi. 示威	U5TA
denounce	[dɪˈnaʊns]	vt. 谴责，公然抨击；告发；通告废除	U3TA
derivation	[ˌderɪˈveɪʃn]	n. 引出物，派生物；转成物	U4TB
destined	[ˈdestɪnd]	adj. 注定的；命定的；去往……的	U2TA
devoid	[dɪˈvɔɪd]	adj. 缺乏的；全无的	U8TA
dim	[dɪm]	vt. 使暗淡，使失去光泽；使变模糊	U3TA
dispenser	[dɪˈspensər]	n. 药剂师；施与者；分配者；自动售货机	U5TA
diverse	[daɪˈvɜːrs]	adj. 不同的；多种多样的；变化多的	U8TA
divine	[dɪˈvaɪn]	adj. 神圣的；非凡的；天赐的；极好的	U8TA
divisive	[dɪˈvaɪsɪv]	adj. 区分的；造成不和的	U4TA
dodge	[dɑːdʒ]	vt. 躲避，避开	U7TA
dominate	[ˈdɑːmɪneɪt]	vt. 控制；支配；占优势；在……中占主要	

			地位	U2TA
down-to-earth	[ˌdaʊn tu ˈɜːrθ]	adj. 实际的；现实的		U5TB
dreary	[ˈdrɪrɪ]	adj. 沉闷的，枯燥的		U1TA
droop	[druːp]	vi. 下垂；萎靡；凋萎		U1TA
durable	[ˈdʊrəbl]	adj. 持久的；耐用的		U1TB
dwelling	[ˈdwelɪŋ]	n. 住处，寓所		U6TA
dynamic	[daɪˈnæmɪk]	adj. 有活力的；动态的；动力的		U1TB
dynamism	[ˈdaɪnəmɪzəm]	n. 活力；动态		U8TA
earthenware	[ˈɜːrθnwer]	n. 陶器		U1TA
effortlessly	[ˈefərtləsli]	adv. 轻松地，毫不费劲地		U2TB
elevate	[ˈelɪveɪt]	vt. 提升；举起；振奋（情绪等）；提升……的职位		U5TB
elite	[eɪˈliːt]	adj. 出类拔萃的，精锐的，精英的		U8TB
elitist	[ɪˈliːtɪst]	adj. 精英主义的		U8TA
elucidate	[iˈluːsɪdeɪt]	vt. 阐明；说明		U4TA
embody	[ɪmˈbɑːdi]	vt. 体现，使具体化；具体表达		U2TA
emerge	[ɪˈmɜːrdʒ]	vi. 浮现；摆脱；暴露		U5TA
emigrate	[ˈemɪɡreɪt]	vi. 移居；移居外国		U3TA
emit	[iˈmɪt]	vt. 发出，放射		U4TB
emotional	[ɪˈmoʊʃənl]	adj. 感动人的；情绪的；易激动的		U1TA
empathize	[ˈempəθaɪz]	vt. 移情；神会		U1TA
enclosed	[ɪnˈkloʊzd]	adj. 被附上的；与世隔绝的		U6TB
encompass	[ɪnˈkʌmpəs]	vt. 包含；包围		U1TA
enthrall	[ɪnˈθrɔːl]	vt. 迷住，使着迷		U7TA
entourage	[ˈɑːntʊrɑːʒ]	n. 周围；环境；随从		U8TA
envisage	[ɪnˈvɪzɪdʒ]	vt. 正视，重视		U4TA
envision	[ɪnˈvɪʒn]	vt. 想象；展望（尤指美好的事）		U8TA
epitomize	[ɪˈpɪtəmaɪz]	vt. 成为……的缩影；摘要；概括		U8TA
eponymous	[ɪˈpɑːnɪməs]	adj. 使得名的，齐名的		U7TA
erode	[ɪˈroʊd]	vi. 侵蚀；受腐蚀		U8TA
erupt	[ɪˈrʌpt]	vi. 爆发；喷出；长芽		U1TA
essence	[ˈesns]	n. 本质，实质；精华；香精		U3TA
esteem	[ɪˈstiːm]	vt. 尊敬；认为；考虑；估价		

		n. 尊重，尊敬	U7TA
ethereal	[i'θɪriəl]	adj. 优雅的；缥缈的；超凡的	U4TB
ethic	['eθɪk]	adj. 伦理的；道德的	U4TA
ethos	['iːθɑːs]	n. 社会思潮，精神特质；民族精神；气质	U3TA
evolution	[ˌiːvə'luːʃn]	n. 演变；进化；进展	U3TB
exclusive	[ɪk'skluːsɪv]	adj. 独有的；排外的；专一的	U8TB
exemplify	[ɪɡ'zemplɪfaɪ]	vt. 例证；例示	U1TA
experimentation	[ɪkˌsperɪmen'teɪʃn]	n. 实验；试验；实验法；实验过程	U2TA
expertise	[ˌeksp3ːr'tiːz]	n. 专门知识；专门技术；专家的意见	U6TA
expressionist	[ɪk'spreʃənɪst]	n. 表现派作家；表现主义艺术家	U3TA
exquisite	[ɪk'skwɪzɪt]	adj. 精致的；细腻的；优美的；高雅的	U8TB
extravagant	[ɪk'strævəɡənt]	adj. 奢侈的；过度的	U4TB
facade	[fə'sɑːd]	vt. 建筑的正面	U4TA
facet	['fæsɪt]	n. 面；方面；小平面	U6TA
fascinate	['fæsɪneɪt]	vt. 使着迷，使神魂颠倒 vi. 入迷	U1TA
feature	['fiːtʃə]	n. 地势，地形；以……为特色；由……主演	U6TB
feminist	['femənɪst]	n. 女权主义者	U7TB
fertile	['fɜːrtl]	adj. 富饶的，肥沃的；能生育的	U3TB
filmography	[ˌfɪl'mɑːɡrəfi]	n. 电影作品年表；影片集锦	U7TA
fixture	['fɪkstʃər]	n. 固定装置；设备	U6TA
flickering	['flɪkərɪŋ]	adj. 闪烁的，忽隐忽现的；摇曳的	U1TA
fluid	['fluːɪd]	adj. 流动的；流畅的；不固定的	
		n. 流体；液体	U5TA
formality	[fɔːr'mæləti]	n. 礼节；拘谨；仪式；正式手续	U2TA
formulate	['fɔːrmjuleɪt]	vt. 制定，规划；用公式表示	U6TA
functionalist	['fʌŋkʃənəlɪst]	n. 实用主义者；机能主义者	U3TA
fundamental	[ˌfʌndə'mentl]	adj. 基本的；根本的	
		n. 基本原理，基本原则	U5TA
fundamentally	[ˌfʌndə'mentəli]	adv. 根本地，从根本上；基础地	U2TB
furnishing	['fɜːrnɪʃɪŋ]	n. 家具；供给；装备；服饰	U6TA
fusion	['fjuːʒn]	n. 融合；熔化；熔接；融合物	U3TA
garish	['ɡeərɪʃ]	adj. 炫耀的；过分装饰的；过分鲜艳的	U8TA
garner	['ɡɑːrnər]	vt. 获得；储存	U7TA

geometric	[ˌdʒiːəˈmetrɪk]	adj. 几何学的；[数] 几何学图形的	U1TB
glorify	[ˈglɔːrɪfaɪ]	vt. 赞美；美化	U8TA
glossy	[ˈglɑːsi]	adj. 光滑的；有光泽的	U7TA
gospel	[ˈgɑːspl]	n. 真理；信条	U1TA
graphic	[ˈgræfɪk]	adj. 绘画似的；形象的；图表的	U5TB
gut-wrenching	[ˈgʌt rentʃɪŋ]	adj. 极度痛苦的，撕心裂肺的	U1TB
gypsy	[ˈdʒɪpsi]	n. 吉卜赛人；吉卜赛语 adj. 吉卜赛人的	U2TA
halo	[ˈheɪloʊ]	n. 光环；荣光	U1TA
handicraft	[ˈhændikræft]	n. 手工艺；手工艺品	U3TA
heritage	[ˈherɪtɪdʒ]	n. 遗产；传统；继承物；继承权	U8TB
horticulture	[ˈhɔːrtɪkʌltʃər]	n. 园艺；园艺学	U6TB
hotchpotch	[ˈhɑːtʃpɑːtʃ]	n. 杂烩	U6TB
iconic	[aɪˈkɑːnɪk]	adj. 形象的；图标的	U3TB
iconography	[ˌaɪkəˈnɑːgrəfi]	n. 肖像研究；肖像学；图解	U5TA
ideology	[ˌaɪdiˈɑːlədʒi]	n. 意识形态；思想意识	U3TB
illustration	[ˌɪləˈstreɪʃn]	n. 说明，插图；例证；图解	U2TB
impasse	[ˈɪmpæs]	n. 僵局；死路	U1TB
impasto	[ɪmˈpæstoʊ]	n. 厚涂的颜料；厚涂颜料的绘画法	U2TB
implacable	[ɪmˈplækəbl]	adj. 难和解的；不能缓和的；不能安抚的	U1TB
implication	[ˌɪmplɪˈkeɪʃn]	n. 含义；暗示；牵连，卷入；可能的结果，影响	U8TA
impoverished	[ɪmˈpɑːvərɪʃt]	adj. 无趣的；穷困的	U4TA
inclination	[ˌɪnklɪˈneɪʃn]	n. 倾向，爱好；斜坡	U1TA
inconsistent	[ˌɪnkənˈsɪstənt]	adj. 不一致的；前后矛盾的	U5TB
incorporate	[ɪnˈkɔːrpəreɪt]	vt. 包含，吸收；把……合并	U6TB
indelible	[ɪnˈdeləbl]	adj. 难忘的；擦不掉的	U4TA
infatuated	[ɪnˈfætʃueɪtɪd]	adj. 入迷的；昏头昏脑的	U8TA
influential	[ˌɪnfluˈenʃl]	adj. 有影响的；有势力的	U1TA
ingenious	[ɪnˈdʒiːnɪs]	adj. 有独创性的；机灵的；精制的；心灵手巧的	U3TB
inheritance	[ɪnˈherɪtəns]	n. 遗产；继承；遗传	U1TB

inhumanity	[ˌɪnhjuːˈmænəti]	n. 不人道，无人性；残暴	U2TA
inimitable	[ɪˈnɪmɪtəbl]	adj. 独特的，无比的；无法仿效的	U1TA
initiate	[ɪˈnɪʃieɪt]	vt. 开始，创始；发起；使初步了解	U3TA
innovation	[ˌɪnəˈveɪʃn]	n. 创新，革新；新方法	U5TA
insight	[ˈɪnsaɪt]	n. 洞察力；洞悉	U8TA
integrate	[ˈɪntɪgreɪt]	vt. 整合；使……成整体	U5TA
intellectual	[ˌɪntəˈlektʃuəl]	n. 知识分子	
		adj. 智力的；聪明的；理智的	U2TA
intensify	[ɪnˈtensɪfaɪ]	vt. 使加强，使强化；使变激烈	U8TB
interior	[ɪnˈtɪriər]	n. 室内；内部	
		adj. 内部的；国内的	U2TB
intermittently	[ˌɪntərˈmɪtəntli]	adv. 间歇地	U8TA
intertwine	[ˌɪntərˈtwaɪn]	vi. 纠缠；编结	
		vt. 缠绕；纠缠	U5TB
intervention	[ˌɪntərˈvenʃn]	n. 干涉，干预，介入	U8TA
intricacy	[ˈɪntrɪkəsi]	n. 错综，复杂；难以理解	U7TA
intricately	[ˈɪntrɪkətli]	adv. 复杂地；错综地，缠结地	U3TA
intrigue	[ɪnˈtriːg]	vt. 激起……的兴趣；用诡计取得	U3TB
invaluably	[ɪnˈvæljʊblɪ]	adv. 非常贵重地，无价地	U5TB
inventory	[ˈɪnvəntɔːri]	n. 存货；存货清单；详细目录；财产清册	U8TB
irrelevant	[ɪˈreləvənt]	adj. 不相干的；不切题的，无关紧要的	U8TA
isolation	[ˌaɪsəˈleɪʃn]	n. 隔离；孤立	U1TB
jade	[dʒeɪd]	n. 翡翠；碧玉	U8TB
landscape	[ˈlændskeɪp]	n. 风景；地形；风景画，山水画	U6TB
lavish	[ˈlævɪʃ]	vt. 慷慨给予；浪费；滥用	U1TB
layout	[ˈleɪaʊt]	n. 布局；设计；安排；陈列	U6TB
legacy	[ˈlegəsi]	n. 遗赠，遗产	U2TA
level	[ˈlevl]	vt. 使同等；对准；弄平	U3TA
lifespan	[ˈlaɪfspæn]	n. 寿命；预期生命期限；预期使用期限	U6TB
locomotive	[ˌloʊkəˈmoʊtɪv]	n. 机车；火车头	
		adj. 火车头的；运动的，移动的	U5TA
lucidity	[luːˈsɪdəti]	n. 明朗；清澈；清醒度	U1TA
lucrative	[ˈluːkrətɪv]	adj. 有利可图的，赚钱的；合算的	U6TB

word	pronunciation	meaning	ref
luminous	[ˈluːmɪnəs]	adj. 发光的；明亮的	U4TB
lush	[lʌʃ]	adj. 丰富的；豪华的；苍翠繁茂的	U1TB
luxury	[ˈlʌkʃərɪ]	n. 奢侈，奢华；奢侈品；享受	U8TB
lyricism	[ˈlɪrɪsɪzəm]	n. 抒情性；抒情诗体；抒情方式抒情	U2TA
magnitude	[ˈmæɡnɪtuːd]	n. 重要；大小；量级；（地震）震级	U5TA
mainstay	[ˈmeɪnsteɪ]	n. 支柱；中流砥柱；主要的依靠	U5TB
maintenance	[ˈmeɪntənəns]	n. 维护，维修；保持；生活费用	U6TB
manifestation	[ˌmænɪfeˈsteɪʃn]	n. 表现；显示；示威运动	U2TA
manifesto	[ˌmænɪˈfestoʊ]	n. 宣言；声明；告示	U3TA
manifold	[ˈmænɪfoʊld]	adj. 多方面的，有许多部分的；各式各样的 vt. 复写，复印；增多；使……多样化 n. 多种；复印本	U2TB
manipulate	[məˈnɪpjuleɪt]	vt. 操纵；操作；巧妙地处理	U8TA
manuscript	[ˈmænjuskrɪpt]	n. 手稿；原稿	U8TB
marketable	[ˈmɑːrkɪtəbl]	adj. 市场的；可销售的；有销路的	U3TA
masonry	[ˈmeɪsənri]	n. 石造建筑	U4TB
masterpiece	[ˈmæstərpiːs]	n. 杰作；绝无仅有的人	U5TA
mastery	[ˈmæstəri]	n. 掌握；精通；优势；征服；统治权	U6TB
meditative	[ˈmedɪteɪtɪv]	adj. 冥想的，沉思的	U4TB
mega-star	[ˈmeɡəstɑːr]	n. 巨星，超级明星	U8TA
melancholy	[ˈmelənkɑːli]	adj. 忧郁的；使人悲伤的 n. 忧郁；悲哀；愁思	U2TA
memorabilia	[ˌmemərəˈbɪlɪə]	n. （复数）纪念品，收藏品	U8TB
merge	[mɜːrdʒ]	vt. 合并	U3TA
methodical	[məˈθɑːdɪkl]	adj. 有系统的；有方法的	U1TB
microcosm	[ˈmaɪkroʊkɑːzəm]	n. 微观世界；小宇宙	U3TA
mimic	[ˈmɪmɪk]	vt. 模仿，模拟	U4TB
mindset	[ˈmaɪndset]	n. 心态；倾向；习惯；精神状态	U3TA
minimalism	[ˈmɪnɪməlɪzəm]	n. 极简派艺术；最低纲领；极保守行动	U5TB
misanthropic	[ˌmɪsənˈθrɑːpɪk]	adj. 厌恶人类的；不愿与人来往的	U7TA
missionary	[ˈmɪʃəneri]	n. 传教士	U1TA
modernity	[məˈdɜːrnəti]	n. 现代性；现代的东西；新式	U3TA
modify	[ˈmɒdɪfaɪ]	vt. 修改；修饰；更改	U5TB

mold	[moʊld]	vt. 塑造；使发霉；用模子制作	
		vi. 发霉	U5TA
mosaic	[moʊˈzeɪɪk]	n. 马赛克；镶嵌	
		adj. 镶嵌细工的；用拼花方式制成的	U2TA
neophyte	[ˈniːəfaɪt]	n. 新信徒；新入教者；初学者	U7TA
nomination	[ˌnɑːmɪˈneɪʃn]	vt. 提名；推荐	U7TA
nude	[nuːd]	adj. 裸的，裸体的；无装饰的；与生俱有的	
		n. 裸体；裸体画	U2TA
objectify	[əbˈdʒektɪfaɪ]	vt. 对象化；物化	U7TB
obsession	[əbˈseʃn]	n. 痴迷；困扰	U8TA
occupant	[ˈɑːkjəpənt]	n. 居住者；占有者	U4TA
oeuvre	[ˈɜːvrə]	n. 全部作品；毕生之作	U2TB
opaque	[oʊˈpeɪk]	adj. 不透明的；阴暗的	U2TB
optimize	[ˈɑːptɪmaɪz]	vt. 使最优化，使完善	U6TA
organic	[ɔːrˈɡænɪk]	adj. [有化] 有机的；组织的；器官的；	
		根本的	U3TB
ornament	[ˈɔːrnəmənt]	n. 装饰；[建][服装] 装饰物；教堂用品	U6TB
ornamentation	[ˌɔːrnəmenˈteɪʃn]	n. 装饰物	U3TB
outlier	[ˈaʊtlaɪər]	n. 局外人；离开本体的部分	U7TA
overdose	[ˈoʊvərdoʊs]	n. 药量过多（亦作 overdosage）	U8TA
overshadow	[ˌoʊvərˈʃædoʊ]	vt. 使失色；使阴暗；遮阴	U1TB
overstate	[ˌoʊvərˈsteɪt]	vt. 夸张，夸大叙述	U6TB
overwhelming	[ˌoʊvərˈwelmɪŋ]	adj. 压倒性的；势不可挡的	U1TA
pacifist	[ˈpæsɪfɪst]	n. 和平主义者	U7TB
package	[ˈpækɪdʒ]	n. 包，包裹	
		vt. 打包；将……包装	U5TA
palette	[ˈpælət]	n. 调色板；颜料	U2TA
pastor	[ˈpæstər]	n. 牧师	U1TA
pastoral	[ˈpæstərəl]	adj. 田园生活的，乡村的	U7TA
patronage	[ˈpætrənɪdʒ]	n. 赞助；光顾；任免权	U2TA
pearl	[pɜːrl]	n. 珍珠	U8TB
pendant	[ˈpendənt]	n.（项链上的）垂饰，挂件，吊坠	U8TB
penny-pinching	[ˈpenɪpɪntʃɪŋ]	adj. 小气的，吝啬的	U3TB

perennial	[pəˈrenɪl]	adj. 多年生的；常年的；四季不断的；常在的；反复的	U6TB
perilous	[ˈperələs]	adj. 危险的，冒险的	U3TA
perky	[ˈpɜːrki]	adj. 神气的；得意扬扬的；自信的；活泼的	U1TA
persuasive	[pərˈsweɪsɪv]	adj. 有说服力的；劝诱的，劝说的	U5TB
pictorial	[pɪkˈtɔːriəl]	adj. 绘画的；形象化的 n. 画报，画刊	U1TB
piercing	[ˈpɪrsɪŋ]	adj. 敏锐的；刺穿的；尖刻的；打动人心的	U2TA
pigment	[ˈpɪɡmənt]	n. 色素；颜料 vt. 给……着色	U2TB
pilgrimage	[ˈpɪlɡrɪmɪdʒ]	n. 朝圣之行；漫游	U4TB
pioneer	[ˌpaɪəˈnɪr]	vt. 开辟；倡导，提倡 n. 先锋；拓荒者	U8TA
pioneering	[ˌpaɪəˈnɪrɪŋ]	adj. 首创的；先驱的	U5TB
pointed	[ˈpɔɪntɪd]	adj. 尖锐的，犀利的	U8TA
polemicist	[pəˈlemɪsɪst]	n. 善辩论者；辩论家	U4TA
porcelain	[ˈpɔːrsəlɪn]	n. 瓷；瓷器	U8TB
portraiture	[ˈpɔːrtrətʃər]	n. 肖像画；肖像绘制；人像摄影	U2TB
potential	[pəˈtenʃl]	adj. 潜在的；可能的 n. 潜能；可能性	U8TB
pragmatist	[ˈpræɡmətɪst]	n. 实用主义者	U3TA
precedent	[ˈpresɪdənt]	n. 先例，前例 adj. 在前的，在先的	U5TB
preeminent	[ˌpriːˈemɪnənt]	adj. 卓越的，超群的	U5TB
prefabricated	[ˌpriːˈfæbrɪkeɪtɪd]	adj.（建筑物）预制的；组装的	U4TA
prefigure	[ˌpriːˈfɪɡjər]	vt. 预示；预想	U8TA
preliminary	[prɪˈlɪmɪneri]	adj. 初步的；开始的；预备的	U3TA
prescribe	[prɪˈskraɪb]	vt. 规定；开处方	U6TB
prestigious	[preˈstɪdʒəs]	adj. 有名望的；享有声望的	U2TB
pretentious	[prɪˈtenʃəs]	adj. 自命不凡的；炫耀的；做作的	U5TB
primacy	[ˈpraɪməsi]	n. 首位；卓越	U3TA
proceed	[proʊˈsiːd]	vi. 开始；继续进行；发生；行进 n. 收入，获利	U5TA
process	[ˈprɑːses]	vt. 处理；加工	U8TA

Word	Pronunciation	Meaning	Reference
prodigious	[prə'dɪdʒəs]	adj. 惊人的，异常的；奇妙的；巨大的	U2TA
productive	[prə'dʌktɪv]	adj. 多产的；能生产的；富有成效的	U1TA
professional	[prə'feʃənl]	n. 专业人员；职业运动员	U6TB
progressive	[prə'gresɪv]	adj. 进步的；先进的	U3TA
proliferation	[prə,lɪfə'reɪʃn]	n. 增殖；扩散；分芽繁殖	U5TA
prolific	[prə'lɪfɪk]	adj. 多产的；丰富的	U2TA
prominence	['prɑːmɪnəns]	n. 突出；显著；突出物；卓越	U3TA
prophet	['prɑːfɪt]	n. 先知，预言者；提倡者	U1TB
proponent	[prə'poʊnənt]	n. 支持者；建议者	U8TA
prosperity	[prɑː'sperəti]	n. 繁荣，兴隆，发达，昌盛	U8TA
prostitute	['prɑːstətuːt]	n. 妓女	U2TA
provocative	[prə'vɑːkətɪv]	adj. 激发感情（或行动）的；令人振奋的	U4TA
pseudonym	['suːdənɪm]	n. 笔名；假名	U4TA
publicity	[pʌb'lɪsəti]	n. 宣传，宣扬；公众	U8TA
quart	[kwɔːrt]	n. 夸脱（容量单位）；一夸脱的容器	U5TA
radical	['rædɪkl]	n. 激进分子；基础	
		adj. 激进的；根本的；彻底的	U2TA
raid	[reɪd]	vi. 对……进行突然袭击	U3TA
rake	[reɪk]	vi. 轻易挣得	U8TB
ramp	[ræmp]	n. 斜坡，坡道	U4TA
rarity	['rerəti]	n. 珍品（需用复数）；罕见；珍贵	U8TB
rational	['ræʃnəl]	adj. 合理的；理性的	
		n. 有理数	U5TB
rationally	['ræʃnəli]	adj. 理性地	U4TA
reassemble	[,riːə'sembl]	vt. 重新装配；重新召集	U2TA
recurrence	[rɪ'kɜːrəns]	n. 重视，反复出现	U7TB
refined	[rɪ'faɪnd]	adj. 精炼的；精确的；微妙的；有教养的	U3TA
register	['redʒɪstər]	vt. 记录；登记，注册	U8TA
reluctant	[rɪ'lʌktənt]	adj. 不情愿的，勉强的；顽抗的	U1TB
remarkable	[rɪ'mɑːrkəbl]	adj. 卓越的；非凡的；值得注意的	U2TB
reminiscent	[,remɪ'nɪsnt]	adj. 怀旧的，回忆往事的；耽于回想的	U8TA
render	['rendər]	vt. 使处于（某种状态）；实施；着色	U1TA
renovator	['renəuveɪtə]	n. 革新者，更新者；修理者	U6TA

renowned	[rɪ'naʊnd]	adj. 著名的；有声望的	U5TA
residential	[ˌrezɪ'denʃl]	adj. 住宅的；与居住有关的	U6TB
resign	[rɪ'zaɪn]	vt. 辞职；放弃；委托；使听从	U3TA
resistance	[rɪ'zɪstəns]	n. 阻力；电阻；抵抗，反抗；抵抗力	U5TA
restrain	[rɪ'streɪn]	vt. 抑制，控制；约束；制止	U1TB
retain	[rɪ'teɪn]	vt. 保持；记住	U5TA
revamp	['riːvæmp]	vt. 修补；翻新；修改	
		n. 改进	U5TB
reveal	[rɪ'viːl]	vt. 显示；透露；揭露；泄露	U3TB
revere	[rɪ'vɪr]	vt. 敬畏；尊敬；崇敬	U7TA
rhythmic	['rɪðmɪk]	adj. [生物] 有节奏的；间歇的；合拍的	U1TA
ripple	['rɪpl]	n. 波纹；涟漪	U7TA
ruby	['ruːbi]	n. 红宝石	U8TB
salvation	[sæl'veɪʃn]	n. 拯救；救助	U1TB
savior	['seɪvjər]	n. 救世主；救星；救助者	U7TB
scheme	[skɪm]	n. 计划；组合；体制；诡计	U6TB
scratch	[skrætʃ]	vt. 抓；刮；挖出；乱涂	
		vi. 抓；搔；发刮擦声	
		n. 擦伤；抓痕；刮擦声；乱写	U5TB
sculpture	['skʌlptʃər]	n. 雕塑；雕刻；刻蚀	
		vt. 雕塑；雕刻；刻蚀	U2TA
seclusion	[sɪ'kluːʒn]	n. 隔离；隐退；隐蔽的地方	U1TB
secondary	['sekənderɪ]	adj. 第二的；次要的；中等的，中级的	U1TB
secularism	['sekjələrɪzəm]	n. 世俗主义；现世主义；宗教与教育分离论	U7TB
sensibility	[ˌsensə'bɪləti]	n. 情感；敏感性；感觉；识别力	U3TB
sensuous	['senʃuəs]	adj. 感觉上的，依感观的；诉诸美感的	U1TB
sheer	[ʃɪr]	adj. 绝对的；透明的；峻峭的；纯粹的	
		adv. 完全地；陡峭地	U5TB
signify	['sɪgnɪfaɪ]	vt. 表示；意味；预示	U5TB
sinuous	['sɪnjuəs]	adj. 蜿蜒的；弯曲的；迂回的	U2TB
skyline	['skaɪlaɪn]	adj. 天际线	U4TA
slenderize	['slendəˌraɪz]	vt. 使苗条；使成细长状	U5TA
solidify	[sə'lɪdɪfaɪ]	vt. 团结；凝固	U7TA

span	[spæn]	vt. 跨越；持续；以手指测量	U7TB
sparing	['sperɪŋ]	adj. 节约的；贫乏的；保守的	
		n. 抽出；宽恕；免去；给予（spare 的现在分词形式）	
			U5TA
sphere	[sfɪr]	n. 范围，领域；球体	U8TA
spontaneous	[spɑːn'teɪniəs]	adj. 自发的，自然的，无意识的	U2TB
sporadic	[spə'rædɪk]	adj. 零星的；分散的	U4TB
staggering	['stægərɪŋ]	adj. 惊人的，令人震惊的	U1TB
standardize	['stændərdaɪz]	vt. 标准化	U4TA
stark	[stɑːrk]	adj. 完全的；荒凉的；刻板的；光秃秃的；朴实的	
			U2TA
steady	['stedɪ]	adj. 稳定的，持续的	U8TB
sterile	['sterəl]	adj. 枯燥乏味的	U4TB
stimulating	['stɪmjuleɪtɪŋ]	adj. 刺激的；有刺激性的	U8TA
strategy	['strætədʒi]	n. 战略，策略	U5TB
streamline	['striːmlaɪn]	vt. 把……做成流线型；使现代化；组织；使合理化；使简单化 n. 流线；流线型 adj. 流线型的	U5TA
stripe	[straɪp]	n. 条纹；斑纹；种类	U5TB
stroke	[stroʊk]	n. 笔画；（游泳或划船的）划；中风；（打、击等的）一下	U5TA
stylistic	[staɪ'lɪstɪk]	adj. 风格上的；格式上的；文体论的	U2TB
subsequently	['sʌbsɪkwəntli]	adv. 随后，其后；后来	U7TB
subsidiary	[səb'sɪɪerɪ]	n. 子公司；附属公司	
		adj. 附属的；辅助的	U8TB
subtly	['sʌtli]	adv. 巧妙地；精细地；敏锐地	U8TA
superlative	[suː'pɜːrlətɪv]	n. 赞美之词；最高程度；最高级	U1TB
suppress	[sə'pres]	vt. 抑制；镇压；废止	U1TB
swirling	['swɜːrlɪŋ]	adj. 打旋的	U1TA
swooping	[swuːpɪŋ]	adj.（表面）陡斜的	U4TA
symbolism	['sɪmbəlɪzəm]	n. 象征，象征主义；符号论；记号	U1TA
tangible	['tændʒəbl]	adj. 可触摸的；有形的；切实的	U6TA
taper	['teɪpər]	vt. 逐渐减少	U4TB
temperament	['temprəmənt]	n. 气质，性情，性格；急躁	U1TA

单词	音标	释义	出处
template	['templət]	n. 模板，样板	U6TA
tenacious	[tə'neɪʃəs]	adj. 顽强的；坚韧的；固执的；紧握的；黏着力强的	U7TA
tension	['tenʃn]	n. 张力，拉力；紧张，不安	U7TA
terror	['terər]	n. 恐怖；恐怖行动；恐怖时期；可怕的人	U2TA
testament	['testəmənt]	n. [法] 遗嘱；圣约；确实的证明	U2TA
testimony	['testɪmoʊnɪ]	n. [法] 证词，证言；证据	U5TA
theology	[θi'ɑːlədʒi]	n. 神学；宗教体系	U1TA
thought-provoking	['θɔːt prəvoʊkɪŋ]	adj. 发人深省的；引起思考的	U7TB
timeless	['taɪmləs]	adj. 永恒的；不受时间影响的	U5TB
tinge	[tɪndʒ]	vt. 微染；使带气息 n. 淡色；些许味道；风味	U2TB
trailer	['treɪlər]	n.（电视）预告片；追踪者	U7TA
transform	[træns'fɔːrm]	vt. 改变；使……变形；转换 vi. 变换；改变；转化	U5TB
turmoil	['tɜːrmɔɪl]	n. 混乱，骚动	U1TA
typicality	['tɪpɪ'kælɪtɪ]	n. 典型性	U2TA
ultimately	['ʌltɪmətli]	adv. 最后；根本；基本上	U5TB
uncanny	[ʌn'kæni]	adj. 神秘的；离奇的；可怕的	U5TB
uncompromisingly	[ʌn'kɑːmprəmaɪzɪŋli]	adv. 坚决地；不妥协地	U2TB
undermine	[ˌʌndər'maɪn]	vt. 破坏，渐渐破坏	U1TA
unify	['juːnɪfaɪ]	vt. 统一；使相同，使一致	U6TB
unleash	[ʌn'liːʃ]	vt. 发动；解开……的皮带；解除……的束缚	U7TA
unparalleled	[ʌn'pærəleld]	adj. 无比的；无双的；空前未有的	U8TA
unrivalled	[ʌn'raɪvld]	adj. 无与伦比的；无敌的	U2TB
uphold	[ʌp'hoʊld]	vt. 鼓励；赞成；支撑；举起	U3TB
utilitarian	[juːˌtɪlɪ'teriən]	adj. 功利的；功利主义的；实利的	U7TB
vacation	[və'keɪʃn]	vi. 休假，度假 n. 假期	U2TB
vacuum	['vækjuəm]	n. 真空；空间；真空吸尘器 adj. 真空的	U5TA
venture	['ventʃər]	n. 企业；风险；冒险	U8TA
versatile	['vɜːrsətl]	adj. 多才多艺的；通用的，万能的	U1TB

vestment	['vestmənt]	n.（神职人员）法衣；官服；祭坛布；礼服；衣服	U2TB
via	['vaɪə]	prep. 通过；经由，经过；借助于	U8TA
vibrant	['vaɪbrənt]	adj. 充满生气的；振动的	U1TA
vintage	['vɪntɪdʒ]	adj. 老式的；过时的	U8TB
visionary	['vɪʒəneri]	n. 空想家；梦想者；有眼力的人 adj. 梦想的；幻影的	U5TA
vista	['vɪstə]	n. 远景；狭长的街景；展望；回顾	U7TA
visual	['vɪʒuəl]	adj. 视觉的；视力的；栩栩如生的	U5TB
visually	['vɪʒuəli]	adv. 形象化地；外表上；看得见地	U5TB
vitality	[vaɪ'tæləti]	n. 活力，生气；生命力；生动性	U5TA
volatile	['vɑlətl]	adj. 不稳定的；爆炸性的；反复无常的	U1TB
vulnerable	['vʌlnərəbl]	adj. 易受攻击的；易受伤害的；有弱点的	U7TB
vying	['vaɪɪŋ]	vi. 争夺（vie 的现在分词）	U3TA
watchful	['wɑːtʃfl]	adj. 警惕的，警醒的；注意的	U2TA
whimsical	['wɪmzɪkl]	adj. 古怪的；异想天开的；滑稽可笑的	U8TA
whimsy	['wɪmzɪ]	n. 怪念头；反复无常	U7TA
wrought	[rɔːt]	adj. 锻造的；加工的；精细的	U6TA